GAY ROBINS

EGYPTIAN STATUES

SHIRE EGYPTOLOGY

Cover photographs
(Left) Colossal statue of King Amenhotep III, quartzite, Eighteenth Dynasty, funerary
temple of Amenhotep III at Thebes.
(Top right) Colossal statues of King Ramesses II, sandstone, Nineteenth Dynasty, temple
of Ramesses II at Abu Simbel, Nubia.
(Bottom right) Colossal statues of various kings in front of the eighth pylon at the temple
of Karnak, limestone and quartzite, Eighteenth Dynasty, Thebes.
(Author's photographs)

This book is dedicated to the memory of my beloved husband, Charles Shute, who
saw its beginning but not its end.

British Library Cataloguing in Publication Data:
Robins, Gay
Egyptian Statues. – (Shire Egyptology; no. 26)
1. Statues – Egypt
2. Sculpture, Ancient – Egypt
1. Title
731.7'6'0962
ISBN 0 7478 0520 2.

Published by
SHIRE PUBLICATIONS LTD
Cromwell House, Church Street, Princes Risborough,
Buckinghamshire HP27 9AA, UK.
Website: www.shirebooks.co.uk

Series Editor: Barbara Adams

Number 26 in the Shire Egyptology Series.

ISBN 0 7478 0520 2.

First published 2001.

Printed in Great Britain by
CIT Printing Services Ltd, Press Buildings,
Merlins Bridge, Haverfordwest, Pembrokeshire SA61 1XF.

Contents

Acknowledgements

I would like to thank Peter Lacovara, Dorothea Arnold, Catharine Roehrig, Eileen Sullivan and Mary Doherty for all their help with the illustrations, Glenn Gunhouse for reading the manuscript and making many valuable suggestions, and Brian Winterfeldt for his generous support of my work.

4

List of illustrations

Chronology

Early Dynastic Period	3050–2686 BC
	3050–2890 Dynasty I *Den*
	2890–2686 Dynasty II *Khasekhem(wy)*
Old Kingdom	2686–2181 BC
	2686–2613 Dynasty III
	2668–2649 Djoser
	2613–2498 Dynasty IV
	2566–2558 Djedefre
	2558–2528 Khaefre
	2525–2497 Menkaure
	2498–2345 Dynasty V
	2477–2467 Neferirkare
	2345–2181 Dynasty VI
	2332–2283 Pepi I
	2278–2184 Pepi II
First Intermediate Period	2181–2040 BC
	2181–2040 Dynasties VII–X
	2134–2040 Dynasty XI (Theban)
	2060–2040 Nebhepetre Mentuhotep
Middle Kingdom	2040–1782 BC
	2040–1991 Dynasty XI (all Egypt)
	2040–2010 Nebhepetre Mentuhotep
	1991–1782 Dynasty XII
	1881–1842 Sesostris III
Second Intermediate Period	1782–1570 BC
	1782–1650 Dynasties XIII–XIV
	1663–1555 Dynasties XV–XVI (Hyksos)
	1663–1570 Dynasty XVII (Theban)
New Kingdom	1570–1070 BC
	1570–1293 Dynasty XVIII
	1498–1483 Hatshepsut
	1504–1450 Tuthmosis III
	1453–1419 Amenhotep II
	1386–1349 Amenhotep III

1350–1334 Akhenaten
1334–1325 Tutankhamun
1321–1293 Horemheb
1293–1185 Dynasty XIX
1279–1212 Ramesses II
1212–1199 Merneptah
1199–1193 Seti II
1185–1070 Dynasty XX

Third Intermediate Period 1070–713 BC
1070–945 Dynasty XXI
945–712 Dynasty XXII
828–712 Dynasty XXIII
724–713 Dynasty XXIV
772–712 Dynasty XXV/1

Late Period 713–332 BC
713–656 Dynasty XXV/2
664–525 Dynasty XXVI
664–610 Psammetichus I
525–404 Dynasty XXVII
404–399 Dynasty XXVIII
399–380 Dynasty XXIX
380–343 Dynasty XXX
360–342 Nectanebo II

Ptolemaic Period 332–30 BC

Roman Emperors 30 BC – AD 395

1
Introduction

For over three thousand years ancient Egyptian sculptors created statues of deities, kings and members of the governing elite group. Statues were not made as isolated objects to be viewed as works of art – as we view them today in museums and art books – but were produced for a specific setting in a temple or tomb, where they played a vital role in temple or funerary ritual. Most statues were places where a non-physical entity – a deity, the royal *ka*-spirit, or the *ka*-spirits of the dead – could manifest in this world. The statue provided a physical body and had to be recognisable and appropriate to the being that was meant to manifest in it. Since such beings were not physical entities, they were unrestricted by time and space and could be simultaneously present in all their images wherever they were located. Most statues formed a ritual focal point. Offerings were made to them, or rather to the being inhabiting them, incense was burned before them, and the correct words were recited and actions performed. In order for a statue to function in this way, it had to undergo the opening of the mouth ritual, which vitalised it and enabled it to house the being it represented. The burning of incense was important because the word for 'incense', *senetjer*, also meant 'to make divine'.

Egyptian society was hierarchically structured with the king at the top, followed by the different ranks of elite government officials and their families, and finally the non-elite, who provided services and food for the elite. Although the non-elite formed at least 95 per cent of the population, we know little about them, since they have left no written records nor any representations of themselves. What we today regard as Egyptian art, including statues, was commissioned by the king and the elite and mainly represented the king, the elite and deities. In the Old and Middle Kingdoms, statuettes and models showing the activities of non-elite servants and peasants were included in elite burials, but these were commissioned by the elite to serve the needs of the elite.

The king, with all the resources of his office, was by far the largest commissioner of statues – at least a thousand monumental statues of Amenhotep III are still known today. Even the most important officials came nowhere near the king, although they might commission a number of statues for themselves and members of their families. Lower-ranking officials could probably afford only one or two statues, and these were often run of the mill or even mediocre in quality. Nevertheless, statues were more prestigious than the cheaper, two-dimensional relief-cut stone stelae that were often the only monuments that the lowest members

of the elite could afford. Size, material and quality of workmanship all played a role in signifying the status of the person represented by a statue.

2
Materials and techniques

Statues, like most artistic production in ancient Egypt, were made in workshops, where artists worked in teams overseen by master sculptors. The main materials used in the manufacture of statues were stone, wood and metal. Because of the different techniques involved, individual workshops would probably have specialised in a particular material.

The majority of surviving statues are made of stone, of which there was a plentiful local supply. The cliffs that border the Nile valley are mainly limestone, but in some places sandstone is exposed, while at Aswan granite and granodiorite predominate. Other available stones

included greywacke (schist), steatite, calcite, quartzite, diorite, basalt, serpentine and dolorite.

A statue began as a rectangular block of stone slightly larger than the desired size of the finished object. Front and back views of the image were sketched out on the front and back of the block, while profile images were drawn on each of the sides. From the Middle Kingdom on, these outlines were probably laid out on a squared grid (known to have been used in two-dimensional art) that ran all the way around the block so as to ensure that all the sketches matched up. Sculptors then cut away the stone on all four sides

1. Unfinished statuette of Menkaure, granodiorite, Fourth Dynasty, pyramid complex of Menkaure at Giza, height 35.2 cm. (Harvard University Museum of Fine Arts Expedition. 11.730. Courtesy, Museum of Fine Arts, Boston. Reproduced by permission. © 2000 Museum of Fine Arts, Boston. All rights reserved.)

and the top around the sketched outline until they achieved the rough shape of the statue. As they cut the sketch and grid away with the stone, they would re-mark important levels and points with lines or dots of paint. Once they had the outline of the statue shaped, they could concentrate on modelling the face and body, and executing the details of costume and other accoutrements (figure 1). The eyes were often inlaid with white and black stones, such as calcite and obsidian, and might be surrounded by a copper rim.

Soft stones, such as limestone and sandstone, could be worked with copper tools, such as chisels. However, these tools alone were incapable of making an impression on the harder stones. These had to be worked by hammering with still harder stones and by using a quartz abrasive, supplied by sand from the desert. From early on Egyptian stoneworkers had learned how to use drills with copper bits in conjunction with an abrasive in order to make hard-stone vessels. It is the abrasive, not the drill bit, that cuts the stone.

Soft-stone statues were finished by smoothing, plastering and painting, using the same pigments, techniques and colour conventions employed in painted relief and flat painting (figure 2). Pigments were made from naturally occurring minerals: for example, white from calcium carbonate

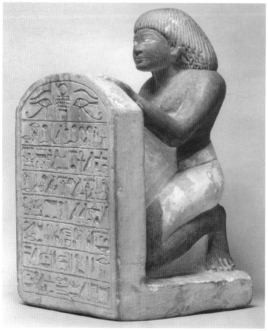

2. Kneeling stelophorous statue of the official Roy, painted limestone, Eighteenth Dynasty, height 31.5 cm. (Courtesy of the Metropolitan Museum of Art, New York, Gift of J. Pierpont Morgan, 1917.) (17.190.1960)

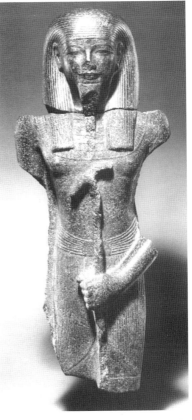

3. Standing statue of a god, granodiorite, Eighteenth Dynasty, reign of Amenhotep III, probably from the funerary temple of Amenhotep III at Thebes, height 91.8 cm. (Courtesy of the Metropolitan Museum of Art, New York, Rogers Fund, 1919.) (19.2.15) (The Metropolitan Museum of Art, Fletcher Fund, 1996.) (1996.362)

(whiting) or calcium sulphate (gypsum); black from carbon (mostly soot or charcoal); shades of yellow, red and brown from ochre (iron oxide); and green from malachite. Blue was most commonly derived from an artificial compound made by heating together silica (probably in the form of quartz), a copper compound (probably malachite), calcium carbonate and natron. Pigments were prepared by grinding them on a hardstone mortar, and applied by mixing them with a medium, such as plant gum or animal glue, so as to attach them to the plastered surface of the statue.

There is some evidence that paint and gilding could be applied to hardstone statues. In some examples, clothing and insignia were painted, while the skin was left the colour of the bare stone. In others, the paint may have been used only to highlight details, since the surface of the stone was otherwise finished with a high polish, or made to exhibit a deliberate contrast between highly polished areas and unpolished ones (figure 3). In addition, many hard stones were probably chosen for the significance of their colours. Red granite and brown, yellow, red and purple quartzite had solar connections, while black stones were associated with the fertility of the black Nile silt and the regenerative properties of the underworld and its ruler, Osiris. Small steatite statues, common for instance in the reign of Amenhotep III, were not painted but glazed blue or turquoise. The shiny, reflective surface of the glaze was associated with the brilliance of the sun.

Most formal stone statues, that is those representing deities, the king and the elite, recall the shape of the original block of stone, so that the

12

4. Kneeling statuette of King Amenhotep II, limestone, Eighteenth Dynasty, Deir el-Medina, Thebes, height 30 cm. (Courtesy of the Metropolitan Museum of Art, New York, Rogers Fund, 1913.) (13.182.6)

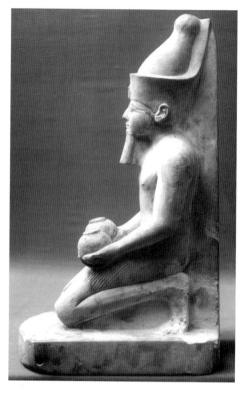

resulting statues are strongly rectilinear. Furthermore, the stone was usually not cut away between the arms and the body, and between the legs in standing figures and the legs and the seat in seated figures, and items do not stick out from the body. For instance, in two-dimensional images of officials, the official carries a long staff held ahead of the body in one hand and a sceptre in the other. These could be replicated in wooden statues, but in stone statues both arms were held close to the sides of the body with the hands clenched, and the staff and sceptre omitted. Stone statues also usually have a wide, rectilinear back slab or a narrower back pillar (figures 4 and 9).

The fact that formal stone statues were rarely fully freed from the original stone block from which they were cut gives an impression of solidity, strength and power. While this may have been partly symbolic, it was also practical in helping to protect the statue from accidental damage and breakage. The reason why so many statues have broken noses is precisely because this feature projects from the surface of the statue. In the same way, the projecting head of the royal cobra worn on the king's forehead has often been broken off.

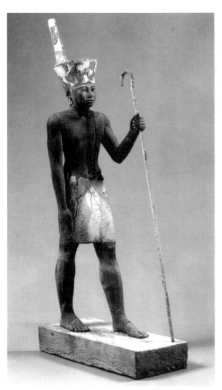

5. Standing statuette of a king, painted cedar, Twelfth Dynasty, Lisht, height 58 cm. (Courtesy of the Metropolitan Museum of Art, New York, Museum Excavations 1913–14; Rogers Fund supplemented by Contribution of Edward S. Harkness.) (14.3.17)

Wooden statues were already being produced in the Early Dynastic Period, but they have survived less well than stone ones because wood is subject to decay and the depredations of insects. Wood was provided by native Egyptian trees, such as acacia, tamarisk and sycamore fig, which produce relatively small, irregularly shaped pieces of wood. Better-quality timber was imported from the coniferous forests of Syria, but this was probably available only to the king and wealthy upper elite.

The wood was worked with copper or, from the Middle Kingdom, bronze saws and adzes. The head, torso, legs and back part of the feet were normally cut in one piece that included pegs beneath the heels which slotted into a separate statue base. The front part of each foot was commonly made independently. Each arm was usually made from a separate piece of wood that was then attached to the torso by a peg. Unlike stone statues, the arms could be held away from the body and could be bent. Objects such as staffs and sceptres were made separately and slotted through clenched hands, which were worked with a hole through the middle. Wooden statues do not usually have back slabs or pillars (figure 5).

Like soft-stone statues, wooden statues were normally covered with a layer of plaster and painted; sometimes the paint was applied directly to high-quality wood. This process hid the joints at the shoulders and on the feet, but today these are often exposed owing to the deterioration of the paint and plaster over time (figure 5). In some statues, the eyes were inlaid.

Metal statues included figures made out of gold and silver (figures 6 and 7), but most of those that survive today are made of bronze (figure 8). True bronze (copper and tin) was introduced during the later Middle Kingdom. Before that, arsenic bronze (copper and arsenic) was used in the early Middle Kingdom; in the Old Kingdom copper alone was used. Statues were cast by the lost-wax technique, already known in the Old Kingdom and well developed by the Middle Kingdom. In the case of

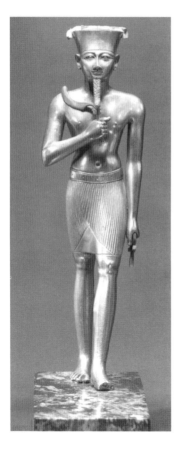
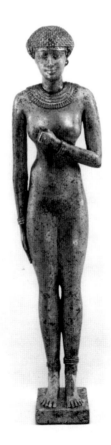

6. (Far left) Standing statuette of the god Amun, gold, Twenty-second Dynasty, height 17.5 cm. (Courtesy of the Metropolitan Museum of Art, New York, Gift of Edward S. Harkness, 1926.) (26.7.1412)

7. (Left) Standing statuette of a woman, silver, Twenty-sixth Dynasty, height 24 cm. (Courtesy of the Metropolitan Museum of Art, New York, Bequest of Theodore M. Davis, 1915. The Theodore M. Davis Collection.) (30.8.93)

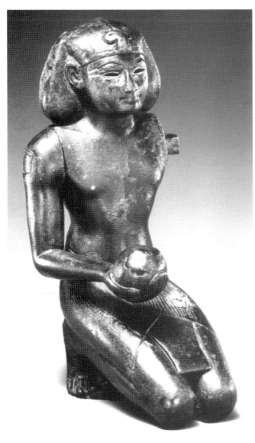

8. Kneeling statuette of King Tuthmosis III, bronze with gold inlay, Eighteenth Dynasty, height 13.5 cm. (Courtesy of the Metropolitan Museum of Art, New York, Purchase, Edith Perry Chapman Fund and Malcolm Hewitt Wiener Foundation, Inc. Gift, 1995.) (1995.21)

small statues, the image was first made in wax, around which a layer of clay was pressed in order to take up the shape and all the details of the wax image. This was then heated to bake the clay and melt the wax, leaving a hollow mould into which molten metal could be poured. After the metal had cooled, the mould was broken away to reveal the statue. For larger statues, the Egyptians usually used core casting. This is basically the same as the lost-wax method except that the wax is modelled round a clay or sand core. When the clay is placed around the wax to form the mould, pins are pushed through from the outside into the core so that when the wax is melted the core remains in position. Metal is then poured into the space between the outer mould and the inner core. When the metal has cooled, the mould is broken away and as much of the core as possible is removed. The process thus produces a hollow

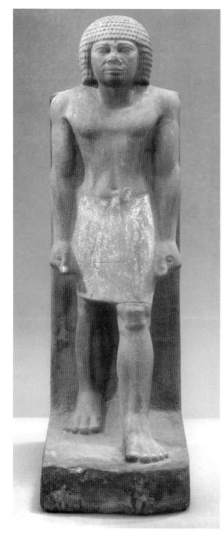

9. Standing statue of an official, painted quartzite, Fourth Dynasty, probably from el-Kab, height 89.5 cm. (Courtesy of the Metropolitan Museum of Art, New York, Harris Brisbane Dick Fund, 1962.) (62.200)

statue and saves on the amount of metal used. As with wooden statues, the various parts of metal figures were often made separately and pegged together, and the arms, for instance, may be held away from the body and separate objects carried. Complex compositions can include separately cast items that are pegged to the main figure or slotted through the hollows of the clenched hands. The metal was not painted, but it could be engraved with designs or inlaid with precious stones, as in cult statues, or with other metals, as was common in the best work of the Third Intermediate and Late Periods.

In addition to cast-metal statues, other statues were made by wrapping sheet metal around a wooden image, which had been produced in the same way as a wooden statue. The sheets of metal were moulded around the core image, and details were then incised into the metal. This technique was used, for instance, to make the gold royal and divine statues found in the tomb of Tutankhamun.

One characteristic that all formal statues have in common, whatever their material, is what is known as 'frontality'. This means that they face straight ahead and do not bend, turn or twist the body or head to any marked degree (figure 9). Because this is such a contrast to classical Greek statuary, once considered the epitome of sculpture in the round, frontality was at one time regarded as an unfortunate shortcoming arising

from the technical inadequacies of the Egyptian sculptors. In fact, informal statues representing non-elite servant figures, such as servant statuettes from the Old Kingdom, or New Kingdom cosmetic items that incorporate figures of servants, show that sculptors were perfectly capable of rendering the human figure in other poses. The servant figures bend or squat to accomplish their various tasks and, in contrast to most formal figures, their bodies and limbs are fully released from the stone. In the New Kingdom figures, the body often twists or bends to balance the weight of a jar carried on the hip, shoulder or head (figure 10). Frontality, therefore, has little to do with the technical abilities of

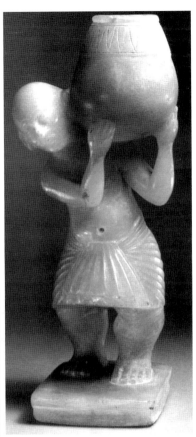

10. (Above) Dwarf with cosmetic pot, calcite, Eighteenth Dynasty, height 19.5 cm. (Courtesy of the Metropolitan Museum of Art, New York, Gift of J. Pierpont Morgan, 1917.) (17.190.1963)

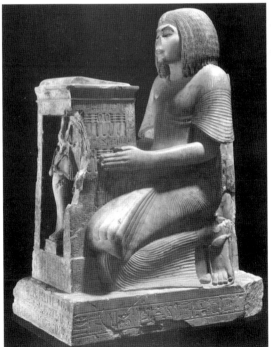

11. (Left) Kneeling statue of the official Iuny with shrine containing an image of Osiris, limestone, Nineteenth Dynasty, tomb at Asyut, height 129 cm. (Courtesy of the Metropolitan Museum of Art, New York, Rogers Fund, 1933.) (33.2.1)

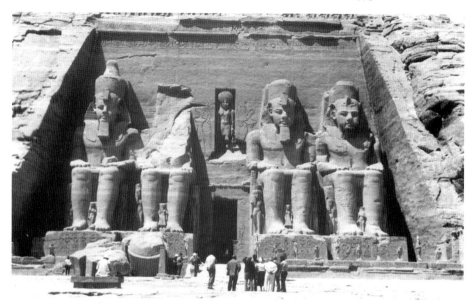

12. Colossal statues of King Ramesses II, sandstone, Nineteenth Dynasty, temple of Ramesses II at Abu Simbel, Nubia. (Author's photograph.)

sculptors but is rather the mark of a formal statue and is related to its function. Placed in a rectangular shrine or in an enclosed room (*serdab* = Arabic for 'cellar') with the opening to the front, before which rituals were performed, the statue could not effectively face in any other direction than forwards (figure 11). The being manifest in the statue and the performer of the ritual thus faced each other and could interact. The same frontal characteristic was also ideally suited to statues in an architectural context, placed in front of a temple pylon, or in front of or between pillars or columns (figures 12 and 36).

3
Poses and statue types

Statues of deities

The basic poses of formal statues were limited to standing, seated or kneeling. Deities usually stand or sit. Standing statues of gods are either shown with the left leg well advanced (figure 6) – the normal male pose – or they are mummiform with their feet together, as though wrapped in a shroud (figure 13). The most common mummiform god is Osiris, ruler of the underworld, but Ptah, god of Memphis, Khonsu, the child god of Thebes, and the ithyphallic Min of Koptos are also mummiform. Standing statues of goddesses are usually shown with the left foot placed only slightly forward so that the heel overlaps the toes of the right foot – the normal female standing pose. Female deities are rarely shown as mummiform.

Seated deities sit on a throne (figure 14). From the Eighteenth Dynasty, goddesses such as Renenutet, the harvest goddess, were sometimes shown suckling a child. This type of image became extremely popular in the first millennium BC, when the goddess was usually Isis suckling the infant Horus (figure 15). Deities may also appear in pair or group statues, either with other deities – for instance, consorts such as Amun and Mut of Thebes often appear together – or with the king. Deities do not normally kneel, since kneeling implies deference in the presence of a being of higher status. In the Late and Ptolemaic Periods, wooden statues of Isis and Nephthys, placed in the burials of the elite, kneel in mourning because the body of the deceased was identified with the god Osiris. Deities can also appear completely in animal form – for instance, Hathor as

13. Standing statuette of the god Osiris, bronze with gilding and engraved decoration, Late Period, height 25.5 cm. (Courtesy of the Metropolitan Museum of Art, New York, Harris Brisbane Dick Fund, 1956.) (56.16.2)

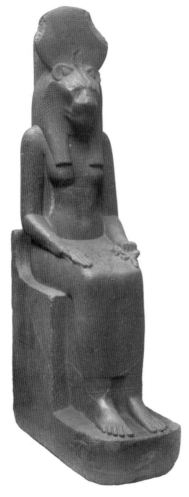

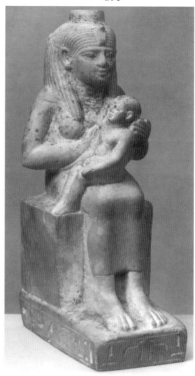

14. (Left) Seated statue of the goddess Sekhmet, granodiorite, Eighteenth Dynasty, reign of Amenhotep III, temple of Mut at Karnak, Thebes, height 210 cm. (Courtesy of the Metropolitan Museum of Art, New York, Gift of Henry Walters, 1915.) (15.8.2)

15. (Above) Statuette of the goddess Isis and her son Horus, stone, Late Period, height 14.5 cm. (Courtesy of the Metropolitan Museum of Art, New York, Rogers Fund, 1945.) (45.2.10)

a cow, Renenutet as a cobra, or Horus as a falcon. Sometimes the animal protects a small image of the king (figure 16).

Statues of kings

Although no standing statues of kings survive from the Early Dynastic Period, representations of such images are known from both the First and Second Dynasties. Standing statues show the king either in the normal male pose with his left leg well advanced (figure 17) or with his

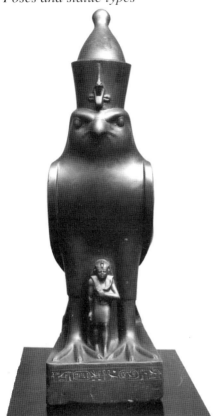

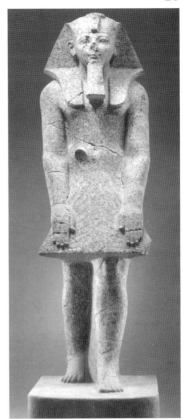

16. (Above left) Statue of the god Horus as a falcon protecting King Nectanebo II, schist, Thirtieth Dynasty, height 72 cm. (Courtesy of the Metropolitan Museum of Art, New York, Rogers Fund, 1934.) (34.2.1)

17. (Above right) Standing statue of King Hatshepsut, red granite, Eighteenth Dynasty, funerary temple of Hatshepsut at Deir el-Bahri, Thebes, height 280.5 cm. (Courtesy of the Metropolitan Museum of Art, New York, Museum Excavations, 1927–8.) (28.3.18)

feet together in the 'mummiform' pose (figure 18). The first is an active image referring to the king's role as the performer of ritual and the aggressive keeper of cosmic order. In stone statues, he normally holds his arms by his sides with his hands clenched. In a variant pose, known from the Twelfth Dynasty on, the hands are placed palm down against the royal kilt, a gesture that indicates the king is adoring a deity (figure 17). 'Mummiform' figures of the king are often shrouded like the mummified Osiris, but in other examples, although the king's feet are

placed together, the figure is not shrouded but wears the *sed*-festival robe or the royal kilt (figure 18). This pose is a passive one – Osiris himself is a somewhat inactive deity to whom things are done by others – and it is often found in architectural contexts where statues are placed against or between pillars.

Seated statues show the king enthroned (figure 19). The earliest surviving examples are two statues of the Second Dynasty king Khasekhem, found in the temple at Hierakonpolis. A statuette of Pepi I of the Sixth Dynasty shows him kneeling offering two jars, but this pose is rare in surviving royal statues until the Eighteenth Dynasty (figure 4). Kneeling statues imply that the king is a worshipper or supplicant in the presence of a god. A kneeling statue of King Horemheb, discovered in 1989 buried with a

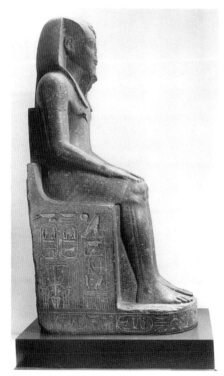

18. (Above) Standing statue of King Nebhepetre Mentuhotep, painted sandstone, Eleventh Dynasty, funerary temple of Nebhepetre Mentuhotep at Deir el-Bahri, Thebes, height 252 cm. (Courtesy of the Metropolitan Museum of Art, New York, Museum Excavations, 1923–4; Rogers Fund, 1922.) (26.3.29)

19. (Left) Seated statue of King Amenhotep III, porphyritic diorite, Eighteenth Dynasty, temple of Luxor at Thebes, height 255 cm. (Courtesy of the Metropolitan Museum of Art, New York, Rogers Fund and Gift of Edward S. Harkness, 1921.) (22.5.1.)

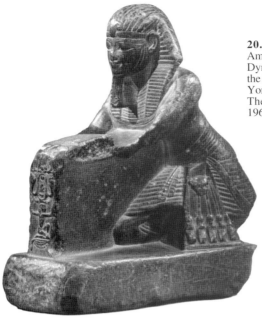

20. Kneeling statuette of King Amenhotep III, serpentine, Eighteenth Dynasty, height 14 cm. (Courtesy of the Metropolitan Museum of Art, New York, Purchase, Fletcher Fund and The Guide Foundation, Inc. Gift, 1966.) (66.99.28)

number of statues in the temple of Luxor, was found to have been slotted into a large stone base that also held a seated statue of the god Atum. The resulting group showed Horemheb kneeling, offering two jars to the seated Atum, who faced him. Metal figures of kings attached to ritual furniture also often kneel for the same reason (figure 8). Most kneeling statues show the king with his legs side by side and his body held vertically. From the later Eighteenth Dynasty, the king is also shown in a kneeling pose that comes halfway towards prostration: one leg is stretched out behind and his body is bent forward as he presents an offering (figure 20).

Pair and group statues of kings and deities are known from the Old Kingdom on. In some, all the figures are on the same scale and in the same pose, either standing or seated. In others, the deity sits and the king, on a smaller scale, stands, so that the king is under the protection of the deity.

A seated statue of King Djedefre of the Fourth Dynasty shows a small female figure – probably his wife – seated on the ground by his leg. Small figures of royal women also stand by the lower legs of Middle and New Kingdom kings' statues (cover). Pair statues may also show the king and his wife or mother seated or standing together on the same scale. Statues of royal women, normally the king's mother or the king's principal wife, occur alone. They normally depict the subject seated or, less often, standing.

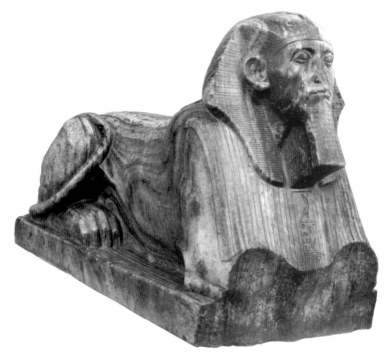

21. Sphinx statue of King Sesostris III, diorite, Twelfth Dynasty, height 42.5 cm. (Courtesy of the Metropolitan Museum of Art, New York, Gift of Edward S. Harkness, 1917.) (17.9.2)

The king also appears in the form of a sphinx, normally with a lion's body and a human head (figure 21). The most famous example is the Fourth Dynasty sphinx on the Giza plateau, originally representing King Khaefre.

Statues of the elite

Statues of elite men and women occur in both standing and seated poses. When standing, men advance their left leg, whereas women have their feet closer together in a less active pose (figure 22). In wooden statues, men hold a staff in one hand and a sceptre in the other, denoting the concept of authority (figure 22). In stone statues, their arms are held by their side with fists clenched (figure 9). Women, by contrast, hold their hands open (figure 22). From the Old Kingdom to the New Kingdom, husband and wife pair statues – seated or standing – are common, often with smaller figures of children included (figure 23). Similar pair statues sometimes show the man not with his wife but with

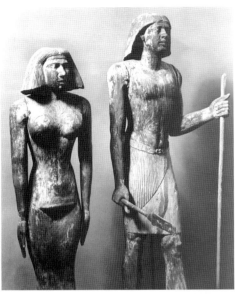

22. Standing statues of the official Merti and his wife, painted wood, Fifth Dynasty, Saqqara, heights 148 and 133 cm. (Courtesy of the Metropolitan Museum of Art, New York, Rogers Fund, 1926.) (26.2.2 & .3)

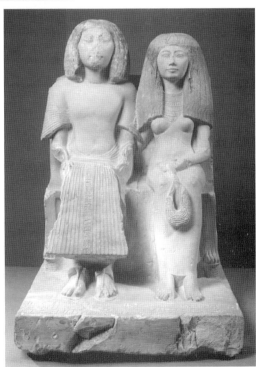

23. Seated pair statue of the official Iuny and his wife Renenutet, painted limestone, Nineteenth Dynasty, tomb at Asyut, height 84.5 cm. (Courtesy of the Metropolitan Museum of Art, New York, Rogers Fund, 1915.) (15.2.1)

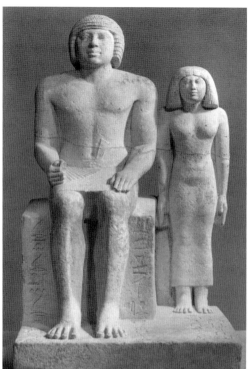

24. Pair statue of the official Demedji and his wife Henutsen, painted limestone, Fifth Dynasty, height 83 cm. (Courtesy of the Metropolitan Museum of Art, New York, Rogers Fund, 1951.) (51.37)

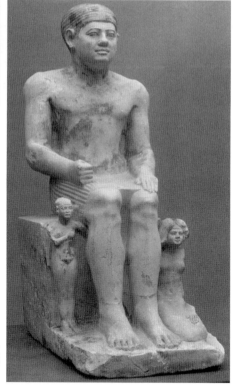

25. Seated statue of Nikare with his wife and daughter, painted limestone, Fifth Dynasty, height 57 cm. (Courtesy of the Metropolitan Museum of Art, New York, Rogers Fund 1952.) (52.19)

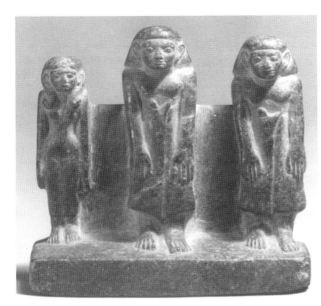

26. (Left) Group of two men, Tjeniwen and Sobekaa, and a woman, Tiw, black stone, Middle Kingdom, height 7.9 cm. (Courtesy of the Metropolitan Museum of Art, New York, Purchase, Fletcher Fund and The Guide Foundation, Inc. Gift, 1966.) (66.99.9)

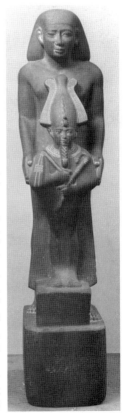

27. (Right) Standing statue of the official Horbes holding a figure of Osiris, schist, Twenty-sixth Dynasty, temple of Karnak at Thebes, height 61.5 cm. (Courtesy of the Metropolitan Museum of Art, New York, Rogers Fund, 1919.) (19.2.2)

his mother. In the Old Kingdom, the poses of the man and woman may differ. In some statues, the husband is seated – the more prestigious pose – and the wife, shown on a smaller scale, stands beside him (figure 24). In others, the wife is depicted as a miniature figure standing or squatting by her husband's leg (figure 25). After the Old Kingdom, the wife in elite statues is rarely depicted in miniature form. In the Twelfth and Thirteenth Dynasties, larger family groups of three, four or five figures become fairly common (figure 26). New Kingdom pair statues more usually show the figures seated rather than standing. After the New Kingdom, pair statues become rare, perhaps because their association is with tombs, while most statues were now dedicated in temples. At the same time, standing statues of men are frequently shown presenting images of deities (figure 27).

Scribe statues show male officials seated cross-legged on the ground with their kilts stretched taut across the legs. On this surface they unroll a papyrus

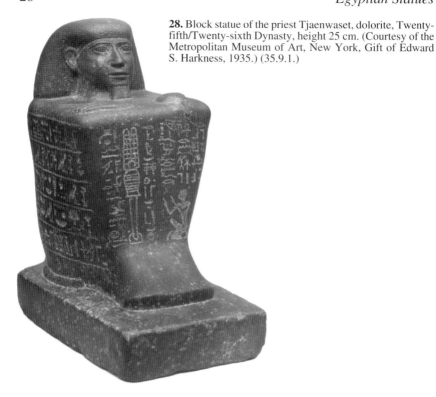

28. Block statue of the priest Tjaenwaset, dolorite, Twenty-fifth/Twenty-sixth Dynasty, height 25 cm. (Courtesy of the Metropolitan Museum of Art, New York, Gift of Edward S. Harkness, 1935.) (35.9.1.)

scroll and either write on it or read it. Since literacy and scribal training were prerequisites for obtaining a government office, officials from the Old to the New Kingdom frequently depicted themselves as scribes. The image became rare in the first millennium BC and virtually disappeared after the beginning of the Twenty-sixth Dynasty. The pose is a male one only, because women could not hold government office.

At the beginning of the Middle Kingdom a new pose was introduced for elite men. The subject is shown sitting on the ground with his knees drawn up to his chest underneath a robe that is stretched tight over his legs and body. The cuboid shape of the body has led to the term 'block statue' for this type of pose. Block statues remained popular for the next two millennia, becoming the most frequent type of statue in the Late and Ptolemaic Periods (figure 28). The amount of modelling and detail vary according to period. Sometimes only the head protruded. At other times the hands or feet appeared, or the arms were shown crossed on top of the 'block'. The smooth surface of the 'block' provided an ideal

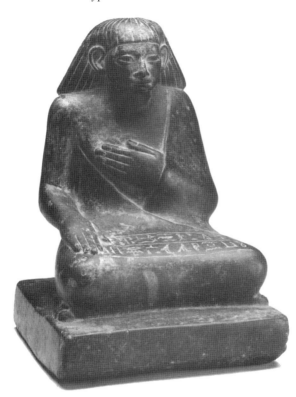

29. Statuette of the official Khnumhotep, cross-legged with a long cloak pulled over his knees, basalt, Twelfth Dynasty, height 19 cm. (Courtesy of the Metropolitan Museum of Art, New York, Bequest of Mrs H.O. Havemeyer, 1929. The H.O. Havemeyer Collection.) (29.100.151)

space for inscriptions and, especially in the Third Intermediate Period, for incised figures and scenes. The pose rarely occurs in groups or in the depiction of women and is not used for divine or royal figures. Although block statues have been found in tombs, the majority were placed in temples.

In the later Twelfth and Thirteenth Dynasties elite men adopted yet another pose. The subject is shown seated cross-legged on the ground with a long robe tucked tautly around the legs (figure 29). This statue type had a fairly short lifespan, although it was occasionally revived at later periods.

Kneeling statues showing elite men became common in the Eighteenth Dynasty. Those holding stelae inscribed with hymns to the sun were placed over entrances to tomb chapels and depict the owner of the chapel (figure 2). Others, usually intended for a temple context, presented ritual items, most commonly a shrine (*naos*) holding a divine statue, but also divine emblems such as the rearing cobra associated with the

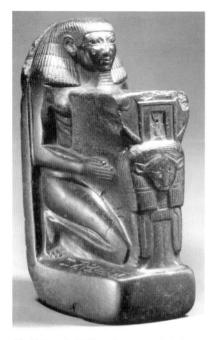
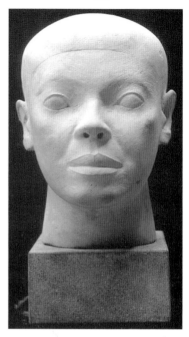

30. (Above left) Kneeling statuette of the official Senenmut, porphyritic diorite, Eighteenth Dynasty, reign of Hatshepsut, height 22.5 cm. (Courtesy of the Metropolitan Museum of Art, New York, Bequest of George D. Pratt, 1935.) (48.149.7.)

31. (Above right) Reserve head, limestone, Fourth Dynasty, mastaba tomb G4440 at Giza, height 30 cm. (Harvard University – Museum of Fine Arts Expedition. 14.719. Courtesy, Museum of Fine Arts, Boston. Reproduced by permission. © 2000 Museum of Fine Arts, Boston. All rights reserved.)

harvest goddess Renenutet, or the *sistrum* (rattle) sacred to the goddess Hathor (figure 30). These temple statues continued to be made during the Late and Ptolemaic Periods.

For a brief time in the Fourth Dynasty images consisting only of a head and neck, without a body, were made in the royal workshops for members of the king's family and high officials (figure 31). They were usually made of limestone and today are known as 'reserve heads', from the hypothesis that they were meant to act as substitutes if the actual head of the deceased was damaged. Of the thirty or so that are known, virtually all of them come from Giza and were found in tomb shafts associated with solid stone mastabas that had no interior chapel or place for statues, in contrast to mastabas at other sites. When solid mastabas at Giza gave way to those with an interior chapel and space for complete statues, reserve heads were no longer produced.

4
Context and function

Statues of deities

The most important part of any temple was the cult statue in which the deity of the temple became manifest. This statue was placed in the sanctuary – the most sacred and protected part of the temple – inside a shrine. The doors of the shrine, which were opened to reveal the deity during the performance of ritual, were called 'the doors of heaven'. They acted as an interface between the normal dwelling place of deities outside the human world and the temple, enabling the deity to enter the temple and be present at the ritual. The importance of divine statues was such that the making of new statues was regularly mentioned in the royal annals of the Early Dynastic Period and Old Kingdom.

Today few cult statues survive. The descriptions we have of them in texts make clear the reason why. They were made of gold and silver, inlaid with precious stones such as lapis lazuli and turquoise, and almost all have long since been melted down for their metal and their inlays reused. Some were undoubtedly made of cast metal. Others may have been made of wood and gilded or covered with sheets of gold and silver. The materials were highly significant for the Egyptians, apart from their value. Gold was the flesh of the gods, silver their bones, and lapis lazuli their hair. These substances were thought to be solidified light from the celestial bodies that manifested the deities in the heavens. The resulting statue replicated the proper form of the deity, thus providing a physical and recognisable body for this being. Although temples were usually dedicated to one main deity, other deities could also reside there as guests, manifest in their own statues.

At festivals, cult statues were carried in procession out of the temple in sacred boats. The cabin of the boat formed the shrine for the statue, which remained hidden inside it. The boats were made of fine-quality imported wood sheathed in gold and silver. The prow and stern were formed into heads representing the deity within – for instance, a falcon's head for the falcon god Horus, or a ram's head for Amun, the god of Thebes – and adorned with necklaces, pectorals and collars of precious metals and stones.

In addition to the cult statues in the sanctuary, many other images of deities were dedicated by the king within temples (figures 3, 14, 40 and 41). These were usually on a larger scale and made of stone. Although few large-scale images of deities have survived from the Early Dynastic Period and the Old and Middle Kingdoms, colossal statues of the ithyphallic god Min stood in the Protodynastic temple of the god at Koptos.

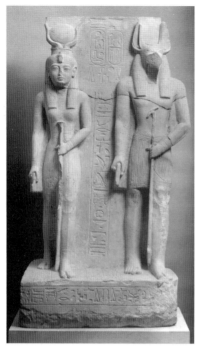

32. Statue group of the deities Wepwawet and Isis-Hathor, limestone, Nineteenth Dynasty, tomb of the official Saaset at Asyut, height 129 cm. (Courtesy of the Metropolitan Museum of Art, New York, Rogers Fund, 1917.) (17.2.5)

In the Late and Ptolemaic Periods it became a common custom for visitors to temples to present bronze votive statues of deities (figure 13). Most of the images were mass-produced and uninscribed, but those specially commissioned carried the name of the donor. Such statuettes provided a link between the dedicator and the deity.

The tomb of Tutankhamun contained a series of small divine statues, made of wood covered with sheet gold, wrapped in pieces of linen, and placed in small shrines. It seems probable that such statues were standard for royal burials of the New Kingdom, but by the time of the royal burials at Tanis in the Twenty-first and Twenty-second Dynasties they were no longer included.

Statues of deities were not commonly placed in elite tombs during the Old and Middle Kingdoms and the Eighteenth Dynasty. During the Ramesside period the situation changed and free-standing and rock-cut images occurred (figure 32). In some tomb chapels, the statues forming the focal point for the performance of ritual represented deities instead of the deceased, as in earlier times. Taken in conjunction with changes in tomb-chapel decoration, it seems that the chapel was now regarded as a private temple for the deceased and his family, in which they could

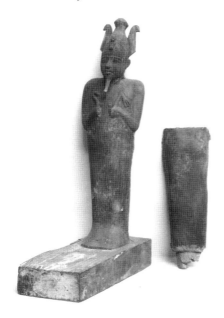

33. (Left) Standing statue of Osiris for holding a Book of the Dead, sycamore wood with a coniferous-wood base, Twenty-first Dynasty, tomb of Gautsoshen at Thebes, height 54 cm. (Courtesy of the Metropolitan Museum of Art, New York, Rogers Fund, 1925.) (25.3.37)

34. (Below) Standing statuette of Anubis, painted wood, Ptolemaic Period, height 42 cm. (Courtesy of the Metropolitan Museum of Art, New York, Gift of Mrs Myron C. Taylor, 1938.) (38.5)

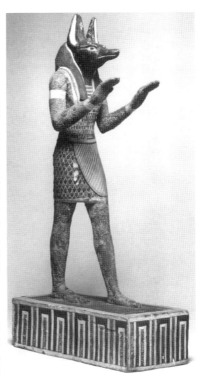

worship the gods after death. During the same period, wooden images of Osiris containing a copy of the Book of the Dead were placed with the body in the burial chamber (figure 33). In the Late and Ptolemaic Periods it became common to place painted wooden statues of funerary deities – Ptah-Sokar-Osiris, Isis and Nephthys as mourners, the four sons of Horus, Anubis – in the burial chamber to help the deceased make a successful transfer to the afterlife (figure 34).

Statues of the king

Statues of the king were placed in royal funerary complexes and in temples but rarely in non-royal burials. At Abydos, it appears that there was

an enclosed room for a statue (*serdab*) in the tomb of the First Dynasty king Den. A small ivory statuette of a king from Abydos may have been associated with a royal burial. Fragments of statues of the king from the Third Dynasty Step Pyramid complex of Djoser at Saqqara show that originally the complex contained a considerable number of royal statues. Today, the best-preserved is a seated limestone statue, now in the Cairo Museum, that was placed in a *serdab* on the north side of the pyramid. The statue faced north and two holes at eye level in the front wall allowed the king's *ka*-spirit, manifest in the statue, to look out at the area in front of the *serdab* where the ritual presentation of offerings and burning of incense for the benefit of the royal *ka* took place.

After the Third Dynasty the rectangular Step Pyramid complex was replaced by a linear complex in association with a true pyramid. This complex consisted of a valley temple at the eastern end, which was joined by a causeway to a pyramid temple situated on the eastern side of the actual pyramid, which formed the western end of the complex. Statues of the king were placed in the valley and pyramid temples (figure 1). Besides being recipients of offerings and ritual performance, they embodied the king in his role as cosmic ruler and depicted his relationship with Egypt's deities.

In the New Kingdom tomb of Tutankhamun, situated in the Valley of the Kings at Thebes, small, gold-covered wooden statues of the king were placed in sealed shrines along with the similarly made divine statues. These were probably standard for all New Kingdom royal tombs, and images of similar statues are depicted on the walls of the tomb of Seti II of the Nineteenth Dynasty. In addition, two life-sized wooden statues of the king covered in black resin and gold foil guarded the sealed entrance to Tutankhamun's burial chamber. Statues similar to the last, although much less well preserved, have also survived from other royal tombs.

In the New Kingdom, the king's burial in the desert, in what is now known as the Valley of the Kings, was separated from his funerary temple, which stood at the edge of the desert where it meets the cultivation. The king merged with the Theban god Amun to produce a specific form of the deity that was worshipped in the temple. Statues of the king of all sizes and types were placed throughout the temple (figure 17 and cover). After the New Kingdom, the royal funerary complex changed entirely. Instead of being constructed in the desert, royal tombs were now built within the main temple enclosure of the city where the king had his residence, or from which the royal family originated. It is not clear if royal statues were associated with royal funerary complexes after the New Kingdom, but there seems to have been none obviously associated with the royal burials of the Twenty-first and Twenty-second Dynasties at Tanis.

State temples from the Early Dynastic Period and the Old and Middle Kingdoms were built primarily of mud brick with some stone elements. Beginning in the Eighteenth Dynasty, these were mostly replaced by monumental stone temples. However, there is evidence from as early as the Second Dynasty that royal statues were set up in temples. The production of a copper statue of the late Second Dynasty king Khasekhemwy is recorded in the royal annals preserved on the Palermo Stone. Two small stone statues of Khasekhem, probably the same king as Khasekhemwy, were found in the temple of Horus at Hierakonpolis. Unfortunately, since they were both discovered in secondary deposits, we have no information about their original locations in the temple. From a similar context came a life-sized statue of Pepi I of the Sixth Dynasty and another smaller figure about a third of the size, both made of sheets of copper. The annals also record the manufacture of other royal statues made of metal during the Old Kingdom.

From the later Old Kingdom to at least the Eleventh Dynasty statues of the king were placed in *ka*-chapels erected within the precincts of state temples, such as the temple of the god Khentamentiu at Abydos and the temple of the goddess Bastet at Bubastis. The image of the king was inhabited by the royal *ka*-spirit that carried the essence of divine kingship from one king to the next. The statue formed the ritual focus in the chapel, being the recipient of offerings and other cult performance, like the cult statue of a deity. Such statues enabled the king's *ka* to be present throughout the land at all times while he was alive and after his death, even though his physical body was restricted to a single location. A decree of Pepi II from Abydos concerns statues of the king, two queens, and the vizier Djau that were set up in the temple of the god Khentamentiu at Abydos. It lays down that each statue was to receive an eighth of an ox and a jug of milk at every festival.

More temple statues representing kings survive from the Middle Kingdom, even though the temples have disappeared, but the vast majority come from the New Kingdom and later. These statues enabled the king to have a perpetual presence in all the temples throughout Egypt, wherever he actually was. The king was a human being who embodied the divine aspect of kingship carried by the royal *ka*-spirit and could thus mediate between humanity and the potentially dangerous realm of the divine. His statues incorporated his various aspects. As bodies for the royal *ka*-spirit, they were focal points of cult, but, as mediators between humanity and the divine, the king stood in a junior relationship with the deities as the performer of their rituals. This is most obvious when the king is shown kneeling and offering (figure 4).

Royal statues frequently related the king to deities in other ways too. Sometimes the king is associated with a deity, as, for example, in statues

with the shrouded mummiform pose of Osiris, or those made of stones such as red granite or quartzite, which were associated with the sun god. Other statues show the king together with one or two deities. Sometimes the figures are on the same scale, and sometimes the king is smaller and visually under the protection of the deity (figure 35).

From the Old Kingdom the king appears as a sphinx with a lion's body and human head (figure 21). In its recumbent form the sphinx seems to have had a protective function and pairs were placed to guard temple entrances. These developed into the avenues of sphinxes, known from the New Kingdom onwards, that lined the approaches to temples and processional ways. The great pylon gateway at the entrance of the temple represented the horizons of the sky where the sun rises and sets. The paired images of the king as sphinx incorporated the form of the two lions that guard the horizon. The lion is also a symbol of strength and ferocity appropriate to the king.

35. Head of King Tutankhamun from a statue of the king and a god with the god's hand resting on the king's head, limestone, Eighteenth Dynasty, height 15 cm. (Courtesy of the Metropolitan Museum of Art, New York, Rogers Fund, 1950.) (50.6)

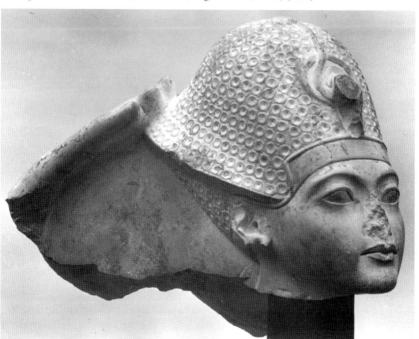

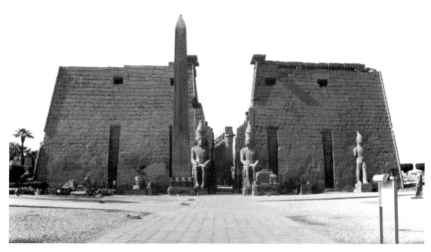

36. Colossal statues of King Ramesses II, granodiorite, Nineteenth Dynasty, temple of Luxor at Thebes. (Author's photograph.)

In front of the pylon itself were often placed colossal seated or standing statues of the king (figures 12 and 36). These are sometimes specifically identified by their texts as *ka*-statues of the king – places where the royal *ka*-spirit dwells. In addition to impressing and overawing viewers with the power of the king, they guarded the temple entrance and protected the pure sacred space inside from the polluting mundane world outside. They were also focal points of cult in their own right, receiving offerings and worship, so that they would act as intermediaries between people who had access only to the less sacred outer parts of the temple and the inaccessible deities inhabiting the sacred interior parts.

Small standing or kneeling images of the king made of metal – bronze, silver or gold, with the least valuable bronze having the best survival rate – were often attached to items of ritual furniture such as sacred barks, offering-tables and censers (figure 8). These depicted the king as the perpetual performer of the cult for the deities at all times and on all occasions. In the Third Intermediate and Late Periods, metal images of the king may also have been presented as votive offerings.

During the reign of Akhenaten, small statues of the king were placed in domestic shrines located in houses and gardens at the king's new capital city of Akhetaten, now known as Amarna, where they formed the focal point for the ritual performed there. It is possible that similar statues of Akhenaten's father, Amenhotep III, had the same function. The divine essence of the king manifest in the statues was worshipped

in its own right but also acted as a link between the human and divine worlds.

Statues of the elite in tombs

In the Early Dynastic period and the Old Kingdom, statues of elite officials and their wives were exclusively associated with tombs. Here they provided a place that could be inhabited by the *ka*-spirit of the deceased person, so as to receive incense and offerings brought by the living. From the end of the First Dynasty come the fragmentary remains of two wooden statues, two-thirds life size, representing striding male figures, found in tomb 3505 at Saqqara. During the Old Kingdom, tomb chapels, which only the upper elite could afford, were mainly free-standing but they could also be rock-cut. In both cases the actual body was placed in a burial chamber at the bottom of a shaft cut into the ground, which was sealed after burial. Above the shaft was the tomb chapel, which remained accessible. This was where funerary priests and living family members brought offerings and performed the rituals for the deceased. In the Old Kingdom, these centred on the false door linking the realms of the dead and living that was placed on the west wall of the offering-chamber. Behind the false door, there was often an enclosed room (*serdab*) linked to the tomb chapel by a small slot in the wall and containing the statues of the deceased and his family. In chapels where the *serdab* was not behind the false door, it formed a separate ritual focus. In the Fifth Dynasty mastaba of the official Ti, the relief decoration on either side of one of the *serdab* slots shows two men burning incense, reflecting the actual ritual performed there. In rock-cut tomb chapels, statues were often carved out of the walls rather than being hidden in a *serdab*. During the later Sixth Dynasty, fewer and fewer tomb chapels were built, so that tombs consisted of just the shaft leading to the burial chamber. Statues were placed in the shaft or more usually in the burial chamber itself.

In the Middle Kingdom, tomb chapels were once more built for the upper elite. The focal point of the funerary ritual was now a rock-cut or free-standing statue of the deceased in a shrine or niche placed at the back of the chapel on the central axis. Statues of other family members, such as the deceased's wife, could be included (figure 37). For the less wealthy, who had no tomb chapel, statues – often small and of mediocre quality – were placed in the burial chamber.

The famous rock-cut Theban tomb chapels of the New Kingdom continued the Middle Kingdom tradition of focusing on rock-cut or free-standing statues. The basic shape of the chapels was that of an inverted 'T', in front of which lay an open court. The statue niche or shrine was placed on the back wall at the end of the stem of the 'T'. The

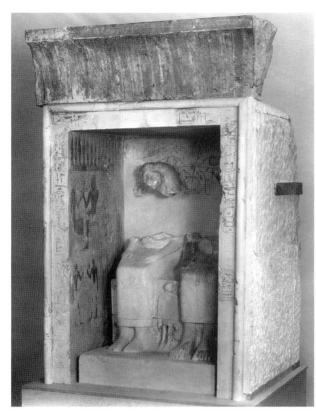

37. Shrine with statues of the official Amenemhat and his wife Neferu, limestone, Middle Kingdom, tomb 202 at Thebes, height 134.5 cm. (Courtesy of the Metropolitan Museum of Art, New York, Rogers Fund and Edward S. Harkness Gift, 1922.) (22.3.68)

ka-spirits of the deceased could manifest in the appropriate statue and receive the offerings and other benefits of the ritual performed by their living relatives. The decoration of the statue niche often showed images appropriate to its function, such as the deceased tomb-owner seated before a table of offerings or rows of offering-bringers.

A kneeling statue of the tomb-owner holding a stela was often put in a niche cut either into the façade above the chapel entrance in the Eighteenth Dynasty or, by the Nineteenth Dynasty, into the small pyramid that now topped the tomb chapel. Whatever the actual orientation of the tomb, which depended on the orientation of the cliff face into which it was cut, the chapel was ritually regarded as facing east towards the sunrise. The stela held by the statue was inscribed with a hymn to the sun on behalf of the deceased, who hoped to spend the afterlife in the entourage of the sun god accompanying him on his daily journey across the sky (figure 2).

At Saqqara, the necropolis of Memphis, many New Kingdom tombs were free-standing. Large tomb chapels imitated the form of a temple

38. Standing statue of an elite woman, Tey, ebony, Eighteenth Dynasty, height 24 cm. (Courtesy of the Metropolitan Museum of Art, New York, Rogers Fund, 1941.) (41.2.10)

with a monumental entrance, open court, colonnaded court and a cult room and, like temples, contained a number of statues. The commonest are seated pair statues showing the tomb-owner and his wife, followed by statues showing the tomb-owner kneeling holding a *naos* (shrine), divine image or offering-table. Block statues of the tomb-owner have also been found. Although few standing statues have survived, they are often shown in the reliefs of these tomb chapels and seem to have flanked doorways. Other statues were placed around the colonnaded courts. Surprisingly, no evidence has been found of statues in the cult room, which was occupied instead by one or more stelae.

In addition to stone statues from tombs, small wooden statues, depicting male or female standing figures, are also known from Thebes, Memphis and elsewhere (figure 38). A few were found *in situ* placed with other grave goods in burials that had no chapel, and it may be that wooden statues were most commonly made for this type of burial.

After the New Kingdom, changes in burial practices meant that for the Third Intermediate, Late and Ptolemaic Periods very few tomb statues were made. Instead, statues were dedicated in temples even though they had funerary functions.

Statues of the elite in temples

In the Early Dynastic Period and most of the Old Kingdom, elite statues were basically confined to the tomb and had no place in temples, where statues only of deities and the king were set up. The decree of Pepi II of the later Sixth Dynasty (see page 35) shows that the vizier Djau, brother of two queens of Pepi I, had a statue set up in the temple of Khentamentiu at Abydos. Another royal decree, this time of the Eighth Dynasty, refers to a *ka*-chapel of the vizier Shemai in the temple

precinct of the god Min at Koptos, the *ka*-chapel undoubtedly containing a statue of Shemai. A further decree from the next king to Shemai's son, the vizier Idi, refers to 'your statues, your offering-tables, your *ka*-chapels ... which are in any temple or any temple precinct'. Clearly, by the end of the Old Kingdom, high-ranking officials were placing their statues in temple areas, and during the Middle Kingdom it became increasingly common for the male elite to dedicate their statues in other places besides tombs.

The necropolis of Abydos, where the kings of the First Dynasty had been buried, became the centre in Upper Egypt for the cult of Osiris, ruler of the underworld. A temple was built for him, and every year at his festival his death and resurrection were celebrated by a great procession that carried his statue from the temple to his supposed tomb and back. In order to be associated with the deity, the elite of the Middle Kingdom built small memorial chapels near where the processional route left the temple. In the chapels they placed stelae and statues to enable the owner to be eternally present at the cult centre of the god whose favour was essential for a successful afterlife, and to celebrate his triumphal resurrection during his festival.

A more local phenomenon occurred on the island of Elephantine at Aswan on the southern border of Egypt. An official of the area called Heqaib, who had lived during the Old Kingdom, had been deified during the First Intermediate Period and a shrine was set up, where his cult was celebrated. It was renewed at the beginning of the Twelfth Dynasty by the official Sarenput I, who set up statues of himself and his father. Over the course of the Twelfth and Thirteenth Dynasties, subsequent officials of the area set up shrines containing their own statues, in front of which were placed offering-tables for the presentation of offerings and libations.

Elsewhere elite officials placed their statues in the outer, less sacred areas of state temples. In the tomb chapel of the high official Khnumhotep II at Beni Hasan, a scene shows a statue of Khnumhotep being transported in a shrine, escorted by priests, dancers and Khnumhotep himself, with a caption that says: 'accompanying the statue to the temple'. Setting up a statue in a temple formed a link between the donor and the deity of the temple and allowed the donor to have a perpetual presence in the temple. Although the statue might be set up in the owner's lifetime, it continued to function after he was dead, so that in effect it became a funerary statue.

The mechanism for dedicating a statue in a temple is not clear, but the privilege would seem to have been limited to high-level officials. Sometimes the inscription on a statue states that it was given as a favour of the king, as in the case of a statue representing the treasurer and

steward Gebu, which was placed in the temple of Amun at Karnak. To possess a temple statue was to display status amongst one's peers. The statue itself received a portion of offerings presented in the temple. In another text in his tomb chapel at Beni Hasan, Khnumhotep II says: 'I accompanied my statues to the temple and I arranged for their offerings for them.' There is evidence that such offerings were provided for through a formal contract between the temple priesthood and the owner of the statue, by which the latter made an endowment to the temple in return for offerings being given to the statue.

By the New Kingdom, elite male officials were freely dedicating statues of themselves in the major state temples (figure 30). Some of them even carry texts offering to intercede with the deity of the temple in return for offerings. One such text is specifically addressed to women and offers to intercede on their behalf with the goddess Hathor to obtain a good husband for them. By contrast, few statues of women were placed in temples, and almost all female statues come from tombs.

Since most statues in the Third Intermediate Period and the Late Period were dedicated in temples, they almost all represent men, except for statues of the 'god's wife of Amun', who was a royal priestess in the cult of Amun at Thebes, and women in her entourage. During the Ptolemaic Period, even though statues were still placed mainly in temples, more images of women are found, although in smaller numbers than those of men.

Audience

Despite the central role played by statues in the religious and funerary cults carried out in temples and tomb chapels, human access to most of these images would have been strictly limited, although restrictions would have varied according to where the statue was set up. Within a temple, the least accessible statues would have been the cult images kept sealed in their shrines deep within the temple. Only purified priests carrying out the rituals of the temple would have seen these statues after they had been made functional through the opening of the mouth ritual. When the statues were carried out in public procession in their sacred boats, most were concealed within a shrine, so they were not actually visible to the people lining the processional route. In fact, their beauty was primarily designed for the deity and not for appreciation by any human viewer.

Statues in the less restricted outer parts of the temple would have had a larger human audience. Letters from the Twentieth Dynasty show that it was customary, at least for the elite, to go and pray in the outer courts of temples, where they would have seen the divine, royal and elite statues set up in this area. However, most visible in a temple would

have been the colossal *ka*-statues of the king set up in front of the temple entrance pylon, which were objects of cult in their own right (figure 36). Numerous small stelae relating to the cult of the four *ka*-statues of Ramesses II that stood in front of the temple at his Delta city of Pi-Ramesses show male and female worshippers adoring one of the four statues.

Just as temples were restricted in their access, so too was the king's funerary complex, where the cult of the deceased king was performed by a limited number of purified priests. Although many of the royal statues found in this context impress by their beauty, large size, and representation of power and regal authority, they were never intended as propaganda to overawe the general populace, for the population as a whole had no access to them. Similarly, statues in elite tomb chapels were not intended for general viewing, but to provide physical forms for the deceased when they entered this world, so that living relatives and funerary priests could interact with them through the performance of the funerary rituals.

5
The ideal image and changing styles

Since the primary function of formal statues was to provide a non-physical being with an appropriate physical body in which to manifest itself, this body had to be recognisable – both to the being and to the viewer – as the proper body for that being. The statue had to reflect the category of being – divine, royal, elite – and identify the individual being it was intended for. Categories were distinguished by their insignia and costume. Individual identity was most clearly secured by inscription. Sculptors were aiming to produce neither an exact likeness incorporating the distinguishing features and blemishes of an individual, nor a psychological dimension, even when the image was ultimately based on the actual features of the subject. Instead, the intention was to produce an ideal image that reflected the identity and role of the subject portrayed.

The king was recognisable by his various crowns and sceptres and by his dress, such as the centrepiece worn over the kilt and the bull's tail

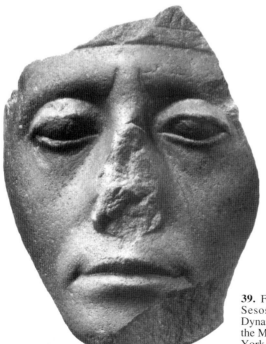

39. Fragment from a statue of King Sesostris III, quartzite, Twelfth Dynasty, height 16.5 cm. (Courtesy of the Metropolitan Museum of Art, New York, Carnarvon Collection, Gift of Edward S. Harkness, 1926.) (26.7.1394)

40. Head from a statue of the god Amun, granodiorite, Eighteenth Dynasty, height 52.1 cm. (Courtesy of the Metropolitan Museum of Art, New York, Rogers Fund, 1907.) (07.228.35)

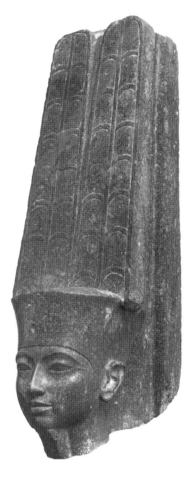

hanging behind him from his belt. His face was normally youthful and his body vigorous (figures 4, 5, 8, 12, 17, 19 and 20). However, individual kings do not all look the same. Although the features are idealised to produce a fittingly regal image, they are often recognisable as belonging to a particular king and may have been based on actual appearance. One of the most unusual and distinctive royal images belongs to Sesostris III of the later Twelfth Dynasty with his heavy-lidded, bulging eyes and thin-lipped mouth. In many instances, his face is not youthful but mature, or even aging, with bags under his eyes and deep lines running between his nose and the corners of his mouth (figures 21 and 39). Interpretations of this image range from seeing the king as a care-worn ruler on the one hand to casting him as a tyrannical despot on the other. It is impossible now to know exactly what the image was intended to convey, although one might suggest that it was meant to imply the wisdom of maturity. It should be noted that the king's body is shown as youthfully vigorous on all his statues and does not change to match his mature, even aging, facial image.

Images of deities in human form were given perfect youthful bodies and faces, and their features often reflected the image of the reigning king (figure 3). Other deities were depicted with a human body and an animal head (figures 14 and 34). Deities were distinguished visually by their insignia, such as the two tall falcon feathers of Amun (figure 40), the double crown of Atum, the *atef*-crown of Osiris (figures 13 and 33), or by their animal heads, such as the falcon head of Horus, the cow head of Hathor (figure 41), and the lion head of Sekhmet (figure 14).

46

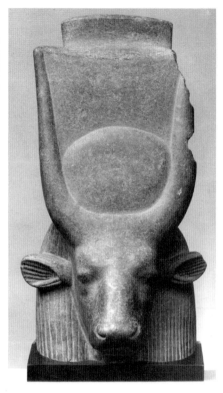

41. Head from a statue of a cow goddess, probably Hathor, porphyritic diorite, Eighteenth Dynasty, probably reign of Amenhotep III, height 52 cm. (Courtesy of the Metropolitan Museum of Art, New York, Rogers Fund, 1919.) (19.2.5)

Statues of the elite depicted the ideal of any given period, which was often related to the royal image. Although specially commissioned statues of the wealthy might reflect an individual's actual features, many statues were bought ready-made from workshops and only given an identity when inscribed or put into a context where the identity was made clear. There were two ideal images used for elite men, one youthful and one mature, which represented different life stages. The first incorporated youthful features and a physically fit body. The second image showed a corpulent body or rolls of fat on the chest. In the Old Kingdom, statues of elite men were often made in youthful and mature pairs (figure 42). The two were also frequently distinguished by costume, with the youthful image wearing a wig and short kilt and the mature one with close-cropped hair and a calf-length kilt. The mature image does not represent aging but rather a particular stage in the life of a successful official who eats well, leads a sedentary lifestyle and has acquired wisdom through experience.

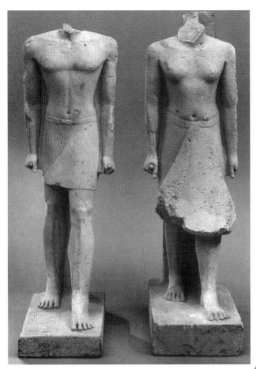

42. (Left) Youthful and mature statues of the official Khnumbaef, limestone, Fifth Dynasty, tomb of Khnumbaef at Giza, height 120.5 and 141 cm. (Courtesy of the Metropolitan Museum of Art, New York, Fletcher Fund, 1964.) (64.66.1 & .2)

43. (Below) Upper part of a statue of an official, schist, Thirtieth Dynasty, height 36.5 cm. (Courtesy of the Metropolitan Museum of Art, New York, Harris Brisbane Dick Fund, 1925.) (25.2.1)

In the late Twelfth and Thirteenth Dynasties, the features of officials represented with a mature image were typically based on the royal model of Sesostris III, described above, and therefore show signs of aging. In the Late Period, the mature image is characterised by a lined face (figure 43). In the past such images have often been interpreted as realistic, but in fact they represent a type and should not be seen as individualising portraits.

44. Standing statuette of the official Tjeteti, wood, Sixth Dynasty, Saqqara, height 42 cm. (Courtesy of the Metropolitan Museum of Art, New York, Rogers Fund, 1926.) (26.2.9.)

There was no equivalent of this mature image for women, who were normally given youthful features and bodies. The contours of the body – the breasts, stomach, pubic region, thighs – were emphasised to signify female fertility and the child-bearing potential of women (figures 22, 24, 38 and 49). Women were valued not only because of their ability to give birth to the next generation and ensure the continuation of the family, but also, since the Egyptians envisioned passage into the next world as rebirth, because they were believed to facilitate this process.

Despite this system of formal and idealising representation, neither the bodily proportions of male and female figures nor the clothes they wore remained unchanged over the three thousand years of pharaonic history. From the Fourth to the Fifth Dynasty, male statues had broad shoulders, a low waist, well-developed musculature and a full face (figure 9). Beginning in the late Fifth and continuing through the Sixth Dynasty into the First Intermediate Period, they changed to have narrow shoulders, a high waist, little or no musculature and a tapering face with large eyes (figure 44). At the beginning of the Middle Kingdom, artists returned to older models for their inspiration and produced statues that once again had broad shoulders, low waists and well-developed musculature. These proportions lasted until the middle of the Twelfth Dynasty, after which shoulders grew narrower, the level of the waist was raised, and musculature disappeared (figure 26). At the same time, far more of the body was covered than before. During the Old Kingdom and earlier Twelfth Dynasty, male figures most commonly wore knee-length or calf-length kilts that left the upper part of the body and the arms bare, except for a collar worn round the neck and bracelets. In the later Middle Kingdom and Second Intermediate Period, standing male figures wore a long calf-length to ankle-length robe that wrapped

round the body under the arms, just below the nipples. Although the arms were not covered, only a small part of the upper torso was left bare and the robe obscures the body beneath it (figure 45). Seated figures were usually wrapped in an enveloping robe or shawl that covered the body from shoulder to ankles. One hand protruded from under the garment in order to hold it securely in place, while the other was placed flat on the chest (figure 46).

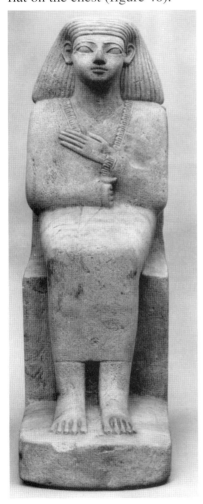

45. (Above) Standing statue of the vizier Yuy, wood, Second Intermediate Period, tomb of Yuy at Thebes, height 89.5 cm. (Courtesy of the Metropolitan Museum of Art, New York, Rogers Fund, 1923.) (23.3.37)

46. (Left) Seated statuette of a man, limestone, Twelfth Dynasty, height 31 cm. (Courtesy of the Metropolitan Museum of Art, New York, Bequest of Theodore M. Davis, 1915. The Theodore M. Davis Collection.) (30.8.73)

At the beginning of the Eighteenth Dynasty, royal sculpture drew on earlier Middle Kingdom statues as a model, producing figures with broad shoulders, a low waist and developed musculature (figure 17). While some statues of officials show similar trends, others exhibit slighter proportions with narrower shoulders and less obvious musculature. From the reign of Amenhotep II onwards, male dress became more elaborate. Around the middle of the dynasty, statues of men began to wear the bag tunic that covers the upper part of the body and tops of the arms. It follows the outline of the body and does not obscure its shape, which is clearly modelled beneath it, but its presence is made clear by the rendering of the sleeves, neckline, and often the cords that tie the garment at the front (figure 23). From the reign of Amenhotep III, the volume of material incorporated into male garments increased, and elaborate pleated

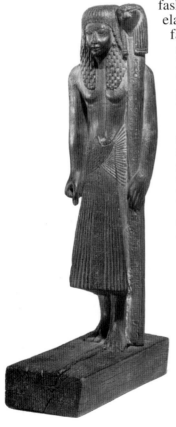

sashes that tied round the waist became fashionable. Male shoulder-length wigs were elaborately dressed in braids and curls, often falling in two layers with the upper one arranged to reveal the lower. By the Nineteenth Dynasty, the lower layer of the wig had lengthened so that it fell down in front of the shoulders as far as the collar bone (figure 47).

Although there are few non-royal statues surviving from the reign of Amenhotep III's son, Akhenaten, images of the king show a marked change in bodily proportions from what went before. The head and neck are long and thin, the shoulders are narrow, the small of the back is high, and the arms are thin. The swelling belly falls in a fold, while the large buttocks and thighs sit atop short, spindly lower legs (figure 48).

After the death of Akhenaten there was a return to more traditional proportions, which together with the elaborate costume of the later Eighteenth Dynasty formed the basis for male images throughout the rest of the New Kingdom and much of the Third Intermediate Period.

47. Standing statuette of the artist Karo holding a standard, wood, Nineteenth Dynasty, Deir el-Medina at Thebes, height 48 cm. (Courtesy of the Metropolitan Museum of Art, New York, Rogers Fund, 1965.) (65.114)

48. Standing statue of Akhenaten, limestone, Eighteenth Dynasty, Amarna boundary stela A at Tuna el-Gebel. (Author's photograph.)

The New Kingdom style was totally abandoned at the end of the Third Intermediate Period, and sculptors of the Late Period returned to earlier models from the Old Kingdom, Middle Kingdom and early Eighteenth Dynasty. Musculature was again emphasised, together with broad shoulders and low waists (figure 27). Much of the depicted costume returned to the simpler styles of earlier times, with figures frequently wearing only the knee-length kilt.

Female statues were always carefully differentiated from those of men by their bodily proportions and costume. Thus, whatever the male proportions being employed, female figures were normally more slender, with a higher waist and no musculature – all differences based on nature. From the Old Kingdom to the early Eighteenth Dynasty, female figures tend to have fairly small breasts (although there is considerable

variation), a flat stomach and an emphasised pubic region. The standard costume was the so-called sheath dress that covers the body from on or just below the breasts to just above the ankles. Two straps run over the breasts, across the shoulders and down the back. The dress hugs the body, clearly revealing its shape (figures 22 and 26).

During the later Eighteenth Dynasty a fuller figure with a swelling stomach under a clearly marked waist becomes fashionable (figure 49). This develops into the image used to portray Nefertiti and her daughters during the reign of Akhenaten – pronounced breasts, a high, narrow waist above a broad, swelling stomach, and large, curvaceous buttocks and hips. The sheath dress was abandoned and replaced by a long, pleated dress wrapped around the body, often worn together with a shawl that was tied at the front of the body (figures 23 and 38). In two-dimensional representation the dress falls away from the body, which is often revealed beneath it as though the material were transparent. In statues the dress is moulded to the body so that its shape is clearly revealed (figure 49).

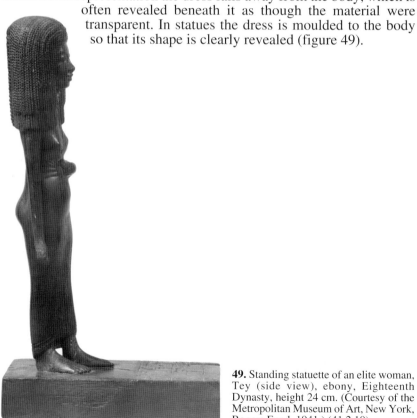

49. Standing statuette of an elite woman, Tey (side view), ebony, Eighteenth Dynasty, height 24 cm. (Courtesy of the Metropolitan Museum of Art, New York, Rogers Fund, 1941.) (41.2.10)

6
Texts and relief decoration

The majority of statues are inscribed, and some include relief decoration on their surfaces. Placing a name on a statue gave the image its individual identity. Some elite statues were, however, uninscribed and one must assume that they acquired their identity from their context, most usually the burial with which they were associated. Others may originally have been placed in a shrine or statue niche that carried identifying inscriptions. The identity of a statue could be changed by deleting the original name and replacing it with a new one. Royal statues were quite often treated in this way (figure 50). Sometimes the name alone was changed; in other cases the statue was recut to bring it into line with images of the king for whom it was now inscribed.

A divine statue not only named the deity portrayed but often also included the name of the king who had dedicated it. The two names were linked because the king was said to be beloved of the deity concerned. The inscription, therefore, not only identified the deity but established and displayed a link between the king and the deity. It signified that the king had fulfilled his duty to provide for the cult of the deity and that the deity acknowledged the king as legitimate ruler.

Statues of the king referred to his cosmic duties and to his relationship with deities. In addition to identifying the king, texts frequently describe the king as being beloved of a deity, usually the deity in whose temple the statue was placed. The sides of the seated king's throne often carry the *sema tawy* symbol representing the union of Upper and Lower Egypt. This consists of a central hieroglyph that means 'to unite/union', around which stems of the plants of Upper and Lower Egypt, the lily and papyrus, are knotted (figure 50). Thus the enthroned king unites the two parts of Egypt in his person. In some cases the motif can be rendered very elaborately. In addition to the *sema* hieroglyph and the two plants of Upper and Lower Egypt, two divine figures representing the two parts of the country may be shown tying the plants. These may be the gods Seth for Upper Egypt and Horus for Lower Egypt, although, because Seth was a somewhat ambivalent figure as a result of his association with chaos, Thoth was often substituted as the Upper Egyptian representative. In other examples the plants are tied by two fecundity figures, personifications of the wealth and fertility of Egypt. One figure wears the Upper Egyptian lily on his head and the other wears the papyrus of Lower Egypt. Such statues were meant to be oriented so that the Upper Egyptian figure was to the south and the Lower Egyptian one to the north.

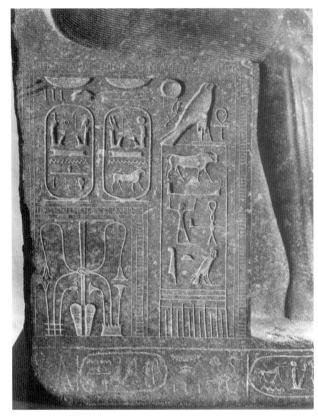

50. Detail of side of throne with *sema tawy* motif from a statue of Amenhotep III usurped by Merneptah, porphyritic diorite, Eighteenth Dynasty, temple of Luxor at Thebes. (Courtesy of the Metropolitan Museum of Art, New York, Rogers Fund and Gift of Edward S. Harkness, 1921.) (22.5.1)

On top of the surface of the statue base, under the king's feet, are frequently carved nine archery bows. These symbolised the traditional enemies of Egypt who represented the forces of chaos that the king must overcome in order to maintain cosmic order (*maat*). This image visually recalls the frequent phrase 'All foreign lands are under your feet/sandals' and shows the king triumphant over his enemies and chaos.

In the Old, Middle and New Kingdoms, images of family members, especially children, were often included in relief on elite statues. During the Third Intermediate Period, two-dimensional images of deities and divine emblems were commonly incorporated into the surface of statues, a trend that continued into later periods (figure 28).

Old Kingdom statues of the elite were mostly inscribed with the titles and names of the people represented. From the Fourth Dynasty, and more commonly in the Fifth and Sixth Dynasties, the owner was

designated as *imakhu*, 'revered one', or *imakhu kher netjer aa*, 'one revered before the great god', phrases that relate to the funerary function of the statue. From the Middle Kingdom onwards, statues also carry the offering formula (*hetep di nesu*) which petitions deities for benefits on behalf of the owner. The formula originally developed in a tomb context on coffins and stelae and invoked the funerary deities Anubis and Osiris. Its use later spread also to temple statues, where the formula often invoked the deities of the temple where the statue was placed and asked for benefits beyond the normal funerary ones. These included entrance to and egress from the temple and a share of the offerings presented on the altar of the deity.

In the Middle and New Kingdoms, some statues of male officials specifically say that they were 'given as a favour of the king', a fact that is recorded because it links the official to the king and thereby enhances his status. The surface of statues began to be used for recording traditional 'autobiographical' texts that cast the official's career into a standard form relating how he successfully fulfilled his duties and moral obligations within society. As time went on through the New Kingdom and Late Period, there was a tendency for texts on statues to increase in length. Male statues also sometimes have the cartouche of the king they served placed on the surface of their body.

The texts inscribed on many statues are today eagerly read by Egyptologists who wish to glean all the information they can from them, but who was originally meant to read them? First we have to remember that only a small group of the population – elite male officials – were literate. The majority of ancient Egyptians, male and female, would have been illiterate. Although there is some evidence of literacy on the part of a few elite women, it is unclear whether elite women as a group were generally literate, sometimes literate, or only rarely literate.

In any case, literacy for an ancient Egyptian meant first and foremost reading and writing the cursive hieratic script written with a brush on papyrus. Although derived from hieroglyphs, at first sight it bears little resemblance to them. Thus, for many literate Egyptians, reading monumental hieroglyphic texts may not have come easily. Furthermore, statues were rarely set up so that the texts would be readily accessible. Those on the sides and back were likely to be concealed by a surrounding shrine or niche, or simply to be invisible because of poor lighting conditions. How many people, passing through the outer precincts of a temple pursuing their own purposes, would have had time to read the often densely written inscriptions on the statues placed there? If relatives or priests were visiting a particular statue in a tomb chapel or temple precinct, presumably they already knew whom it represented. Did someone who could read hieroglyphs recite what was written there for

everyone present or did the text remain silent? In temples, who could even see, let alone read, the texts high up on a colossal statue? Could it be that the texts were meant more for the dead and the deities represented by the statues than they were for the living? Clearly we do not know all the answers to these questions, but it seems safe to say that most texts on statues would have had a very restricted audience among the living. However, the presence of hieroglyphs on a monument was probably prestigious in itself and added to the status of the person portrayed. Furthermore, the content of the texts must have had a potency irrespective of whether there were any living readers or not, since objects which were never meant to be seen by the living once they had been placed in a sealed burial were nevertheless frequently inscribed. We must never forget that, for the ancient Egyptians, the world was inhabited not only by living human beings but also by deities and the dead, and that the latter were a major part of the audience for whom the monuments of ancient Egypt were designed.

7
Conclusion

The basic characteristics of ancient Egyptian formal statues were governed by their function as focal points in cult. Frontality was a fundamental feature from the beginning to the end of the pharaonic period, and its dominance together with the limited poses for formal statues may give the impression that little changed during this time. In fact, new types of statues were introduced from time to time, the context for elite statues moved from the tomb to the temple, and above all there were continual changes in style, proportions and depicted dress.

Outside Egypt, knowledge of ancient Egyptian monumental statues inspired the creation of life-size, and over-life-size, hard-stone statuary by Greek sculptors. Psammetichus I, the first king of the Twenty-sixth Dynasty, brought Ionian and Carian mercenaries to Egypt to help him consolidate his hold on the country, after which Greeks, although strictly controlled, were allowed to settle and trade in Egypt. There, they would have seen monumental hard-stone statues, in contrast to the much smaller limestone or sandstone statues produced until that time by Greek sculptors. Not long after, the first monumental Greek statues, made of marble, which is harder than either limestone or sandstone, appeared. The male *kouroi* of the Greek Archaic Period exhibit frontality and stand with the left leg advanced, the arms held at the sides of the body, and the fists clenched. Clearly the pose is based on that of a typical Egyptian male standing statue.

A story told by the Greek author Diodorus recounted how two Greek sculptors of the mid sixth century BC, one in Samos and the other at Ephesus, each made one half of a statue 'and when they were brought together they fitted so perfectly that the whole work had the appearance of having been done by one man'. The explanation given is that the sculptors got the proportions of the two halves to correspond so exactly by using the standard grid system employed by Egyptian sculptors at that time, suggesting that Greek artists were familiar not only with the form of Egyptian statuary but also with the working methods of sculptors in Egypt. Thus, it seems that the long tradition of Egyptian statue-making helped shape the development of monumental Greek statuary, which in its turn was to have a profound influence on later western artistic traditions.

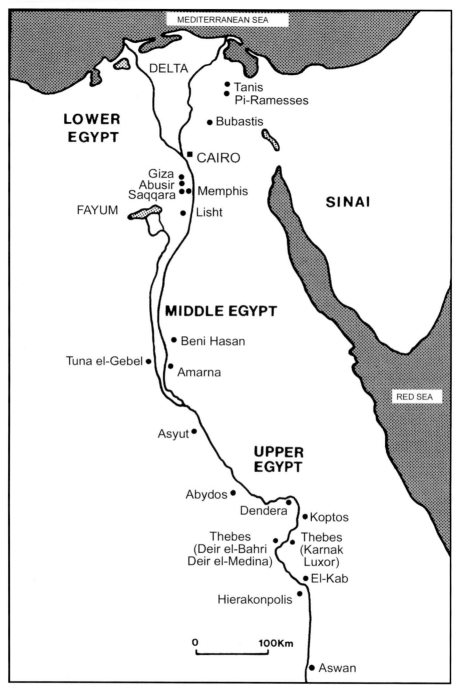

51. Map of Egypt, showing places mentioned in the text.

8
Further reading

Arnold, D. (editor). *Egyptian Art in the Age of the Pyramids*. Metropolitan Museum of Art, New York, 1999. (Excellent exhibition catalogue that includes essays and entries on Old Kingdom statues.)

Borchardt, L. *Statuen und Statuetten von Königen und Privat Leuten*, I–V. Catalogue Général des Antiquités Égyptiennes du Musée du Caire. Reichsdruckerer, Berlin, 1911–36. (Illustrated catalogue of royal and private statues in the Cairo Museum.)

Bothmer, B.V. *Egyptian Sculpture of the Late Period, 700 BC to AD 100*. Brooklyn Museum, 1960. Reprint, Arno Press, New York, 1969.

Daressy, G. *Statues de Divinités*. Catalogue Général des Antiquités Égyptiennes du Musée du Caire. Institut Français d'Archéologie Orientale, Cairo, 1906. (Illustrated catalogue of statues of deities in the Cairo Museum.)

Délange, E. *Catalogue des Statues Égyptiennes du Moyen Empire 2060–1560 avant J.-C*. Editions de la Réunion des Musées Nationaux, Paris, 1987. (Illustrated catalogue of the Middle Kingdom statues in the Musée du Louvre, Paris.)

Eaton-Krauss, M. *The Representations of Statuary in Private Tombs of the Old Kingdom*. Otto Harrassowitz, Wiesbaden, 1984.

Evers, H.G. *Staat aus dem Stein, Denkmäler, Geschichte und Bedeutung der Ägyptischen Plastik während des Mittleren Reichs*, I–II. F. Bruckmann A.-G., Munich, 1929.

Habachi, L. *The Sanctuary of Heqaib*, I–II. Philipp von Zabern, Mainz, 1985. (A well-illustrated publication of a group of Middle Kingdom statues found in the sanctuary of Heqaib on the island of Elephantine. Excellent for observing stylistic changes during this period.)

James, T.G.H., and Davies, W.V. *Egyptian Sculpture*. British Museum Publications, London, 1983.

Josephson, Jack A. *Egyptian Royal Sculpture of the Late Period, 400–246 BC*. Philipp von Zabern, Mainz, 1997.

Koefoed-Petersen, O. *Catalogue des Statues et Statuettes Égyptiennes*. Ny Carlsberg Glyptotek Publications, no. 3, Copenhagen, 1950.

Kozloff, A., and Bryan, B. *Egypt's Dazzling Sun. Amenhotep III and His World*. Cleveland Museum of Art and Indiana University Press, 1992. (Exhibition catalogue that includes important sections on divine, royal and private statues of the reign of Amenhotep III.)

Legrain, G. *Statues et Statuettes des Rois et des Particuliers*, I–III. Catalogue Général des Antiquités Égyptiennes du Musée du Caire. Institut Français d'Archéologie Orientale, Cairo, 1906–25. (Illustrated

catalogue of royal and private statues in the Cairo Museum.)

Linblad, I. *Royal Sculpture of the Early Eighteenth Dynasty in Egypt.* Medelhavsmuseet Memoir 5, Stockholm, 1984.

Lorton, D. 'The Theology of Cult Statues in Ancient Egypt', in M. Dick (editor), *Born in Heaven, Made on Earth: The Making of the Cult Image in the Ancient Near East.* Eisenbraun, Winona Lake, Indiana, 1999.

Malek, J. 'The Saqqara Statue of Ptahmose, Mayor of the Memphite Suburbs', in *Revue d'Égyptologie* 38 (1987), pages 117–37. (Overview of statue types found in New Kingdom tombs at Saqqara.)

Robins, G. *The Art of Ancient Egypt.* British Museum Press, 1997.

Russman, E.R. *The Representation of the King in the XXVth Dynasty.* Brussels and Brooklyn, 1974.

Russmann, E.R. *Egyptian Sculpture, Cairo and Luxor.* University of Texas Press, Austin, 1989.

Russmann, E.R. 'A Second Style in Egyptian Art of the Old Kingdom', in *Mitteilungen der Deutschen Archäologischen Instituts, Kairo* 51 (1995), pages 269–79. (Discusses changes in style that occurred in the late Fifth and Sixth Dynasties in relation to statues.)

Seipel, W. *Gott, Mensch, Pharao: Viertausend Jahre, Menschenbild in der Skulptur des alter Ägypten.* Kunsthistorisches Museum, Vienna, 1992. (Well-illustrated catalogue of an exhibition on divine, royal and non-royal statues.)

Smith, W.S. *The Art and Architecture of Ancient Egypt.* Yale University Press, New Haven and London, third edition 1998.

Smith, W.S. *A History of Egyptian Sculpture and Painting in the Old Kingdom.* Oxford University Press, 1946. Reprint, Hacker Art Books, New York, 1978.

Tefnin, R. *La Statuaire d'Hatshepsout.* Foundation Égyptologique Reine Élisabeth, Brussels, 1979.

Tooley, A.M.J. *Egyptian Models and Scenes.* Shire Publications, 1995. (Treats servant statuettes not covered in the present volume.)

Vandier, J. *Manuel d'Archéologie Égyptienne*, III. *Les Grandes Époques: la Statuaire*, I–II. Éditions A. et J. Picard, Paris, 1958.

Ziegler, C. *Les Statues Égyptiennes de l'Ancien Empire.* Éditions de la Réunion des Musées Nationaux, Paris, 1997. (Illustrated catalogue of the Old Kingdom statues in the Musée du Louvre, Paris.)

9
Museums

Great Britain

Ashmolean Museum of Art and Archaeology, Beaumont Street, Oxford OX1 2PH. Telephone: 01865 278000. Website: www.ashmol.ox.ac.uk
British Museum, Great Russell Street, London WC1B 3DG. Telephone: 020 7636 1555 or 020 7580 1788 (infoline). Website: www.britishmuseum.ac.uk
Durham University Oriental Museum, Elvet Hill, Durham DH1 3TH. Telephone: 0191 374 7911. Website: www.dur.ac.uk/orientalmuseum
Fitzwilliam Museum, Trumpington Street, Cambridge CB2 1RB. Telephone: 01223 332900. Website: www.fitzwilliam.cam.ac.uk
Liverpool Museum, William Brown Street, Liverpool L3 8EN. Telephone: 0151 478 4399. Website: www.nmgm.org.uk
National Museum of Scotland, Chambers Street, Edinburgh EH1 1JF. Telephone: 0131 225 7534. Website: www.nms.ac.uk
Petrie Museum of Egyptian Archaeology, University College London, Malet Place, London WC1E 6BT. Telephone: 020 7679 2884. Website: www.petrie.ucl.ac.uk

Austria

The Vienna Kunsthistorisches Museum, Maria-Theresien Platz, A-1010 Vienna. Telephone: (+431) 525 24 401. Website: www.khm.at

Belgium

Musées Royaux d'Art et d'Histoire, Avenue J. F. Kennedy, 1040 Brussels. Telephone: (+32) 2 741 72 11. Website: www.kmkg-mrah.be

Canada

Royal Ontario Museum, 100 Queen's Park, Toronto, Ontario M5S 2C6. Telephone: (+1) 416 586 5549. Website: www.rom.on.ca

Denmark

Ny Carlsberg Glyptotek, Dantes Plads 7, DK-1556 Copenhagen V. Telephone: (+45) 33 41 81 41. Website: www.glyptoteket.dk

Egypt

Egyptian Antiquities Museum, Tahrir Square, Kasr el-Nil, Cairo. Telephone: (+20) 2 575 4267.
Luxor Museum of Ancient Egyptian Art, Luxor.
Nubia Museum, Aswan.

France
Musée du Louvre, Palais du Louvre, F-75041 Paris. Telephone: (+33) 1
40 20 53 17. Website: www.louvre.fr

Germany
Ägyptisches Museum, Staatliche Museen zu Berlin, Bodestrasse 1–3,
1020 Berlin. Website: www.smb.spk-berlin.de
Ägyptisches Museum und Papyrussammlung, Schlossstrasse 70, 14059
Berlin. Telephone: (+33) 34 34 73 37. Website: www.smb.spk-
berlin.de
Roemer-Pelizaeus-Museum, Amsteiner 1, 3200 Hildesheim,
Niedersachsen.

Greece
National Archaeological Museum of Athens, Patission 44 St, Athens
10682. Telephone: (+30) 1 8217717. Website: www.culture.gr

Italy
Museo Egizio, Palazzo dell'Accademia delle Scienze, Via Accademia
delle Scienze 6, Turin.

Netherlands
Rijksmuseum van Oudheden, Rapenburg 28, 2311 EW, Leiden.
Telephone: (+31) 71 516 31 63. Website: www.rmo.nl

Russia
Pushkin Museum of Fine Arts, Volkhonka 19, 121019, Moscow.

United States of America
Brooklyn Museum of Art, 200 Eastern Parkway, Brooklyn, New York 11238-
6052. Telephone: (+1) 718 638 5000. Website: www.brooklynart.org
Field Museum of Natural History, 1400 Lake Shore Drive, Chicago,
Illinois 60605. Telephone: (+1) 312 922 9410. Website: www.fmnh.org
Metropolitan Museum of Art, 1000 Fifth Avenue at 82nd Street, New
York, New York 10028-0198. Telephone: (+1) 212 535 7710. Website:
www.metmuseum.org
Museum of Fine Arts, 465 Huntington Avenue, Boston, Massachusetts
02115-5523. Telephone: (+1) 617 267 9300. Website: www.mfa.org
University of Chicago Oriental Institute Museum, 1155 East 58th Street,
Chicago, Illinois 60637. Telephone: (+1) 773 702 9520. Website:
www-oi.uchicago.edu
Walters Art Gallery, 600 North Charles Street, Baltimore, Maryland
21201. Telephone: (+1) 410 547 9000. Website: www.thewalters.org

Index

Page numbers in italic refer to illustrations

the sun-god, Lord of Revelation, even as in Greek mythology Apollo the sun-god is also Master of poetry and of prophecy. *ghṛta* means clarified butter, but also the bright thing ; *soma* means the wine of the moon-plant, but also delight, honey, sweetness, *madhu*. This is the conception, all other features are subsidiary to this central idea.

The Veda itself gives a key to the Veda.

Key to Vedic Symbolism

ACITRAM. That which is not illumined, has not received the varied light of the dawn, the night of our ordinary darkness.

ADHVARA-YAJNA. The sacrifice that travels. *adhvara* is " travelling ", " moving ", connected with *adhvan*, path or journey from the lost root *adh*, to move, extend, be wide, compact, etc. We see the connection between the two words *adhvan* and *adhvara* in *adhva*, air, sky and *adhvara* with the same sense. The passages in the Veda are numerous in which the *adhvara* or *adhvara yajna* is connected with the idea of travelling, journeying, advancing on the path. Sacrificial action travelling on the path, the sacrifice that is of the nature of a progression or journey. Agni, the Will is the leader of the sacrifice.

ADHVARYU. The conductor of the sacrifice ; the priest of the journey.

ADITI. Originally the pure consciousness of infinite existence one and self-luminous ; she is the Light that is Mother of all things. As the infinite she gives birth to Daksha, the discriminating and distributing Thought of the divine Mind, and is herself born to Daksha as the cosmic infinite, the mystic Cow whose udders feed all the worlds.

It is this divine daughter of Daksha who is the mother of the gods. In the cosmos Aditi is the undivided infinite unity of things, free from duality, *advaya*, and has Diti the separative dualising consciousness for the observe side of her cosmic creation, — her sister and a rival wife in the later myth.

Here in the lower being where she is manifested as the earth-principle, her husband is the lower or inauspicious Father who is slain by their child Indra, the power of the divine Mind manifested in the inferior creation. Indra, says the hymn, slays his father, dragging him by the feet, and makes his mother a

widow. In another image, Surya is said to be the lover of his
sister Dawn and the second husband of his mother Aditi, and
by a variation of the same image Aditi is hymned as the wife
of the all-pervading Vishnu who is in the cosmic creation one
of the sons of Aditi and the younger brother of Indra. Aditi
is the infinite consciousness in the cosmos espoused and held
by the lower creative power which works through the limited
mind and body, but delivered from this subjection by the force
of the divine or illumined Mind born of her in the mentality
of man. It is this Indra who makes Surya the light of the
Truth rise in heaven and dispel the darknesses and falsehoods
and limited vision of the separative mentality. Vishnu is the
vaster all-pervading existence which then takes possession
of our liberated and unified consciousness, but he is born in
us only after Indra has made his puissant and luminous
appearance.

Goddess of infinite being, mother of the gods, the indivisible
consciousness, the Light that cannot be impaired imaged by the
mystic Cow that cannot be slain.

Psychologically, Aditi is the supreme or infinite Conscious-
ness, mother of the gods, in opposition to Danu or Diti, the divided
consciousness, mother of Vritra and the other Danavas —
enemies of the gods and of man in his progress. In a more
general aspect she is the source of all the cosmic forms of
consciousness from the physical upwards.

Children of Aditi : Aditi is the infinite Light of which the
divine world is a formation and the gods, children of the infinite
Light, born of her in the *ṛtam*, manifested in that active truth
of her movement guard it against Chaos and Ignorance. It is
they who maintain the invincible workings of the Truth in the
universe, they who build its worlds into an image of the Truth.
They, bounteous givers, loose out upon man its floods variously
imaged by the mystic poets as the sevenfold solar waters, the
rain of heaven, the streams of the Truth, the seven mighty Ones
of heaven, the waters that have knowledge, the floods that
breaking through the control of Vritra the Coverer ascend and
overflow the mind. They, seers and revealers, make the light
of the Truth to arise on the darkened sky of his mentality, fill
with its luminous and honey-sweet satisfactions the atmosphere
of his vital existence, transform into its vastness and plenitude

by the power of the Sun the earth of his physical being, create everywhere the divine Dawn.

ĀDITYAS. Sons of the Infinite. They have a twofold birth. They are born above in the divine Truth as creators of the worlds and guardians of the divine Law ; they are also born here in the world itself and in man as cosmic and human powers of the Divine. In the visible world they are male and female powers and energies of the universe and it is this external aspect of them as gods of the Sun, Air, Waters, Earth, Ether, the conscious forces ever present in material being which gives us the external or psycho-physical side of the Aryan worship.

AGNI. Agni is the most important, the most universal of the Vedic gods. In the physical world he is the general devourer and enjoyer. He is also the purifier ; when he devours and enjoys, then also he purifies. He is the fire that prepares and perfects ; he is also the fire that assimilates and the heat of energy that forms. He is the heat of life and creates the sap, the *rasa* in things, the essence of their substantial being and the essence of their delight.

He is equally the Will in Prana, the dynamic Life-energy, and in that energy performs the same functions. Devouring and enjoying, purifying, preparing, assimilating, forming, he rises upwards always and transfigures his powers into the Maruts, the energies of Mind. Our passions and obscure emotions are the smoke of Agni's burning. All our forces are assured of their action only by his support.

If he is the Will in our nervous being and purifies it by action, he is also the Will in the mind and clarifies it by aspiration. When he enters into the intellect, he is drawing near to his divine birth-place and home. He leads the thoughts towards effective power ; he leads the active energies towards light.

His divine birth-place and home, — though he is born everywhere and dwells in all things, — is the Truth, the Infinity, the vast cosmic Intelligence in which Knowledge and Force are unified. For there all Will is in harmony with the truth of things and therefore effective ; all thought part of Wisdom, which is the divine Law, and therefore perfectly regulative of a divine action. Agni fulfilled becomes mighty in his own home

— in the Truth, the Right, the Vast. It is thither that he is
leading upward the aspiration in humanity, the soul of the Aryan,
the head of the cosmic sacrifice.

The flame of the Divine Will or Force of Consciousness
working in the worlds. He is described as the immortal in
mortals, the leader of the journey, the divine Horse that bears
us on the road, the ' son of crookedness ' who himself knows
and is the straightness and the Truth. Concealed and hard to
seize in the workings of this world because they are all falsified
by desire and egoism, he uses them to transcend them and
emerges as the universal in Man or universal Power, Agni
Vaishvanara, who contains in himself all the gods and all the
worlds, uphold all the universal workings and finally fulfils the
godhead, the immortality. He is the worker of the divine
Work.

Agni, the divine priest of the offering stands up in the dawn
of the illumination to offer to the gods, to each great god his
portion, to Indra a pure and deified mentality, to Vayu a pure
and divine vital joy and action, to the four great Vasus, Varuna,
Mitra, Bhaga and Aryaman the greatnesses, felicities, enjoyments
and strengths of perfected being, to the Ashvins the youth of
the soul and its raptures and swiftnesses, to Dakṣha and
Sarasvati, Ila, Sarama and Mahi the activities of the Truth and
Right, to the Rudras, Maruts and Adityas, the play of the
physical, vital, mental and ideative activities.

Agni in the Veda is always presented in the double aspect
of force and light. He is the divine power that builds up the
worlds, a power which acts always with a perfect knowledge,
for it is *jātavedas*, knower of all births ; it knows all manifesta-
tions or phenomena or it possesses all forms and activities of
the divine wisdom. The gods have established Agni as the
immortal in mortals, the divine power in man, the energy of
fulfilment through which they do their work in him.

Agni is a god — He is of the Devas, the shining ones, the
Masters of light — the great cosmic gamesters, the lesser lords
of Lila, of which Yajna is the Mahesvara, our Almighty Lord.
He is fire and unbound or binds himself only in play. He is
inherently pure and he is not touched nor soiled by the impurities
on which he feeds. He enjoys the play of good and evil and
leads, raises or forces the evil towards goodness. He burns in

order to purify. He destroys in order to save. When the body of the sadhaka is burned up with the heat of the tapas, it is Agni that is roaring and devouring and burning up in him the impurity and the obstructions. He is dreadful, mighty, blissful, merciless and loving God, the kind and fierce helper of all who take refuge in his friendship.

Without him the sacrificial flame cannot burn on the altar of the soul. That flame of Agni is the seven tongued power of the Will, a Force of God instinct with knowledge. This conscious and forceful will is the immortal guest in our mortality, a pure priest and a divine worker, the mediator between earth and heaven. It carries what we offer to the higher Powers and brings back in return their force and light and joy into our humanity.

Agni is invoked before all the other gods because it is he that stands before Yajna, the Divine Master of things ; because he is the god whose burning eyes can gaze straight at Truth, which is the seer's own aim and desire and on which all Vedas is based ; because he is the warrior who wars down and removes all the crooked attractions of ignorance and limitation that stand persistently in the way of the Yogin ; because as the vehicle of Tapas, the pure divine superconscious energy which flows from the concealed higher hemisphere of existence, he more than any develops and arranges Ananda, the divine delight.

AJA. The word has the double meaning of goat and unborn.

AMHOH. Narrowness full of suffering and evil, the unenlightened state of our limited mentality.

ANANDA. The state of divine Beatitude in which all the powers of our being are revealed in their perfect godhead, here secret and hidden from us.

ANĀSĀH. Enemies who with their shapeless stammering mouths and their insufficient breath of force mar man's self-expression.

ANGIRASA. The Rishi who represents the Seer-Will. The Angirasa Rishis are the flame-powers of Agni.

The Angirasas, are at once the divine seers who assist in the cosmic and human workings of the gods and their earthly representatives, the ancient fathers who first found the wisdom of which the Vedic hymns are a chant and memory and renewal in experience. The seven divine Angirasas are sons or powers of Agni, powers of the Seer-Will, the flame of divine Force instinct with divine knowledge which is kindled for the victory. The Bhrigus have found the Flame secret in the growths of the earthly existence, but the Angirasas kindle it on the altar of sacrifice and maintain the sacrifice through the periods of the sacrificial year symbolishing the periods of the divine labour by which the Sun of Truth is recovered out of the darkness. Those who sacrifice for nine months are Navagvas, seers of the nine cows or nine rays, who institute the search for the herds of the Sun and the march of Indra to battle with the Panis. Those who sacrifice for ten months are the Dashagvas, seers of the ten rays who enter with Indra into the cave of the Panis and recover the lost herds.

The Angirasas win the wealth of illuminations and powers of the Truth concealed behind the lower life and its crookednesses.

The Angirasas are sons of the Flame, lustres of the Dawn, givers and drinkers of the Wine, singers of the Hymn, eternal youths and heroes who wrest for us the Sun, the Cows, the Horses and all treasures from the grasp of the sons of darkness. They are also seers of the Truth, finders and speakers of the word of the Truth and by the power of the Truth they win for us the wide world of Light and Immortality which is described in the Veda as the Vast, the True, the Right and as the own home of this Flame of which they are the children

Vide Aspiration.

APRAKETAM SALILAM. Sea of Inconscience.

ARANI. Two tinders. Haven and Earth are the two *aranis* which produce Agni : Heaven his father, Earth his mother.

ARCAN (ṚC). In the Veda it means to shine and to sing the *ṛk*.

ARCANĀNAS. He who travels to the illumination created by the word, pilgrim of the Light ; the significant name of a Rishi of the line of Atri.

ARKA. Hymn of illumination. Realising Word.

A vocable which means both hymn and light and is sometimes used of the sun. It is therefore the word of illumination, the word which expresses the truth of which the Sun is the lord.

ARYAMAN. The aspiring power and action of the Truth. Represents, in creation, the light of the divine consciousness working as Force.

The Force of sacrifice, aspiration, battle, journey towards perfection and light and celestial bliss by which the path is created, travelled, pursued beyond all resistance and obscuration to its luminous and happy goal.

Aryaman sums up in himself the whole aspiration and movement of man in a continual self-enlargement and self-transcendence to his divine perfection. By his continuous movement on the unbroken path Mitra and Varuna and the sons of Aditi fulfil themselves in the human birth.

Many-charioted Aryaman has his foundation in the movement and all-discerning force of Tapas.

ARYAN. He who does the work of sacrifice, finds the sacred word of illumination, desires the Gods and increases them and is increased by them into the largeness of the true existence ; he is the warrior of the light and the traveller to the Truth.

The traveller on the Path, the aspirant to immortality by divine sacrifice, one of the shining children of Light, a worshipper of the Master of the Truth, a fighter in the battle against the powers of darkness who obstruct the human journey.

The whole struggle of man is to replace the ordinary unillumined sense activities of life by the luminous working of mind and life which comes from above through the mental existence. Whoever thus aspires, labours, battles, travels, ascends the hill of being is the Aryan ; for the work of the Aryan is a sacrifice which is at once a battle and an ascent and a journey, a battle against the powers of darkness, an ascent to the highest peaks of the mountain beyond earth and heaven into Svar, a journey

2

to the other shore of the rivers and the ocean into the farthest Infinity of things.

Aryan and Dasyu. The Aryan has the will to the work, he is the doer of the work, (*kāru, kiri,* etc.), the gods who put their force into his work are *sukratu,* perfect in power for the sacrifice ; the Dasyu or Pani is the opposite of both, he is *akratu.* The Aryan is the sacrificer, *yajamāna, yajyu* ; the gods who receive, uphold, impel his sacrifice are *yajata, yajatra,* powers of the sacrifice ; the Dasyu is the opposite of both, he is *ayajyu.* The Aryan in the sacrifice finds the divine word, *gīh, mantra, brahma, uktha,* he is the *brahmā* or singer of the word ; the gods delight in and uphold the word, *gīrvāhasah, gīrvanasah,* the Dasyus are haters and destroyers of the Word, *brahmadvisah,* spoilers of speech, *mṛdhravacasah.* They have no force of the divine breath or no mouth to speak it, they are *anāsah* ; and they have no power to think and mentalise the word and the truth it contains, they are *amanyamānāh* ; but the Aryans are the thinkers of the word, *manyamānāh,* holders of the thought, the thought-mind and the seer-knowledge, *dhīra, manīsī, kavi* ; the gods are also the supreme thinkers of the Thought. The Aryans are desirers of the godheads, *devayuh, uśijah* ; they seek to increase their own being and the godheads in them by the sacrifice, the word, the thought ; the Dasyus are god-haters, *devadvisah,* obstructors of the godhead, *devanidah,* who desire no increase, *avṛdhah.* The gods lavish wealth on the Aryan, the Aryan gives his wealth to the gods ; the Dasyu withholds his wealth from the Aryan until it is taken from him by force, and does not press out the immortal Soma-wine for the deities who seek its rapture in man ; although he is *revān,* although his cave is packed with cows and horses and treasures, still he is *arādhas,* because his wealth gives no prosperity or felicity to man or himself — the Pani is the miser of existence. And in the struggle between the Aryan and the Dasyu he seeks always to plunder and destroy, to steal the luminous cows of the latter and hide them again in the darkness of the cave.

The Rivers and Dawns when in the possession of Vritra or Vala are described as *dāsapatnīh* ; by the action of the gods they become *āryapatnīh,* they become the help-mates of the Aryan.

To Indra, Agni and Surya among the gods is especially applied the term *arya,* which describes with an untranslatable compact-

ness those who rise to the noble aspiration and who do the great labour as an offering in order to arrive at the good and the bliss.

ASCENSION AND THE ANCIENTS. The ascension has already been effected by the Ancients, the human forefathers, and the spirits of these great Ancestors still assist their offspring ; for the new dawns repeat the old and lean forward in light to join the dawns of the future. Kanwa, Kutsa, Atri, Kakshiwan, Gotama, Shunashepa have become types of certain spiritual victories which tend to be constantly repeated in the experience of humanity. The seven sages, the Angirasas, are waiting still and always, ready to chant the word, to rend the cavern, to find the lost herds, to recover the hidden Sun.

ASHVINS. The twin divine powers whose special function is to perfect the nervous or vital being in man in the sense of action and enjoyment. But they are also powers of Truth, of intelligent action, of right enjoyment, they are powers that appear with the Dawn, effective powers of action born out of the ocean of being who, because they are divine, are able to mentalise securely the felicities of the higher existence by a thought-faculty which finds or comes to know that true substance and true wealth. They give that impelling energy for the great work which, having for its nature and substance the light of the Truth, carries man beyond the darkness.

Wedded to the daughter of Light, drinkers of honey, bringers of perfect satisfactions, healers of maim and malady they occupy our parts of knowledge and parts of action and prepare our mental, vital and physical being for an easy and victorious ascension.

The Ashwins like the other gods descend from the Truth-consciousness, the *rtam* ; they are born or manifested from Heaven, from Dyau, the pure Mind ; their movement pervades all the worlds, — the effect of their action ranges from the body through the vital being and the thought to the superconscient Truth. It commences indeed from the ocean, from the vague of the being as it emerges out of the subconscient and they conduct the soul over the flood of these waters and prevent its foundering on its voyage. They are therefore *nāsatyā*, lords of the movement, leaders of the journey or voyage.

They help man with the Truth which comes to them especially by association with the Dawn, with Surya, lord of the Truth, and with Suryā, his daughter, but they help him more characteristically with the delight of being. They are lords of bliss, *śubhaspati* ; their car or movement is loaded with the satisfactions of the delight of being in all its planes, they bear the skin full of the overflowing honey ; they seek the honey, the sweetness, and fill all things with it. They are therefore effective powers of the Ananda which proceeds out of the Truth-consciousness and which manifesting itself variously in all the three worlds maintain man in his journey. Hence their action is in all the worlds. They are especially riders or drivers of the Horse, Ashwins, as their name indicates, — they use the vitality of the human being as the motive-force of the journey ; but also they work in the thought and lead it to the Truth. They give health, beauty, wholeness to the body ; they are the divine physicians. Of all the gods they are the most ready to come to man and to create for him ease and joy. For this is their peculiar and perfect function. They are essentially lords of weal, of bliss, *śubhaspati*.

Chariot of the Aswins. The happy movement of the Ananda in man which pervades with its action all his worlds or planes of being, bringing health, youth, strength, wholeness to the physical man, capacity of enjoyment and action to the vital, glad energy of the light to the mental being.

ASPIRATION. The aspiration of the Vedic seer was the enrichment and expansion of man's being, the birth and the formation of the godheads in his life-sacrifice, the increase of the Force, Truth, Light, Joy of which they are the powers until through the enlarged and ever-opening worlds of his being the soul of man rises, sees the *divine doors* (*devīr dvāraḥ*) swing open to his call and enters into the supreme felicity of a divine existence beyond heaven and earth.

This ascent is the parable of the Angirasa Rishis.

ASURA. A word used in the Veda as in the Avesta for the Deva (Ahuramazda) but also for the gods, His manifestations ; it is only in a few hymns that it is used for the dark Titans, by another and fictitious derivation, *a-sura*, the not-luminous, the not-gods.

ASVAMEDHA. *Vide* Horse-Sacrifice.

ATHARVAN. The Rishi of the journeying on the Path.
He forms in the strength of the illuminations and powers of
the Truth, the Path.

ATRI. A Rishi. Devourer.

AYĀSYA. Rishi associated with the Navagva Angirasas;
described as our father who found the vast seven-headed
Thought that was born out of the Truth and as singing the hymn
to Indra.

BATTLE IN THE VEDA. Truth and Light are synonymous
or equivalent words in the thought of the Vedic seers even as
are their opposites, Darkness and Ignorance. The battle of the
Vedic Gods and Titans is a perpetual conflict between Day and
Night for the possession of the triple world of heaven, mid-air
and earth and for the liberation or bondage of the mind, life
and body of the human being, his mortality or his immortality.
It is waged by the Powers of a supreme Truth and Lords of a
supreme Light against other dark Powers who struggle to main-
tain the foundation of this falsehood in which we dwell and the
iron walls of these hundred fortified cities of the Ignorance.

BHADRAM. Good in the sense of felicity the auspicious
things of the divine enjoying, the happiness of the right activity,
the right creation.
The opposite of the false consciousness of that which is not
the *rtam*; opposite of false going which means all evil and
suffering. *bhadram* is equivalent to *suvitam*, right going, which
means all good and felicity belonging to the state of the Truth,
rtam. It is *mayas*, the felicity.

BHAGA. The godhead who brings joy — the illimitable
joy of the Truth — and supreme felicity into the human cons-
ciousness; he is the divine enjoyer in man.
Bhaga has his foundation in the all-embracing joy of Ananda.
Bhaga represents, in creation, Ananda as the creative enjoy-

ment ; he takes the delight of the creation, takes the delight of all that is created.

An increasing and victorious felicity of the soul rejoicing in the growth of its divine possessions which gives us strength to journey on and overcome till we reach the goal of our perfection in an infinite beatitude, this is the sign of the birth of Bhaga in man and this his divine function.

Bhaga is Savitri the Creator, he who brings forth from the unmanifest Divine the truth of a divine universe, dispelling from us the evil dream of this lower consciousness in which we falter amidst a confused tangle of truth and falsehood, strength and weakness, joy and suffering. An infinite being delivered out of imprisoning limits, and infinite knowledge and strength receiving in thought and working out in will a divine Truth, an infinite beatitude possessing and enjoying all without division, fault or sin, this is the creation of Bhaga Savitri, this that greatest Delight.

BHĀRATI. *Vide* Mahi.

BHRIGUS. The Bhrigus in the Veda are burning powers of the Sun, the Lord of Knowledge. They are the powers of the revelatory knowledge, the powers of the seer-wisdom.

BHUJYU. The seeker of enjoyment, son of King Tugra the Forceful-Hastening.

BHUVAR. The middle world including all those states of existence in which the mind and the life are interblended as the double medium through which the Purusha acts and connects Heaven and Earth. The *bhuvah* or middle regions are worlds of rapture and ecstasy because life-energy and the joy of life fulfil themselves there free from the restrictions of the material world in which it is an exile or invader seeking to dominate and use the rebellious earthly material for its purposes.

BIRD. Symbol of the soul liberated and upsoaring, at other times of energies so liberated and upsoaring, winging upwards towards the heights of our being, winging widely with a free flight, no longer involved in the ordinary limited movement or labouring gallop of the Life-energy, the Horse.

BIRTH OF THE GODS. The manifestation of the divine principles in the cosmos and especially the formation of the godhead in its manifold forms in the human being.

BIRTHS OF MAN. Every being really holds in himself all that his outward vision perceives as if external to him. We have subjective faculties hidden in us which correspond to all the tiers and strata of the objective cosmic system and these form for us so many planes of our possible existence. This material life and our narrowly limited consciousness of the physical world are far from being the sole experience permitted to man, — be he a thousand times the Son of Earth. If maternal Earth bore him and retains him in her arms, yet is Heaven also one of his parents and has a claim on his being. It is open to him to become awake to profounder depths and higher heights within and such awakening is his intended progress. And as he mounts thus to higher and ever higher planes of himself, new worlds open to his life and his vision and become the field of his experience and the home of his spirit. He lives in contact and union with their powers and godheads and remoulds himself in their image. Each ascent is thus a new birth of the soul, and the Veda calls the worlds " births " as well as seats and dwelling-places.

BRAHMA. *Vide* Brahman.

BRAHMAN. *Brahman* in the Veda signifies ordinarily the Vedic Word or Mantra in its profoundest aspect as the expression of the intuition arising out of the depths of the soul or being. It is a voice of the rhythm which has created the worlds and creates perpetually. All world is expression or manifestation, creation by the Word. Conscious Being luminously manifesting its contents in itself, of itself, *ātman,* is the superconscient ; holding its contents obscurely in itself it is the subconscient. The higher, the self-luminous descends into the obscure, into the night, into darkness, concealed in darkness, *tamaḥ tamasā gūḍham,* where all is hidden in formless being owing to fragmentation of consciousness, *tucchyenābhvapihitam.* It arises again out of the Night by the Word to reconstitute in the conscient its vast unity. This vast Being, this all-containing and

all-formulating consciousness is Brahman. It is the Soul that emerges out of the subconscient in Man and rises towards the superconscient. And the word of creative Power welling upward out of the soul is also *brahman*.

The Divine, the Deva, manifests itself as conscious Power of the soul, creates the worlds by the Word out of the waters of the subconscient, *apraketam salilam sarvam*, — the inconscient ocean that was this all, as it is plainly termed in the great Hymn of Creation (X. 129). This power of the Deva is *Brahmā*, the stress in the name falling more upon the conscious soul-power than upon the Word which expresses it. The manifestation of the different world-planes in the conscient human being culminates in the manifestation of the superconscient, the Truth and the Bliss, and this is the office of the supreme Word or Veda. Of this supreme Word *Brihaspati* is the master, the stress in this name falling upon the potency of the Word rather than upon the thought of the general soul-power which is behind it. Brihaspati gives the Word of knowledge, the rhythm of expression of the superconscient, to the gods and especially to Indra, the lord of Mind, when they work in man as " Aryan " powers for the great consummation. It is easy to see how these conceptions came to be specialised in the broader, but less subtle and profound Puranic symbolism into Brahmā, the Creator, and Brihaspati, the teacher of the gods. In the name, *Brahmanaspati,* the two varying stresses are unified and equalised. It is the link-name between the general and the special aspects of the same deity.

Brahman is the soul or soul-consciousness emerging from the secret heart of things, but more often the thought, inspired, creative, full of the secret truth, which emerges from that consciousness and becomes thought of the mind.

Brahmās or *brāmaṇa forces* : Powers of the Word, the rhythmic army of the soul-forces ; priests of the Word, the creators by the divine rhythm.

The Veda already contains in the seed the Vedantic conception of the Brahman. It recognises an Unknowable, a timeless Existence, the Supreme which is neither today nor tomorrow, moving in the movement of the Gods, but itself vanishing from the attempt of the mind to seize. It is spoken of in the neuter

as That and often identified with the Immortality, the supreme triple Principle, the vast Bliss to which the human being aspires. The Brahman is the Unmoving, the Oneness of the Gods.

This Brahman, the one Existence, thus spoken of impersonally in the neuter, is also conceived as the Deva, the supreme God-head, the Father of things who appears here as the Son in the human soul. He is the Blissful One to whom the movement of the Gods ascends, manifest as at once the Make and the Female, *vṛṣan, dhenu.* Each of the Gods is a manifestation, an aspect, a personality of the one Deva. He can be realised through any of his names and aspects, through Indra, through Agni, through Soma ; for each of them being in himself all the Deva and only in his front or aspect to us different from the others contains all the gods in himself.

Vide Mantra.

BRĀHMANA. He who has the divine word and the inspired knowledge it carries with it.

The word certainly does not mean Brahmans by caste or priests by profession ; the four castes are only mentioned in the Rig Veda once, in that profound but late composition, the Purusha Sukta.

BRAHMANASPATI. The creator by the Word ; he calls light and visible cosmos out of the darkness of the inconscient ocean and speeds the formations of conscious being upward to their supreme goal.

Brahmanaspati administers always the seed of the creative word from the profundities of the soul.

Vide Brahman.

BRIHASPATI. The Master of the creative Word. An Angirasa with seven mouths, the seven rays of the illuminative thought and the seven words which express it, of whom the Angirasas are the powers of utterance. It is the complete thought of the Truth, the seven-headed, which wins the fourth or divine world for man by winning for him the complete spiritual wealth, object of the sacrifice.

Vide Brahman.

BULL. Means diffusing, generating, impregnating, the father of abundance, the Bull, the Male ; it is he who fertilises Force of consciousness, Nature, the Cow, and produces and bears in his stream of abundance the worlds.

Four-horned Bull : All this creation has been, as it were, ejected into the subconscient by the four-horned Bull, the divine Purusha whose horns are infinite Existence, Consciousness, Bliss and Truth. In images of an energetic incongruity reminding us of the sublime grotesques and strange figures that have survived from the old mystic and symbolic art of the prehistoric world, Vamadeva describes the Purusha in the figure of a man-bull, whose four horns are the four divine principles, his three feet or three legs the three human principles, mentality, vital dynamism and material substance, his two heads the double consciousness of Soul and Nature, Purusha and Prakriti, his seven hands the seven natural activities corresponding to the seven principles. " Triply bound " — bound in the mind, bound in the life-energies, bound in the body — " the Bull roars aloud ; great is the Divinity that has entered into mortals."

Triple Bull : Indra, lord of the three luminous realms of Svar, the Divine Mind.

BULL AND COW. The Bull is the *puruṣa*, soul or conscious being ; the Cow is the *prakṛti,* the power of consciousness. The creation of the godhead, the Sun, comes by the fertilising of the luminous consciousness by the luminous soul of the Truth-being so that that higher consciousness becomes active, creative and fruitful in man.

CAMASA. Drinking-Bowl of the gods. Tvashtri, the Framer of things, has given man originally only a single bowl, the physical consciousness, the physical body in which to offer the delight of existence to the Gods. The Ribhus, powers of luminous knowledge, take it as renewed and perfected by Tvashtri's later workings and build up in him from the material of the four planes three other bodies, vital, mental and the causal or ideal body.

CANDRA. Means both luminous and blissful ; signifies also

the lunar deity Soma, lord of the delight of immortality pouring into man *ānanda* and *amṛta*.

CENTRAL CONCEPTIONS OF THE VEDA. The conception of a Truth-consciousness supramental and divine, the invocation of the gods as powers of the Truth to raise man out of the falsehoods of the mortal mind, the attainment in and by this Truth of an immortal state of perfect good and felicity and the inner sacrifice and offering of what one has and is by the mortal to the Immortal as the means of the divine consummation.

The central idea of the Vedic Rishis was the transition ot the human soul from a state of death to a state of immortality by the exchange of the Falsehood for the Truth, of divided and limited being for integrality and infinity. Death is the mortal state of Matter with Mind and Life involved in it ; Immortality is a state of infinite Being, Consciousness and Bliss. Man rises beyond the two firmaments, *rodasī*, Heaven and Earth, mind and body, to the infinity of the Truth, Mahas, and to the divine Bliss. This is the 'great passage' discovered by the Ancestors, the ancient Rishis.

To turn thought and word into form and expression of the superconscient Truth which is hidden beyond the division and duality of the mental and physical existence was the central idea of the Vedic discipline and the foundation of its mysteries.

CHANDAS. Rhythm. In the Veda there are passages which treat the poetic measure of the sacred Mantras (*anuṣṭubh, triṣṭubh, jagatī, gāyatri* etc.) as symbolic of the rhythms in which the universal movement of things is cast.

CHARIOT. The chariot symbolises movement of energy.

CITY. *Vide sadma.*

COLOUR. In this ancient symbolism colour is the sign of quality, of character, of temperament.

CONQUESTS. The three great conquests to which the human being aspires, which the Gods are in constant battle with

the Vritras and Panis to give to man are the herds, *gāh*, the
waters, *āpah*, and the Sun or the solar world, *svah*.

gāh, herds, are the illuminations from the higher conscious-
ness which have their origin in the Sun of Light, the Sun of Truth.

svar, the solar world, is the world or plane of immortality
governed by that Light or Truth of the all-illumining Sun, called
in the Veda the vast Truth and the true Light.

āpah, the waters, are the floods of this higher consciousness
pouring on the mortal mind from that plane of immortality.

COW AND HORSE. Cow is the symbol of consciousness in
the form of knowledge ; the Horse is the symbol of conscious-
ness in the form of force.

They represent the two companion ideas of Light and Energy,
Consciousness and Force, which to the Vedic and Vedantic mind
were the double or twin aspect of all the activities of existence.

DADHIKRAVAN. Agni Dadhikravan is the symbol of the
divine Will, the force of conscious energy, taking possession of
the nervous vitality and revealing itself in it.

The Divine warhorse, a power of Agni ; the mystic Dragon
of the Foundations.

DAKSHA. The discriminating and distributing Thought of
the divine Mind.

Vide Aditi.

DAKSHINĀ. The Goddess of divine discernment.

Dakshina, the discriminative intellect is the energy of *dakṣa,*
master of the works or unerring right discernment.

One of the four goddesses, Ila, Sarasvati, Sarama, Dakshina,
representing the four faculties of the *ṛtam* or Truth-conscious-
ness — Ila representing truth-vision or revelation, Sarasvati
truth-audition, inspiration, the divine word, Sarama intuition,
Dakshina the separative intuitional discrimination.

The discerning knowledge that comes with the dawn and
enables the Power in the mind, Indra, to know aright and
separate the light from the darkness, the truth from the false-
hood, the straight from the crooked.

The right and left hand of Indra are his two powers of action in knowledge ; his two arms correspond to his two perceptive powers, his two bright horses, *harī*. Dakshina presides over the right-hand power, *dakṣiṇa*. It is this discernment which presides over the right action of the sacrifice and the right distribution of the offerings and it is this which enables Indra to hold the herded wealth of the Panis securely, in his right hand.

Power of the Truth-consciousness whose function is to discern rightly, dispose the action and the offering and distribute in the sacrifice to each godhead its portion.

DASHAGVAS. *Vide* Angirasa.

DASYU.

The undivine being who does no sacrifice, amasses a wealth he cannot rightly use because he cannot speak the word or mentalise the superconscient Truth, hates the Word, the gods and the sacrifice and gives nothing of himself to the higher existences but robs and withholds his wealth from the Aryan. He is the thief, the enemy, the wolf, the devourer, the divider, the obstructor, the confiner.

The Dasyus are powers of darkness and ignorance who oppose the seeker of truth and immortality.

Robbers or destroyers, powers of darkness, adversaries of the seekers of Light and the Truth.

Dividers who hack and cut up the growth and unity of the soul and seek to assail and destroy its divine strength, joy and knowledge. They are powers of Darkness, the sons of Danu or Diti the divided being.

Haters of the sacred word ; they are those who give not to the gods the gift or the holy wine, who keep their wealth of cows and horses and other treasure for themselves and do not give them to the seers ; they are those who do not the sacrifice.

There are two great divisions of the Dasyus, the *Paṇis* who intercept both the cows and the waters but are especially associated with the refusal of the cows, the *Vritras* who intercept the waters and the light, but are especially associated with the withholding of the waters ; all Dasyus without exception stand in the way of the ascent to Svar and oppose the acquisition of the wealth by the Aryan seers.

Home of the Dasyus : The world of falsehood beyond the bound of things. It is the darkness without knowledge. This darkness, this lower world of Night and the Inconscient in the formed existence of things symbolised in the image of the mountain which rises from the bowels of earth to the back of heaven, is represented by the secret cave at the base of the hill, the cave of the darkness.

DAWN. The illumination of the Truth rising upon the mentality to bring the day of full consciousness into the darkness or half-lit night of our being.

The goddess symbolic of new openings of divine illumination on man's physical consciousness. She alternates with her sister Night ; but that darkness itself is a mother of light and always Dawn comes to reveal what the black-browed Mother has prepared.

Dawn comes as a bringer of the Truth, is herself the out-shining of the Truth. She is the divine Dawn and the physical dawning is only her shadow and symbol in the material universe.

The daughter of Heaven, the face or power of Aditi, is the constant opening out of the divine light upon the human being ; she is the coming of the spiritual riches, a light, a power, a new birth, the pouring out of the golden treasure of heaven into his earthly existence.

Dawn and Aditi : The divine Dawn is the force or face of Aditi ; she is the mother of the gods ; she gives them birth into our humanity in their true forms no longer compressed into our littleness and veiled to our vision.

Dawn and Night : Dawn daughter of Heaven and Night her sister are obverse and reverse sides of the same eternal Infinite.

Always Night holds hidden in her bosom her luminous sister ; this life of our ignorance taught by the gods in their veiled human working prepares the birth of the divine Dawn so that, sped forth, she may manifest the supreme creation of the luminous Creator.

There is a constant rhythm and alternation of night and dawn, illuminations of the Light and periods of exile from it, openings up of our darkness and its settling upon us once more, till the celestial Birth is accomplished. Night and Dawn are of different

forms but one mind and suckle alternately the same luminous Child.

One is the bright Mother of the herds, the other the dark Cow, the black Infinite, who can yet be made to yield us the shining milk of heaven.

Triple Dawn : The dawn of the three luminous realms of Svar, the Divine Mind, on the human mentality.

Vide Usha.

DAY AND NIGHT. Day is the state of illumined Knowledge that belongs to the divine Mind of which our mentality is a pale and dulled reflection ; Night the state of Ignorance that belongs to our material Nature.

Symbols of the alternation of the divine and human consciousness in us. The Night of our ordinary consciousness holds and prepares all that the Dawn brings out into conscious being.

DESERT. The material existence not watered by the streams or rivers which descend from the superconscient Bliss and Truth.

DEVA. The Devas are those who play in light, their proper home is in the *vijnānam, maharloka, kāraṇa jagat,* where matter is *jyotirmaya* and all things luminous, by their own inherent lustre and where life is an ordered *lilā* or play.

Vide Gods.

DEVATĀTI. Self-extension of the Divine, of the Godhead ; *devavīti* : manifestation of the Divine, of the Godhead.

DHĀMA. Status ; the placing of the Law (*dharma*) in a founded harmony which creates for us our plane of living and the character of our consciousness, action and thought.

DHARMA. The law ; what holds things together and to which we hold.

DHI. Thought or intellect. *dhi* differs from the more general world, *mati,* which means mentality or mental action generally

and which indicates sometimes thought, sometimes feeling, some-
times the whole mental state. *dhi* is the thought-mind or
intellect ; as understanding it holds all that comes to it, defines
everything and puts it into the right place (root *dhi* means to
hold or to place), or often *dhi* indicates the activity of the
intellect, particular thought or thoughts.

DIRGHATAMAS. A Rishi with a deep and mystic
style.

DITI (or DANU). The division, the separative conscious-
ness, the mother of the Titans.

DOORS. The opening doors of our divine home are the
doors of the felicity, *rāyo duraḥ,* the divine doors which swing
wide open to those who increase the Truth.

DRAṢṬĀ. Seer.

DṚṢṬI. Revelatory knowledge.

DURITAM AND *SUVITAM.* *duritam* means literally
stumbling or wrong doing, figuratively all that is wrong and evil,
all sin, error, calamity ; *suvitam* means literally right or good
going and expresses all that is good and happy, it means
especially the felicity that comes by following the right
path.
Vide suvitam.

DVIPADA AND *CATUṢPADA.* Literally, two-footed and
four-footed, but *pad* also means the step, the principle on which
the soul founds itself. The esoteric meaning is four-principled,
those who dwell in the four-fold principle of the lower world,
and two-principled, those who dwell in the double principle of
the divine and the human.

DVITA. The god or Rishi of the second plane of the human
ascent. It is that of the Life-force, the plane of fulfilled force,
desire, free range of the vital powers which are no longer limited
by the strict limitations of this mould of Matter.

EARTH. In the ancient Vedic formula Earth, type of the more solid states of substance, was accepted as the symbolic name of the material principle.

Earth (the material principle) is spoken of as the foundation of all the worlds or the seven worlds are described as the seven planes of Earth.

Earth is the image of the material being ; material being, delight, action, etc. are the *growths of the Earth ;* therefore their image is the forests, the trees, plants, all vegetation.

Three Earths : Vide trīṇi rocanāni.

ENEMY. The hostile powers who try to break up the unity and completeness of our being and from whom the riches which rightly belong to us have to be rescued, not human enemies.

EPITHETS. In the Veda there are no merely ornamental epithets. Every word is meant to tell, to add something to the sense and bear a strict relation to the thought of the sentence in which it occurs.

FATHER. The Father of all things is the Lord and Male ; he is hidden in the secret source of things, in the super-conscient.

Mother and Father : Always either Nature and the Soul or the material being and the pure mental being.

FATHERS. In the Veda the Fathers are the ancient illu-mined ones, who discovered the Knowledge, created and followed the Path, reached the Truth, conquered Immortality.

Ancient Rishis who discovered the Way of the Vedic mystics and are supposed to be still spiritually present presiding over the destinies of the race, and, like the gods, working in man for his attainment to Immortality.

FEMALE ENERGIES. The Deva is both Male and Female and the gods also are either activising souls or passively executive and methodising energies.

FIELD. *Vide* House.

3

FIRE SACRIFICIAL. The importance of the sacrificial fire in the outward ritual corresponds to the importance of the inward force of unified Light and Power in the inward rite by which there is communication and interchange between the mortal and the Immortal.

FIRST LAWS. Fixed by the Self-knowledge of the Super-mind in the very birth of the form, at the very starting-point of the force. The gods act according to the first laws, original and therefore supreme, which are the law of the truth of things.

FLAME. The Vedic symbol for the Force of the divine consciousness, of the supramental Truth.

FOUNDATION ABOVE. All created forms have their base in the Infinite above Mind, Life and Matter and are here repre-sented, reconstructed — very usually misconstructed — from the infinitesimal. Their foundation is above, their branchings down-ward, says the Rig Veda.

FRUITS OF THE SACRIFICE. The material objects were symbols of the immaterial ; the cows were the radiances or illuminations of a divine Dawn, the horses and chariots were symbols of force and movement, gold was light, the shining wealth of a divine Sun — the true light, *ṛtam jyotiḥ* ; both the wealth acquired by the sacrifice and the sacrifice itself in all their details symbolised man's effort and his means towards a greater end, the acquisition of immortality.

GAYATRI. In the *gāyatri*, the chosen formula of the ancient Vedic religion, the supreme light of the godhead Surya Savitri is invoked as the object of our desire, the deity who shall give his luminous impulsion to all our thoughts.
The power of Gayatri is the Light of the divine Truth. It is a mantra of Knowledge.

GANĀH. Hosts or companies, divine powers, at once priests, seers and patrons of the inner sacrifice, winners and givers of the celestial wealth.

GHṚTA. Clarified butter, yield of the Cow of Light and symbol of the rich clarity that comes to the mind visited by the Light.

The shining yield of the shining cow ; it is the formed light of conscious knowledge in the mentality.

The clarity or brightness of the solar light in the human mentality.

GNĀ. Goddess. Goddess Energy. Power.

GO. The word *go* means in Sanskrit both a cow and a ray of light. This double sense is used by the Vedic symbolists to suggest a double figure which was to them more than a figure ; for light, in their view, is not merely an apt poetic image of thought, but is actually its physical form.

GODS. Represent universal powers descended from the Truth-consciousness which build up the harmony of the worlds and in man his progressive perfection.

The Vedic deities are names, powers, personalities of the universal Godhead and they represent each some essential puissance of the Divine Being. They manifest the cosmos and are manifest in it. Children of Light, Sons of the Infinite, they recognise in the soul of man their brother and ally and desire to help and increase him by themselves increasing in him so as to possess his world with their light, strength and beauty. The Gods call man to a divine companionship and alliance ; they attract and uplift him to their luminous fraternity, invite his aid and offer theirs against the Sons of Darkness and Division. Man in return calls the Gods to his sacrifice, offers to them his swiftnesses, and his strengths, his clarities and his sweetnesses, — milk and butter of the shining Cow, distilled juices of the Plant of Joy, the Horse of the Sacrifice, the cake and the wine, the grain for the God-Mind's radiant coursers. He receives them into his being and their gifts into his life, increases them by the hymn and the wine and forms perfectly — as a smith forges iron, says the Veda — their great and luminous godheads.

The powers of Light, the children of Infinity, forms and personalities of the one Godhead who by their help and by their

growth and human workings in man raise him to the truth and the immortality.

There are in the Veda different formulations of the nature of the Gods : it is said they are all once Existence to which the sages give different names ; yet each God is worshipped as if he by himself is that Existence, one who is all the other Gods together or contains them in his being ; and yet again each is a separate Deity acting sometimes in unison with companion deities, sometimes separately, sometimes even in apparent opposition to other Godheads of the same Existence.

Each god contains in himself all the others, but remains still himself in his peculiar function.

In essence the gods are one existence which the sages call by different names ; but in their action founded in and proceeding from the large Truth and Right Agni or another is said to be all the other gods, he is the One that becomes all ; at the same time he is said to contain all the gods in himself as the nave of a wheel contains the spokes, he is the One that contains all ; and yet as Agni he is described as a separate deity, one who helps all the others, exceeds them in force and knowledge, yet is inferior to them in cosmic position and is employed by them as messenger, a priest and worker, — the creator of the world and father, he is yet the son born of our works, he is, that is to say, the original and the manifest indwelling Self or Divine, the One that inhabits all.

Gods and Dasyus : The Gods are born from Aditi in the Supreme Truth of things, the Dasyus or Danavas from Diti in the nether darkness ; they are the Lords of Light and the Lords of Night fronting each other across the triple world of earth, heaven and mid-air, body, mind and the connecting breath of life.

Double action of the Gods : Divine and pre-existent in themselves, they are human in their working upon the mortal plane when they grow in man to the great ascension.

Double birth of the Gods : The sons of the Infinite have a twofold birth. They are born above in the divine Truth as creators of the world and guardians of the divine Law ; they are born also here in the world itself and in man as cosmic and human powers of the Divine.

Gods in man : In himself the gods are conscious psychological powers. Without them the soul of man cannot distinguish

its right nor its left, what is in front of it nor what is behind, the things of foolishness or the things of wisdom ; only if led by them can it reach and enjoy ' the fearless Light '. For this reason Dawn is addressed ' O thou who art human and divine ', and the gods constantly described as the ' Men ' or human powers (*mānuṣaḥ, naraḥ*). They conduct the sacrifice in their human capacity (*manuṣvat*) as well as receive it in their high divine being.

Importance of the Gods not proportionate to the hymns devoted to them : The importance of the Gods has not to be measured by the number of hymns devoted to them or by the extent to which they are invoked in the thoughts of the Rishis, but by the functions which they perform. Agni and Indra to whom the majority of the Vedic hymns are addressed, are not greater than Vishnu and Rudra, but the functions which they fulfil in the internal and external world were the most active, dominant and directly effective for the psychological discipline of the ancient Mystics ; this alone is the reason of their predominance. The Maruts, children of Rudra, are not divinities superior to their fierce and mighty Father ; but they have many hymns addressed to them and are far more constantly mentioned in connection with other gods, because the function they fulfilled was of a constant and immediate importance in the Vedic discipline. On the other hand, Vishnu, Rudra, Brahmanaspati, the Vedic originals of the Puranic Triad, Vishnu-Shiva-Brahma, provide the conditions of the Vedic work and assist it from behind the more present and active gods, but are less close to it and in appearance less continually concerned in its daily movements.

GOLD. *hiraṇya*, gold is the concrete symbol of the higher light, the gold of the Truth.

The symbolic colour of the light of Surya.

GOTAMA. Full of light ; most full of light ; entirely possessed of light.

GRADATION OF WORLDS. Since all creation is a formation of the Spirit, every external system of worlds must in each of its planes be in material correspondence with some power or rising degree of consciousness of which it is the objective symbol and must house a kindred internal order of things. To

understand the Veda we must seize this Vedic parallelism and
distinguish the cosmic gradations to which it leads.

The three highest worlds are classed together as the triple
divine Principles, — for they dwell always together in a Trinity ;
infinity is their scope, bliss is their foundation. They are
supported by the vast regions of the Truth whence a divine
Light radiates out towards our mentality in the three heavenly
luminous worlds of Svar, the domain of Indra. Below is ranked
the triple system in which we live.

We have the same cosmic gradations as in the Puranas but
they are differently grouped, — seven worlds in principle, five
in practice, three in their general groupings :

1. The Supreme Sat-Chit-Ananda The Triple divine worlds.

2. The Link-World The Truth, Right, Vast,
 Supermind. manifested in Svar, with
 its three luminous heavens.

3. The triple lower world Heaven (Dyaus, the three
 Pure Mind heavens))

 Life-force The Mid-Region
 (Antariksha)

 Matter Earth (the three earths)

And as each principle can be modified by the subordinate
manifestation of the others within, each world is divisible into
several provinces according to different arrangements and self-
orderings of its creative light of consciousness.

HARĪ. The two shining horses of Indra ; the sun's two
powers of perception or of vision in knowledge.

Yoked by speech to their movements, yoked by the Word
and fashioned by the mind. The free movement of the luminous
mind, the divine mind in man, is the condition of all other
immortalising works.

Vide Horses of the Gods.

HAVYA. Oblation (*havya*) signifies always action (*karma*) and each action or mind or body is regarded as a giving of our plenty into the cosmic being and cosmic intention.

HEAVEN AND EARTH. Our Father and our Mother, Parents of the Gods, who sustain respectively the purely mental and psychic and the physical consciousness. Their large and free scope is the condition of our achievement.

HERDS. Trooping Rays of the divine Sun, herds of the luminous Consciousness.

HERO. The heroes are the mental and moral energies which resist the assaults of ignorance, division, evil and falsehood.

HILL (or ROCK). A symbol of formal existence and especially of the physical nature.
Our conscious existence is a hill (*adri*) with many successive levels and elevations, *sānūni* ; the cave of the subconscient is below ; we climb upwards towards the godhead of the Truth and Bliss where are the seats of Immortality.

HOME OF MAN. The higher divine world of his existence which is being formed by the gods in his being through the sacrifice. This home is the complete Beatitude into which all human desires and enjoyings have to be transformed and lose themselves.

HORSE. Symbol of Force, especially of vital force. It is variously the *arvat* or war-steed in the battle and the *vājin*, the steed of the journey which brings us in the plenty of our spiritual wealth.
Figure of the nervous forces that support and carry forward all our action.

HORSE-SACRIFICE. The offering of the Life-Power with all its impulses, desires, enjoyments to the divine existence.

HORSES OF THE GODS. The steeds of Indra, of Vayu, of Surya have each their appropriate name. Indra's horses are

harī or *babhru* red gold or twany yellow ; Surya's *harit*, indicating a more deep, full and intense luminousness ; Vayu's are *niyut*, steeds of the yoking, for they represent those dynamic movements which yoke the energy to its action.

HOTṚ. He who calls and brings the gods and gives to them the offering.

HOUSE. The house in the Veda is a constant image for the bodies that are dwelling-places of the soul, just as the field or habitation means the planes to which it mounts and in which it rests.

HṚDYA SAMUDRA. The ocean heart in things. Indeterminate totality, general, obscure and formless which we call the subconscient.

HUMAN SOUL. The soul is a battlefield full of helpers and hurters, friends and enemies. All this lives, teems, is personal, is conscious, is active. We create for ourselves by the sacrifice and by the word shining seers, heroes to fight for us, children of our works. The Rishis and the Gods find for us our luminous herds ; the Ribhus fashion by the mind the chariots of the gods and their horses and their shining weapons. Our life is a horse that neighing and galloping bears us onward and upward ; its forces are swift-hooved steeds, the liberated powers of the mind are wide-winging birds ; this mental being or this soul is the upsoaring Swan or the Falcon that breaks out from a hundred iron walls and wrests from the jealous guardians of felicity the wine of the Soma. Every shining godward Thought that arises from the secret abysses of the heart is a priest and a creator and chants a divine hymn of luminous realisation and puissant fulfilment. We seek for the shining gold of the Truth ; we lust after a heavenly treasure.

The soul of man is a world full of beings, a kingdom in which armies clash to help or hinder a supreme conquest, a house where the gods are our guests and which the demons strive to possess ; the fulness of its energies and wideness of its being make a seat of sacrifice spread, arranged and purified for a celestial session.

HYMN. The hymn was to the Rishi who composed it a means of spiritual progress for himself and for others. It rose out of his soul, it became a power of his mind, it was the vehicle of his self-expression in some important or even critical moment of his life's inner history. It helped him to express the god in him, to destroy the devourer, the expresser of evil; it became a weapon in the hands of the Aryan striver after perfection.

IDEAL. The Vedic ideal is the inclusion of all life and all joy, divine and human, the wideness and plenty of earth and the vastness and abundance of heaven, the treasure of the mental, vital, physical existence uplifted, purified, perfected in the form of the infinite and divine Truth.

ILĀ. The strong primal word of the Truth who gives us its active vision.
The Highest Word, premier energy of the Truth-consciousness, she who is the direct revealing vision in knowledge and becomes in that knowledge the spontaneous self-attainment of the Truth of things in action, result and experience.

IMMORTALITY. The Vedic immortality is a vast beatitude, a large enjoyment of the divine and infinite existence reposing on a perfect union between the Soul and Nature.

INCARNATION. In the Veda there is no idea or experience of a personal emanation or incarnation of any of the Vedic gods. When the Rishis speak of Indra or Agni or Soma in men, they are speaking of the god in his cosmic presence, power or function. This is evident from the very language when they speak of Agni as the immortal in mortals, the immortal Light in men, the inner Warrior, the Guest in human beings. It is the same with Indra or Soma. The building of the gods in man means a creation of the divine Powers, — Indra the Power of the Light, Soma the Power of the Ananda — in the human nature.

INDRA. Ruler of our being, Master of Svar which is the luminous world of the Divine Mind.

The power of pure Existence self-manifested as the Divine Mind. He comes down into our world as the Hero with the shining horses and slays darkness and division with his lightnings, pours down the life-giving heavenly waters, finds in the trace of the hound, Intuition, the lost or hidden illuminations, makes the Sun of Truth mount high in the heaven of our mentality.

INDRA AND AGNI. Indra with his shining hosts, the Maruts, Agni, the divine force, fulfiller of the Aryan sacrifice, are the most important deities of the Vedic system. Agni is the beginning and the end. This Will that is knowledge is the initiator of the upward effort of the mortal towards Immortality ; to this divine consciousness that is one with divine power we arrive as the foundation of immortal existence. Indra, lord of Svar, the luminous intelligence into which we have to convert our obscure material mentality in order to become capable of the divine consciousness, is our chief helper. It is by the aid of Indra and the Maruts that the conversion is effected. The Maruts take our animal consciousness made up of the impulses of the nervous mentality, possess these impulses with their illuminations and drive them up the hill of being towards the world of Svar and the truths of Indra. Our mental evolution begins with these animal troops, these *paśus* ; they become as we progress in the ascension, the brilliant herds of the Sun, *gāvaḥ*, rays, the divine cows of the Veda.

JĀTAVEDAS. Divine Will which has right knowledge of all births. It knows them in the law of their being, in their relation to other births, in their aim and method, in their process and goal, in their unity with all and their difference from all.
Vide Agni.

KAVI. Poet seer who saw and found the inspired word of his vision. Seer and revealer of truth.
A mind visited by some highest light and its forms of idea and word, a seer and hearer of the Truth, *kavayaḥ satyaśrutaḥ.*
Vide Poet.

KAVIKRATUH. He whose active will or power of effectivity is that of the seer, — works, that is to say, with the knowledge which comes by the Truth-consciousness and in which there is no misapplication or error.

KETU. Ray of perception or intuition.
Perception, a perceptive vision in the mental consciousness, a faculty of knowledge.

KNOWLEDGE. For the individual to arrive at the divine universality and supreme infinity, live in it, possesses it, to be, know, feel and express that alone in all his being, consciousness, energy, delight of being is what the ancient seers of the Veda meant by the Knowledge ; that was the Immortality which they set before man as his divine culmination.

KNOWLEDGE AND IGNORANCE. The distinction between the Knowledge and the Ignorance begins with the hymns of the Rig Veda. Here knowledge appears to signify a consciousness of the Truth, the Right, *satyam ṛtam*, and of all that is of the order of the Truth and Right ; ignorance is an unconsciousness, *acitti*, of the Truth and Right, an opposition to its workings and a creation of false or adverse workings. Ignorance is the absence of the divine eye of perception which gives us the sight of the supramental Truth ; it is the non-perceiving principle of our consciousness as opposed to the truth-perceiving conscious vision and knowledge, (*acitti* and *citti*). In its actual operation this non-perceiving is not an entire inconscience, the inconscient sea from which this world has arisen, but either a limited or a false knowledge, a knowledge based on the division of undivided being, founded upon the fragmentary, the little, opposed to the opulent, vast and luminous completeness of things ; it is a cognition which by the opportunity of its limitations is turned into falsehood and supported in that aspect by the Sons of Darkness and Division, enemies of the divine endeavour in man, the assailants, robbers, coverers of his light of knowledge. It was therefore regarded as an undivine Maya, (*adevī māyā*), that which creates false mental forms and appearances, and hence the later significance of this word which seems to have meant originally a formative power of knowledge, the true magic of

the supreme Mage, the divine Magician, but was also used for
the adverse formative power of a lower knowledge, the deceit,
illusion and deluding magic of the Rakshasa. The divine Maya
is the knowledge of the Truth of things, its essence, law, opera-
tion, which the gods possess and on which they found their own
eternal action and creation (*devānām adabdha-vratāni*) and
their building of their powers in the human being. This idea
of the Vedic mystics can in a more metaphysical thought and
language be translated into the conception that the Ignorance is
in its origin a dividing mental knowledge which does not grasp
the unity, essence, self-law of things in their one origin and in
their universality, but works rather upon divided particulars,
separate phenomena, partial relations, as if they were the truth
we had to seize or as if they could really be understood at all
without going back behind the division to the unity, behind the
dispersion to the universality. The Knowledge is that which
tends towards unification, and, attaining to the supramental
faculty, seizes the oneness, the essence, the self-law of existence
and views and deals with the multiplicity of things out of that
light and plenitude, in some sort as does the Divine Himself from
the highest height whence He embraces the world. It must be
noted, however that the Ignorance in this conception of it is still
a kind of knowledge, but, because it is limited, it is open at any
point to the intrusion of falsehood and error ; it turns into a
wrong conception of things which stands in opposition to the
true Knowledge.

KRATU. Means sometimes the action itself, sometimes
the effective power behind action represented in mental cons-
ciousness by the will. Agni is this power. He is the
divine force which manifests first in matter as heat and
light and material energy and then, taking different forms
in the other principles of man's consciousness, leads him
by a progressive manifestation upwards to the Truth and
the Bliss.

Intelligence, power or resolution and especially the power of
the intelligence that determines the work, the will.

KUMĀRA. Agni, the Kumara, prototype of the Puranic
Skanda, is on earth the child of the force of Rudra.

KUTSA. He who constantly seeks the seer-knowledge.

Kutsa and Indra : Image of the human soul and the divine riding in one chariot through a great battle to the goal of a high-aspiring effort. The Divine is Indra, the Master of the World of Light and Immortality, the power of divine knowledge which descends to the aid of the human seeker battling with the sons of falsehood, darkness, limitation, mortality ; the battle is with spiritual enemies who bar the way to the higher world of our being ; and the goal is that plane of vast being resplendent with the light of the supreme Truth and uplifted to the conscious immortality of the perfected soul, of which Indra is the master. The human soul is Kutsa, he who constantly seeks the seer-knowledge, as the name implies, and he is the son of Arjuna or Arjuni, the White One, child of *Svitra* the White Mother ; he is, that is to say, the sattvic or purified and light-filled knowledge. And when the chariot reaches the end of its journey, the own home of Indra, the human Kutsa has grown into such an exact likeness of his divine companion that he can only be distinguished by Sachi, the wife of Indra, because she is " truth-conscious ".

The parable is evidently of the inner life of man ; it is a figure of the human growing into the likeness of the eternal divine by the increasing illumination of Knowledge.

LADLE. The constantly lifted movement of man's aspiration towards the Truth and the Godhead.

LIGHT. A symbol of knowledge, of spiritual illumination. Surya is the Lord of the supreme Sight, the vast Light, *brhat jyotih,* or, as it is sometimes called, the true Light, *rtam jyotih.*

In the Veda the recovery of the Light is first effected by the Angirasa, the seven sages, the ancient human fathers and is then constantly repeated in human experience by their agency.

LOVE AND DELIGHT. The Vedic seers looked at Love from above, from its source and root and saw it and received it in their humanity as an outflowing of the divine Delight. The Taittiriya Upanishad expounding this spiritual and cosmic bliss of the godhead, Vedantic Ananda, Vedic Mayas, says of it, " Love is its head ". But the word it chooses Love, *priyam,*

means properly the delightfulness of the objects of the soul's inner pleasure and satisfaction. The Vedic singers used the same psychology. They couple *mayas* and *prayas,* — *mayas,* the principle of inner felicity independent of all objects, *prayas,* its outflowing as the delight and pleasure of the soul in objects and beings. The Vedic happiness is this divine felicity which brings with it the boon of a pure possession and sinless pleasure in all things founded upon the unfailing touch of the Truth and Right in the freedom of a large universality.

MAHI (or BHARATI). The vast Word that brings us all things out of the divine source.

The luminous vastness of the Truth ; she represents the Largeness, *bṛhat,* of the superconscient in us containing in itself the Truth, *ṛtam.*

MAN. Man, according to Vedic psychology, consists of seven principles, in which the Atman cases itself, — *annam,* gross matter ; *prāṇa,* vital energy ; *manas,* intelligent mind : *vijñānam,* ideal mind ; *ānanda,* pure or essential bliss ; *cit,* pure or essential awareness ; *sat,* pure or essential being. In the present stage of our evolution ordinary humanity has developed *annam, prāṇa* and *manas* for habitual use ; and well-developed men are able to use with power the *vijñānam* acting not in its own habitation (*sve dame*), nor in its own *rūpa,* but *vijñānam* in the mind and as reasoning faculty, *buddhi* ; extraordinary men are able to aid the action of *manas* and *buddhi* proper by the *vijñānam* acting in the intelligent mind indeed and so out of its proper sphere, but in its own form as ideal consciousness — the combination of *mānasic,* and *vijñānic* action making what is called genius, *pratibhānam,* a reflection or luminous response in the mind to higher ideation ; the Yogin goes beyond to the *vijñānam* itself or, if he is one of the greatest Rishis, like Yajnavalkya, to the *ānanda.* None in ordinary times go beyond the *ānanda* in the waking state, for the *cit* and *sat* are only attainable in *suṣupti,* because only the first five sheaths or *pancakoṣa* are yet sufficiently developed to be visible except to the men of the Satya Yuga and even by them the two others are not perfectly seen. From the *vijñānam* to the *annam* is the *aparārdha* or lower part of Exist-

ence where Vidya is dominated by Avidya ; from the *ānanda* to the Sat is the *parārdha* or higher half in which Avidya is dominated by Vidya and there is no ignorance, pain or limitation.

In man as he is at present developed, the intelligent mind is the most important psychological faculty and it is with a view to the development of the intelligent mind to its highest purity and capacity that the hymns of the Veda are written. In this mind there are successively the following principles : *sūksma annam,* refinement of the gross *annam* out of which the physical part of the *manahkosa* or *sūksma deha* is made ; *sūksma prāna,* the vital energy in the mind which acts in the *nādis* or nervous system of the *sūksma deha* and which is the agent of desire ; *citta* or receptive consciousness, which receives all the impressions from without and within by *tāmasic* reaction, but, being *tāmasic,* does not make them evident to the *sāttvic* consciousness or intelligent awareness which we call knowledge, so that we remember with the *citta* everything noticed or unnoticed, but that knowledge is useless for our life owing to its lying enveloped in *tamas* ; *hrt* or the *rājasic* reaction to impressions which we call feeling or emotion, or, when it is habitual, character ; *manas* or active definite sensational consciousness rendering impressions of all kinds into percept or concept by a *sāttvic* reaction called intelligence or thought which men share with the animals ; *buddhi* or rational, imaginative and intellectually memoric faculty, observing, retaining, comparing, reasoning, comprehending, combining and creating, the amalgam of which functions we call intellect ; *mānasa ānanda,* or the pure bliss of existence manifesting through the impure mind, body and *prāna* impurely, i.e. mixed with pain of various kinds, but in itself pure, because disinterested, *ahaituka ; mānasa tapas,* or the pure will-power acting towards knowledge, feeling and deed, impurely through the impure mind, body and *prāna,* i.e. mixed with weakness, dull inertia and ignorance or error, but in itself pure because *ahaituka,* disinterested, without any ulterior purpose or preference that can interfere with truth of thought, act and emotion ; *ahaituka sat* or pure realisation of existence, operating through the impure organs as *ahankāra* and *bheda,* egoism and limitation, but in itself pure and aware of unity in difference, because disinterested, not attached to any particular form or name in manifestation and finally, Atman or Self seated in mind. This Atman

is Sat and Asat, positive and negative, Sat Brahma and Sunyam Brahma ; both positive and negative are contained in the *Sah* or Vasudeva and *Tat* or *Parabrahman,* and *Sah* and *Tat* are both the same. The Buddhi again divided into understanding (*medhā*), which merely uses the knowledge given by sensation and like, *manas, citta, hrt* and *prāna* is *ādhīna, anīśa,* subject to sensation ; reason or *buddhi* proper (*smrti* or *dhi,* also called *prajnā*), which is superior to sensation and contradicts it in the divided light of a higher knowledge ; and direct *jnānam, satyam* or *sattvam* which is itself that light of higher knowledge. All these faculties have their own *devatās,* one or many, each with his *ganas* or subordinate ministers. The *jīva* or spirit using these faculties is called the *hansa,* he who flies or evolves upward ; when he leaves the lower and rises to the *saccidānanda* in the mind, using *sat cit* and *ananda* only, and reposing in the Sad Atma or in Vasudeva, then he is called the Parabrahma, one who has gone or evolved to the highest in that stage of evolution. This is the fundamental knowledge underlying the Veda.

Chandra is the *devatā* of the *smrti* or *prajnā* ; Surya of the *satyam* ; Indra of the understanding and *manas* ; Vayu of the *sūksma prāna* ; Mitra, Varuna, Aryama and Bhaga are the four masters of the emotional mind or character ; Brihaspati of the *sahaituka cit* or tapas of knowledge ; Brahma of the *sahaituka sat* ; Agni of the *sahaituka* tapas etc.

MAN AND WOMAN. The Indian ideal of the relation between man and woman has always been governed by the symbolism of the relation between the Purusha and Prakriti (in the Veda *nr* and *gna*) the male and female divine Principles in the universe. Even, there is to some degree a practical co-relation between the position of the female sex and this idea. In the earlier Vedic times when the female principle stood on a sort of equality with the male in the symbolic cult, though with a certain preponderance for the latter, woman was as much the mate as the adjunct of man ; in later times when the Prakriti has become subject in idea to the Purusha, the woman also depends entirely on the man, exists only for him and has hardly even a separate existence. In the Tantrik Shakta religion which puts the female principle highest, there is an attempt which

could not get itself translated into social practice, — even as this Tantric cult could never entirely shake off the subjugation of the Vedantic idea, — to elevate woman and make her an object of profound respect and even of worship.

MAN AND THE WORLDS. The human individual is an organised unit of existence which reflects the constitution of the universe. It repeats in itself the same arrangement of states and play of forces. Man, subjectively, contains in himself all the worlds in which, objectively, he is contained. Preferring ordinarily a concrete to an abstract language, the Rishis speak of the physical consciousness as the physical world, earth, Bhu, Prithivi. They describe the pure mental consciousness as heaven, Dyau, of which Svar, the luminous mind, is the summit. To the intermediate dynamic, vital or nervous consciousness they give the name either of Antariksha, the intermediate vision, or of Bhuvar, — multiple dynamic worlds formative of the earth.

For in the idea of the Rishis a world is primarily a formation of consciousness and only secondarily a physical formation of things. A world is a *loka*, a way in which conscious being images itself. And it is the causal Truth, represented in the person of Surya Savitri, that is the creator of all its forms. For it is the causal Idea in the infinite being, — the idea, not abstract, but real and dynamic, — that originates the law, the energies, the formation of things and the working out of their potentialities in determined forms by determined processes. Because the causal Idea is a real force of existence, it is called *satyam*, the True in being ; because it is the determining truth of all activity and formation, it is called *ṛtam*, the True in movement ; because it is broad and infinite in its self-view, in its scope and in its operation, it is called *bṛhat*, the Large or Vast.

Man dwells in the bosom of the Earth-Mother and is aware of this world of mortality only ; but there is a superconscient high beyond where the divine worlds are seated in a luminous secrecy ; there is a subconscient or inconscient below his surface waking impressions and from that pregnant Night the worlds as he sees them are born. And these other worlds between the luminous upper and the tenebrous lower ocean ? They are here. Man draws from the life-world his vital being, from the mind-world his mentality ; he is ever in secret communication with them ;

he can consciously enter into them, be born into them, if he will. Even into the solar worlds of the Truth he can rise, enter the portals of the Superconscient, cross the threshold of the Supreme. The divine doors shall swing open to his increasing soul.

Pure thought and pure psychic state are not the highest height of the human ascension. The home of the Gods is an absolute Truth which lives in solar glories beyond mind. Man ascending thither strives no longer as the thinker but is victoriously the seer ; he is no longer this mental creature but a divine being. His will, life, thought, emotion, sense, act are all transformed into values of an all-puissant Truth and remain no longer an embarrassed or a helpless tangle of mixed truth and falsehood. He moves lamely no more in our narrow and grudging limits but ranges in the unobstructed Vast ; toils and zigzags no longer amid these crookednesses, but follows a swift and conquering straightness ; feeds no longer on broken fragments, but is suckled by the teats of Infinity. Therefore he has to break through and out beyond these firmaments of earth and heaven ; conquering firm possession of the solar worlds, entering on to his highest Height he has to learn to dwell in the triple principle of Immortality.

MANTRA. The theory of the Mantra is that it is a word of power born out of the secret depths of our being where it has been brooded upon by a deeper consciousness than the mental, framed in the heart and not constructed by the intellect, held in the mind, again concentrated on by the waking mental consciousness and then thrown out silently or vocally — the silent word is perhaps held to be more potent than the spoken — precisely for the work of creation. The Mantra can not only create new subjective states in ourselves, alter our psychical being, reveal knowledge and faculties we did not before possess, can not only produce similar results in other minds than that of the user but can produce vibrations in the mental and vital atmosphere which result in effects, in actions and even in the production of material forms on the physical plane.

In the system of the Mystics, which has partially survived in the schools of Indian Yoga, the Word is a power, the Word creates. For all creation is expression, everything exists already in the secret abode of the Infinite, *guhāhitam*, and has only to be brought out here in apparent form by the active conscious-

ness. Certain schools of Vedic thought even suppose the worlds to have been created by the goddess Word and sound as first etheric vibration to have preceded formation. In the Veda itself there are passages which treat the poetic measures of the sacred mantras, — *anuṣṭubh, triṣṭubh, jagati, gāyatri,* — as symbolic of the rhythms in which the universal movement of things is cast.

By expression then we create and men are even said to create the gods in themselves by the mantra. Again, that which we have created in our consciousness by the Word, we can fix there by the Word to become part of ourselves and effective not only in our inner life but upon the outer physical world. By expression we form, by affirmation we establish. As a power of expression the word is termed *gīḥ,* or *vacas* ; as a power of affirmation, *stoma.* In either aspect it is named *manma* or *mantra,* expression of thought in mind, and *brahman,* expression of the heart or the soul, — for this seems to have been the earlier sense of the word *brahman,* afterwards applied to the Supreme Soul or universal Being.

The process of formation : Fashioned by the heart, it receives its just place in the mentality through confirmation by the mind. The mantra, though it expresses thoughts in mind, is not in its essential part a creation of the intellect. To be the sacred and effective word, it must have come as an inspiration from the supra-mental plane, termed in Veda, *ṛtam,* the Truth, and have been received into the superficial consciousness either through the heart or by the luminous intelligence, *manīṣā.* The heart in Vedic psychology is not restricted to the seat of the emotions ; it included all that large tract of spontaneous mentality, nearest to the subconscient in us, out of which rise the sensations, emotions, instincts, impulses and all those intuitions and inspirations that travel through these agencies before they arrive at form in the intelligence. This is the " heart " of Veda and Vedanta, *hṛdaya, hṛd,* or *brahman.* There in the present state of mankind the Purusha is supposed to be seated centrally. Nearer to the vastness of the subconscient, it is there that, in ordinary mankind, — man not yet exalted to a higher plane where the contact with the Infinite is luminous, intimate and direct, — the inspirations of the Universal Soul can most easily enter in and most swiftly take possession of the individual soul. It is therefore by the power of the heart that the mantra takes

form. But it has to be received and held in thought of the intelligence as well as in the perceptions of the heart ; for not till the intelligence has accepted and even brooded upon it, can that truth of thought which the truth of the Word expresses be firmly possessed or normally effective. Fashioned by the heart, it is confirmed by the mind.

What the Vedic poets meant by the mantra was an inspired and revealed seeing and visioned thinking, attended by a realisation of some inmost truth of God and self and man and Nature and cosmos and life and thing and thought and experience and deed. It was a thinking that came on the wings of a great soul rhythm, *chandas*. For the seeing could not be separated from the hearing ; it was one act. Nor could the living of the truth in oneself which we mean by realisation, be separated from either, for the presence of it in the soul and its possession of the mind must precede or accompany in the creator or human channel that expression of the inner sight and hearing which takes the shape of the luminous word.

The mantra is born through the heart and shaped or massed by the thinking mind into a chariot of that godhead of the Eternal of whom the truth seen is a face or a form. And in the mind too of the fit outward hearer who listens to the word of the poet seer, these three must come together, if our word is a real mantra ; the sight of the inmost truth must accompany the hearing, the possession of the inmost spirit of it by the mind and its coming home to the soul must accompany or follow immediately upon the rhythmic message of the Word and the mind's sight of the Truth.

Mantra and Vedic poetry. Poetry is the mantra only when it is the voice of the inmost truth and is couched in the highest power of the very rhythm and speech of that truth. And the ancient poets of the Veda and Upanishads claimed to be uttering the mantra because always it was this inmost and almost occult truth of things which they strove to see and hear and speak and because they believed themselves to be using or finding its innate soul rhythms and the sacrificial speech of it cast up by the divine Agni, the sacred Fire in the heart of man.

MARRIAGE HYMN. *Vide* Symbolic Spirit of the Vedic Age.

MARTĀNDA. There are eight sons of the cosmic Aditi who are born from her body ; by seven she moves to the gods, but the eighth son is *martāṇḍa*, of the mortal creation, whom she casts away from her ; with the seven she moves to the supreme life, the original age of the gods, but Martāṇḍa is brought back out of the Inconscient into which he has been cast to preside over mortal birth and death. This Martāṇḍa or eighth Surya is the black or dark, the lost, the hidden sun. The Titans have taken and concealed him in their cavern of darkness and thence he must be released into splendour and freedom by the gods and seers through the power of the sacrifice.

The mortal life is governed by an oppressed, a hidden, a disguised Truth. Surya the divine Knowledge lies concealed and unattainable in the night and darkness, is enveloped and contained in the ignorance and error of the ordinary human existence. The Seers by the power of truth in their thoughts discover this Sun lying in the darkness, they liberate this knowledge, this power of undivided and all-embracing vision, this eye of the gods concealed in our subconscient being.

MARUTS. Powers of will and nervous or vital Force that have attained to the light of thought and the voice of self-expression. They are behind all thought and speech as its impellers and they battle towards the Light, Truth and Bliss of the supreme Consciousness.

Life-Powers that support by their nervous or vital energies the action of the thought in the attempt of the mortal consciousness to grow or expand itself into the immortality of the Truth and Bliss.

The powers of Thought which by the strong and apparently destructive motion of their progress break down that which is established and help to the attainment of new formations.

MĀTARIŚVAN. Vedic epithet of the God Vayu, who representing the divine principle in the Life-energy, Prana, extends himself in Matter and vivifies its forms.

MĀYĀ. The comprehending, measuring, forming Knowledge which whether divine or undivine, secure in the undivided being of Aditi or labouring in the divided being of Diti, builds up the

whole scene, environment, confines, and defines the whole condi-
tion, law and working of our existence. Māyā is the active,
originative, determinative view which creates for each being
according to his own consciousness his own world.

Maya meant for the Vedic seers the power of infinite
consciousness to comprehend, contain in itself and measure out,
that is to say, to form — for form is delimitation — Name and
Shape out of the vast illimitable Truth of infinite existence. It
is by Maya that static truth of essential being becomes ordered
truth of active being.

There are *two kinds of Māyā*, the divine and undivine, the
formations of the Truth and the formations of the falsehood.

MAYAS. Archaic Vedic word for bliss ; the principle of
inner felicity independent of all objects.

MEDHATITHI KANVA. A Rishi with melodious lucidity.

MITRA. The all-embracing harmony of the Truth, the
Friend of all beings, therefore the Lord of Love.

Lord of Love who introduces the principle of harmony into
the workings of the divine effort in us and thus combines all the
lines of our advance, all the strands of our sacrifice until the
work is accomplished in the supreme unity of Knowledge, Power
and Delight.

Mitra the Happy and the Mighty, most beloved of the Gods,
has his foundation in the all-uniting light of *cit*.

Mitra representing, in creation, light and knowledge, using the
principle of Ananda for creation, is Love maintaining the law
of harmony.

Mitra is the most beloved of the gods ; he binds together by
the fixities of his harmony, by the successive lustrous seats of
Love fulfilling itself in the order of things. His name, *mitra*,
which means also friend, is constantly used with a play upon
the double sense ; it is as Mitra, because Mitra dwells in all,
that the other gods become the friends of man.

His is the principle of harmony by which the manifold work-
ings of the Truth agree together in a perfectly wedded union.
The root of the name means both to embrace and to contain
and hold and, again, to build or form in the sense of linking

together the parts or materials of a whole. Adorable Mitra is born in us as a blissful ordainer of things and a king full of might.

It is when Agni becomes Mitra, when the divine Will realises the divine Love that the Lord and his Spouse agree in their mansion.

MONOTHEISM AND HENOTHEISM IN THE VEDA. It is a marked, an essential feature of the Vedic hymns that, although the Vedic cult was not monotheistic in the modern sense of the word, they continually recognise, sometimes quite openly and simply, sometimes in a complex and difficult fashion, always as an underlying thought, that the many godheads whom they invoke are really one Godhead, — One with many names, revealed in many aspects, approaching man in the mask of many divine personalities. Western scholars, puzzled by this religious attitude which presents no difficulty whatever to the Indian mind, have invented, in order to explain it, a theory of Vedic henotheism. The Rishis, they thought, were polytheists, but to each God at the time of worshipping him they gave pre-eminence and even regarded him as in a way the sole deity. This invention of henotheism is the attempt of an alien mentality to understand and account for the Indian idea of one Divine Existence who manifests Himself in many names and forms, each of which is for the worshipper of that name and form the one and supreme Deity. That idea of the Divine, fundamental to the Puranic religions, was already possessed by our Vedic forefathers.

MOTHER AND FATHER. They are always either Nature and the Soul or the material being and the pure mental being.

MOUNTAIN. The formed existence of things is symbolised in the image of the mountain which rises from the bowels of earth to the back of heaven.

MYSTIC DOCTRINE. The doctrine of the Mystics recognises an Unknowable, Timeless and Unnameable behind and above all things and not seizable by the studious pursuit of the mind. Impersonally, it is That, the One Existence ; to the pursuit of our personality it reveals itself out of the secrecy of things as the God or Deva, — nameless though he has many

names, immeasurable and beyond description, though he holds in himself all description of name and knowledge and all measures of form and substance, force and activity.

The Deva or Godhead is both the original cause and the final result. Divine Existence, builder of the worlds, lord and begetter of all things, Male and Female, Being and Consciousness, Father and Mother of the Worlds and their inhabitants, he is also their Son and ours : for he is the Divine Child born into the Worlds who manifests himself in the growth of the creature. He is Rudra and Vishnu, Prajapati and Hiranyagarbha, Surya, Agni, Indra, Vayu, Soma, Brihaspati, — Varuna and Mitra and Bhaga and Aryaman, all the gods. He is the wise, mighty and liberating Son born from our works and our sacrifice, the Hero in our warfare and Seer of our knowledge, the White Steed in the front of our days who gallops towards the upper Ocean.

The soul of man soars as the Bird, the Hansa, past the shining firmaments of physical and mental consciousness, climbs as the traveller and fighter beyond earth of body and heaven of mind by the ascending path of the Truth to find this Godhead waiting for us, leaning down to us from the secrecy of the highest supreme where it is seated in the triple divine Principle and the source of the Beatitude. The Deva is indeed, whether attracting and exalted there or here helpful to us in the person of the greater Gods, always the Friend and Lover of man, the pastoral Master of the Herds who gives us the sweet milk and the clarified butter from the udder of the shining Cow of the infinitude. He is the source and outpourer of the ambrosial Wine of divine delight and we drink it drawn from the sevenfold water of existence or pressed out from the luminous plant on the hill of being and uplifted by its raptures we become immortal.

Our normal life and consciousness are a dark or at best a starlit Night. Dawn comes by the arising of the Sun of that higher Truth and with Dawn there comes the effective sacrifice. By the sacrifice the Dawn itself and the lost Sun are constantly conquered out of the returning Night and the luminous herds rescued from the darkling cave of the Panis ; by the sacrifice the rain of the abundance of heaven is poured out for us and the sevenfold waters of the higher existence descend impetuously upon our earth because the coils of the obscuring Python, the all-enfolding and all withholding Vritra, have been cloven asunder

by the God-Mind's flashing lightnings ; in the sacrifice the Soma wine is distilled and uplifts us on the stream of its immortalising ecstasy to the highest heavens.

Our sacrifice is the offering of all our gains and works to the powers of the higher existence. The whole world is a dumb and helpless sacrifice in which the soul is bound as a victim self-offered to unseen Gods. The liberating Word must be found, the illuminating hymn must be framed in the heart and mind of man and his life must be turned into a conscious and voluntary offering in which the soul is no longer the victim, but the master of the sacrifice. By right sacrifice and by the all-creative and all-expressive Word that shall arise out of his depths as a sublime hymn to the Gods man can achieve all things. He shall conquer his perfection ; Nature shall come to him as a willing and longing bride ; he shall become her seer and rule her as her King.

By the hymn of prayer and God-attraction, by the hymn of praise and God-affirmation, by the hymn of God-attainment and self-expression man can house in himself the Gods, build in this gated house of his being the living image of their deity, grow into divine births, form within himself vast and luminous worlds for his soul to inhabit. By the word of the Truth the all-engendering Surya creates ; by that rhythm Brahmanaspati evokes the worlds and Twashtri fashions them ; finding the all-puissant Word in his intuitive heart, shaping it in his mind the human thinker, the mortal creature can create in himself all the forms, all the states and conditions he desires and, achieving, can conquer for himself all wealth of being, light, strength and enjoyment. He builds up his integral being and aids his gods to destroy the evil armies ; the hosts of his spiritual enemies are slain who have divided, torn and afflicted his nature.

NAMAS. Literally, bending down ; applied to the act of adoring submission to the deity rendered physically by the prostration of the body. The psychological sense is the inward prostration, the act of submission or surrender to the deity.

Internal and external obeisance is the symbol of submission to the divine Being in ourselves and in the world.

NAMES IN THE VEDA. Everything, their own names, the names of Kings and sacrificers, the ordinary circumstances of their lives were turned, by these ancient Mystics, into symbols and covers for their secret meaning. Just as they used the ambiguity of the word *go*, which means both ray and cow, so as to make the concrete figure of the cow, the chief form of their pastoral wealth, a cover for its hidden sense of the inner light which was the chief element in the spiritual wealth they coveted .from the gods, so also they would use their own names, *gotama* " most full of light ", *gavisthira* " the steadfast in light " to hide a broad and general sense for their thought beneath what seemed a personal claim or desire.

Rishis like Kutsa, Kanva, Ushanas, Kavya have become types and symbols of certain spiritual experiences and victories and placed in that capacity side by side with the gods.

NAMUCHI. Enemy who fights man by his weaknesses.

NĀSATYĀH. From *nas*, to move. Lords of the movement ; leaders of the journey or voyage **(Ashvins).**

NAVAGVAS. *Vide* Angirasa.

NEW CREATION. The new-seeing of all things, the new-moulding of thought, act, feeling, will, consciousness in the terms of the Truth, the Bliss, the Right, the Infinity is a new creation.

NIDAH. Powers of limitation, the Confiners, Restrainers or Censures, who, without altogether obscuring the rays of Light or damming up the energies, yet seek by constantly affirming the deficiencies of our self-expression to limit its field and set up the progress realised as an obstacle to the progress to come.

NIGHT. Symbol of our obscure consciousness full of ignorance in knowledge and of stumblings in will and act, therefore of all evil, sin and suffering.

The great darkness of the Inconscient is the *Vedic Night* which holds the world and all its unrevealed potentialities in her obscure bosom. Night extends her realm over this triple world

of ours and out of her in heaven, in the mental being, Dawn is born who delivers the Sun out of the darkness where it was lying concealed and eclipsed and creates the vision of the supreme Day.

NIGHT AND DAY. In the Veda darkness or night is the symbol of the ignorant mentality, as is the day and its sunlight of the illumined mentality. But before there is the day or the continuous knowledge, the illuminations of Agni are like stars in the nocturnal heavens. Heaven is the mental as Earth is the physical being ; all the truth and knowledge of Agni is there, but hidden only by the darkness of night. Men know that this Light is there pervading the skies but see only the stars which Agni has kindled as his fires of illumination in these heavens.

NṚ. Applicable both to gods and men and does not means simply a man ; it meant originally strong or active and then a male and is applied to the male gods, active divine souls or powers, *puruṣas*, as opposed to female deities, *gnāḥ*, who are their energies. It still preserved in the minds of the Rishis much of its original sense e.g. *nṛmṇa*, strength, *nṛtamā nṛṇām*, strongest of the divine powers.

NUMBERS. Fifty, hundred, a thousand are numbers symbolic of completeness.

NINETY-NINE AND HUNDRED. The constantly recurring numbers ninety-nine, a hundred and a thousand have a symbolic significance in the Veda which it is very difficult to disengage with any precision. The secret is perhaps to be found in the multiplication of the mystic number seven by itself and its double repetition with a unit added before and at the end, making altogether $1 + 49 + 49 + 1 = 100$. Seven is the number of essential principles in manifested Nature, the seven forms of divine consciousness at play in the world. Each, formulated severally, contains the other six in itself ; thus the full number is forty-nine, and to this is added the unit above out of which all develops, giving us altogether a scale of fifty and forming the complete gamut of active consciousness. But there is also its duplication by an ascending and descending series, the descent

of the gods, and the ascent of man. This gives us ninety-nine, the number variously applied in the Veda to horses, cities, rivers, in each case with a separate but kindred symbolism. If we add an obscure unit below into which all descends to the luminous unit above towards which all ascends we have the full scale of one hundred.

OCEAN. Image of infinite and eternal existence.

Ocean and the waters are the symbol of conscient being in its mass and in its movements.

Existence itself is constantly spoken of as an ocean. The Veda speaks of *two oceans*, the upper and the lower waters. These are the oceans of the subconscient, dark and inexpressive, and the ocean of the superconscient, luminous and eternal expression but beyond the human mind.

The superconscient, the sea of the subconscient, the life of the living being between the two, — this is the Vedic idea of existence.

Creation and Ocean : Out of the subconscient ocean the One arises in the heart first as desire ; he moves there in the heart-ocean as an unexpressed desire of the delight of existence and this desire is the first seed of what afterwards appears as the sense-mind. The gods thus find out a means of building up the existent, the conscious being, out of the subconscient darkness ; they find it in the heart and bring it out by the growth of thought and purposeful impulsion, *pratīṣyā*, by which is meant mental desire as distinguished from the first vague desire that arises out of the subconscient in the merely vital movements of nature. The conscious existence which they thus create is stretched out as it were horizontally between two other extensions ; below is the dark sleep of the subconscient, above is the luminous secrecy of the superconscient. These are the upper and the lower ocean.

This Vedic imagery throws a clear light on the similar symbolic images of the Puranas, especially on the famous symbol of *Vishnu sleeping* after the *pralaya* on *the folds of the snake Ananta* upon the *ocean of sweet milk*. *Ananta* means the Infinite. Vishnu, the all-pervading Deity, sleeps in the periods of non-creation on the coils of the Infinite. The ocean must be

the ocean of eternal existence and this ocean of eternal existence
is an ocean of absolute sweetness, in other words of pure Bliss.

PANCA JANĀH (or *KṢITĪH*). Five births for man, five
worlds of creatures. *dyauḥ* and *prithivī* represent the pure mental
and the physical consciousness, between them is *antarikṣa*, the
intermediate or connecting level of the vital or nervous conscious-
ness. *dyauḥ* and *prithivī* are *rodasī*, our two firmaments ; but
these have to be overpassed, for then we find admission to
another heaven than that of the pure mind — to the wide, the
Vast which is the basis, the foundation of the infinite conscious-
ness, Aditi. The Vast is the Truth which supports the supreme
triple world, those highest steps or seats (*padāni, sadānsi*) of
Agni, of Vishnu, those supreme Names of the Mother, the Cow,
Aditi.

To widen is to acquire new birth. The aspiring material
creature becomes the straining vital man ; he in turn transmutes
himself into the subtle mental and physical being ; this subtle
thinker grows into the wide, multiple and cosmic man open on
all sides of him to all the multitudinous inflowings of the Truth ;
the cosmic soul rising in attainment strives as the spiritual man
for a higher peace, joy and harmony. These are the five Aryan
types, each of them a great people occupying its own province
or state of the total human nature. But there is also the absolute
Aryan who would conquer and pass beyond these states to the
transcendental harmony of them all.

PANIS. Powers that preside over those ordinary unillumined
sense activities of life whose immediate root is in the dark sub-
conscient physical being.

A class of Dasyus who are in the Vedic symbolism set in
opposition to the Aryan gods and the Aryan seers and workers.

Pani Dasyus are crooked powers of the falsehood and ignor-
ance who set their false knowledge, their false strength, will and
works against the true knowledge, the true strength, will and
works of the gods and the Aryans.

The Dasyus who withhold or steal the cows are called the
paṇi, a word which seems originally to have meant doers,
dealers or traffickers ; but this significance is sometimes coloured

by its further sense of " misers." Their chief is Vala. The Panis are also represented as concealing the stolen herds (of cows) in a cave of the mountain which is called their concealing prison, *vavra*, or the pen of the cows, *vraja*, or sometimes in a significant phrase, *gavyam ūrvam*, literally the cowey wideness or in the other sense of *go* " the luminous wideness ", the vast wealth of the shining herds.

Always they are powers who receive the coveted wealth but do not use it, preferring to slumber, avoiding the divine action (*vrata*), and they are powers who must perish or be conquered before the wealth can be securely possessed by the sacrificer.

Miser traffickers in the sense-life, stealers and concealers of the higher Light and its illuminations which they can only darken and misuse, — an impious host who are jealous of their store and will not offer sacrifice to the Gods.

Field and action of the Panis : The cave is only the home of the Panis, their field of action is earth and heaven and the mid-world. They are the sons of the Inconscient, but themselves are not precisely inconscient in their action ; they have forms of apparent knowledge, *māyāḥ*, but these are forms of ignorance the truth of which is concealed in the darkness of the inconscient and their surface or front is falsehood, not truth.

Subjugation of the Panis (underlying Idea): The Vedic idea was that the subconscient darkness and the ordinary life of ignorance held concealed in it all that belongs to the divine life and that these secret riches must be recovered first by destroying the impenitent powers of ignorance and then by possessing the lower life subjected to the higher.

PARALLELISM IN THE VEDA. The Rishis arranged the substance of their thought in a system of parallelism by which the same deities were at once internal and external Powers of universal Nature, and they managed its expression through a system of double values by which the same language served for their worship in both aspects. But the psychological sense predominates and is more pervading, close-knit and coherent than the physical.

PARAMĀ PARĀVAT. The supreme of the supraconscient.

PARAMAM VYOMA. The supreme ether. Infinity of the superconscient being.

The highest heavenly space of the supreme superconscient.

PARĀRDHA AND *APARĀRDHA. Vide* Man.

PARISRAVAH. One voice of inspired knowledge. The whole physical and the whole mental consciousness become full of the knowledge which streams into them from the supramental plane.

PARJANYA. Giver of the rain of heaven.

PATH. The path of man is that of his journey to the supreme plane and that which the journeyings of the gods do not violate is the workings of the gods, the divine law of life into which the soul has to grow.

The Sachchidananda consciousness may be at once transcendent and universal ; and to this state of present and all-embracing Bliss the path is surrender and loss of the ego in the universal and possession of an all-pervading equal delight ; it is the path of the ancient Vedic sages.

PERFECTION. Perfection must be attained on all our levels — in the wideness of earth, our physical being and consciousness ; in the full force of vital speed and action and enjoyment and nervous vibration, typified as the Horse which must be brought forward to upbear our endeavour, in the perfect gladness of the heart of emotion and a brilliant heat and clarity of the mind throughout our intellectual and physical being ; in the coming of the supramental Light, the Dawn and the Sun and the shining Mother of the herds, to transform all our existence ; for so comes to us the possession of the Truth, by that Truth the admirable surge of the Bliss, in the Bliss infinite Consciousness of absolute being.

PHYSICAL IMAGERY IN THE VEDA. The forces and processes of the physical world repeat, as in a symbol, the truths of the supraphysical action which produced it. And since it is by the same forces and the same processes, one in the physical worlds and the supra-physical, that our inner life and its develop-

ment are governed, the Rishis adopted the phenomena of physical
Nature as just symbols for those functionings of the inner life
which it was their difficult task to indicate in the concrete lan-
guage of a sacred poetry that must at the same time serve for
the external worship of the Gods as powers of the visible
universe. The solar energy is the physical form of Surya, Lord
of Light and Truth ; it is through the Truth that we arrive at
Immortality, final aim of the Vedic discipline. It is therefore
under the images of the Sun and its rays, of Dawn and day and
night and the life of man between the two poles of light and
darkness that the Aryan seers represent the progressive illumina-
tion of the human soul.

PILGRIM-SACRIFICE. The image of this sacrifice is some-
times that of a journey or voyage ; for it travels, it ascends ; it
has a goal — the vastness, the true existence, the light, the
felicity — and it is called upon to discover and keep the good,
the straight and the happy path to the goal, the arduous, yet
joyful road of the Truth. It has to climb, led by the flaming
strength of the divine Will, from plateau to plateau as of a moun-
tain, it has to cross as in a ship the waters of existence, traverse
its rivers, overcome their deep pits and rapid currents ; its aim
is to arrive at far-off ocean of light and infinity.

POET. To the men of old the poet was a seer, a revealer
of hidden truths, imagination no dancing courtesan but a priestess
in God's house commissioned not to spin fictions but to image
difficult and hidden truths ; even the metaphor or simile in the
Vedic style is used with a serious purpose and expected to con-
vey a reality, not to suggest a pleasing artifice of thought. The
image was to these seers a revelative symbol of the unrevealed
and it was used because it could hint luminously to the mind
what the precise intellectual word could not at all hope to
manifest.

POTR. The purifying priest.

PRABHU. Becoming, coming into existence in front of the
consciousness, at a particular point as a particular object of
experience.

PRACETA. Conscious thinker or knower.

PRAYAS. The soul's satisfaction in its objects.
Vide Love and Delight.

PRIYAM. Love ; the delightfulness of the objects of the soul's inner pleasure and satisfaction.

PR̥ŚNI. Dappled. It is used both for the Bull, the Supreme Male and for the Cow, the Female Energy. Dappled Bull is the Deva in the variety of his manifestation, many-hued.
Some is that first supreme Dappled Bull, generator of the world of becoming ; delight is the parent of the variety of existence.

PUROHITA. He who stands in front as the representative of the sacrificer.

PURUSHA SUKTA. Here the Four Orders of Society are described as having sprung from the body of the creative Deity, from his head, arms, thighs and feet. To us this is merely a poetical image and its sense is that the Brahmins were men of knowledge, the Kshatriyas the men of power, the Vaishyas the producers and support of society, the Shudras its servants.
To the Seers this symbol of the Creator's body was more than an image, it expressed a divine reality. Human society was for them an attempt to express in life the cosmic Purusha who has expressed himself otherwise in the material and the supra-physical universe. Man the cosmos are both of them symbols and expressions of the same hidden Reality.
Here we have the symbolic idea of the four orders expressing the Divine as knowledge in man, the Divine as power, the Divine as production, enjoyment and mutuality, the Divine as service, obedience and work. These divisions answer to four cosmic principles, the Wisdom that conceives the order and principle of things, the Power that sanctions, upholds and enforces it, the Harmony that creates the arrangement of its parts, the Work that carries out what the rest direct.

PUSHAN. The Increaser, a form of the Sun-Power as he manifests himself. The root of this name *pūṣan* means to increase,

5

foster, nourish. The spiritual wealth coveted by the Rishis is one that thus increases ' day by day ', that is, in each return of the fostering Sun. Pushan is the enricher of our sacrifice.

Since the divine work in us cannot be suddenly accomplished, the godhead cannot be created all at once, but only by a luminous development and constant nature through the succession of the dawns, through the periodic revisitings of the illumining Sun.

The luminous *goad* which this resplendent deity bears, is the goad that urges the thoughts of the soul and is the means of accomplishment of the head of the radiant illuminations.

RAIN. The celestial rain is the wealth of the spiritual felicity which the seers desire ; it is the immortality.

RAYI. Internal felicity as well as external happiness.

REPETITION. In the style of the Veda when there is a transition from one movement of thought to another developing out of it, the link of connection is often indicated by the repetition in the new movement of an important word which has already occurred in the close of the movement that precedes. This principle of suggestion by echo pervades the hymns.

RIBHUS. Artisans of Immortality. Human beings who have attained to the condition of godhead by power of knowledge and perfection in their work. Their function is to aid Indra in raising man towards the same state of divine light and bliss which they themselves have earned as their own divine privilege.

Powers of the Light who have descended into Matter and are there born as human faculties aspiring to become divine and immortal.

The names of the three Ribhus are, in the order of their birth, Ribhu or Ribhukshan, the skilful Knower or the Shaper in knowledge, Vibhva or Vibhu, the Pervading, the self-diffusing, and Vāja, the Plenitude.

Ribhu, the eldest is the first in man who begins to shape by his thoughts and works the forms of immortality ; Vibhva gives pervasiveness to this working ; Vāja, the youngest, supplies the

plenitude of the divine light and substance by which the complete work can be done.

Indra's artisans, human powers who by the work of sacrifice and their brilliant ascension to the high dwelling-place of the Sun have attained to immortality and help mankind to repeat their achievement. They shape by the mind Indra's horses, the Ashvins' chariot, the weapons of the Gods, all the means of the journey and the battle.

The works and formations of immortality they effect by the force of Thought, with the mind for field and material ; they are done with power ; they are attended by a perfection in the creative and effective act which is the condition of the working out of Immortality. These formations of the artisans of Immortality are : the horses of Indra, the Car of the Ashvins, the Cow that gives the sweet milk, the youth of the universal Parents, the multiplication into four of the one drinking-bowl of the gods originally fashioned by Twashtri, the Framer of things.

RISHI. One who has lived fully the life of man and found the word of the supra-intellectual, supra-mental, spiritual truth. He has risen above these lower limitations and can view all things from above, but also he is in sympathy with their effort and can view them from within ; he has the complete inner knowledge and the higher surpassing knowledge. Therefore he can guide the world humanly as God guides it divinely, because like the Divine he is in the life of the world and yet above it.

The Rishi was not the individual composer of the hymn, but the seer (*draṣṭā*) of an eternal truth and an impersonal knowledge. The language of Veda itself is *śruti,* a rhythm not composed by the intellect but heard, a divine Word that came vibrating out of the Infinite to the inner audience of the man who had previously made himself fit for the impersonal knowledge.

RIVER. A stream of conscious being.

These rivers are everywhere. They are the waters which flow down from the mountain and ascend the mind ranging through and illuminating with their flow the dark subconscient secrets

of Vritra ; they are the mighty ones of Heaven when Indra brings down on the earth ; they are the streams of the Truth ; they are the rain from its luminous heavens ; they are the seven eternal sisters and companions ; they are the divine waters who have knowledge. They descend upon the earth, they rise from the ocean, they flow to the ocean, they break out from the doors of the Panis, they ascend to the supreme seas.

ṚK. Connected with the word *arka* which means light or illumination, is the Word considered as power of realisation in the illuminating consciousness.

The word which brings with it the illumination.

Hymn of prayer and God-attraction.

ROCK. *Vide* Hill.

RODASĪ. Two sisters, feminine forms of heaven and earth who symbolise the general energies of the mental and physical consciousness.

ṚTA-CIT. The consciousness of essential truth of being (*satyam*), of ordered truth of active being (*ṛtam*) and the vast self-awareness (*bṛhat*) in which alone this consciousness is possible.

ṚTVIK. The Ritvik is he who sacrifices in right order and right season.

RUDRA. Rudra is named in the Veda the Mighty One of Heaven, but he begins his work upon the earth and gives effect to the sacrifice on the five planes of our ascent. He is the Violent One who leads the upward evolution of the conscious being ; his force battles against all evil, smites the sinner and the enemy ; intolerant of defect and stumbling he is the most terrible of the gods. But this violent and mighty Rudra who breaks down all defective formations and groupings of outward and inward life, has also a benigner aspect. He is the supreme healer. Opposed, he destroys ; called on for aid and propitiated he heals all wounds and all evil and all sufferings. The force that battles is his gift, but also the final peace and joy.

Rudra, the Violent and the Merciful, the Mighty One, presides over the struggle of life to affirm itself ; he is the armed, wrathful and beneficent Power of God who lifts forcibly the creation upward, smites all that opposes, scources all that errs and resists, heals all that is wounded and suffers and complains and submits.

Rudra in his wrath and might and violent beneficence forces onward the great evolution and smites the opponent and the recusant and the ill-doer.

SACRIFICE. The outer symbol of an inner work, an inner interchange between the gods and men, — man giving what he has, the gods giving in return the horses of power, the herds of light, the heroes of Strength to be his retinue, winning for him victory in his battle with the hosts of darkness.

The Vedic sacrifice is, psychologically, a symbol of cosmic and individual activity become self-conscious, enlightened and aware of its goal. The whole process of the universe is in its very nature a sacrifice, voluntary or involuntary. Self-fulfilment by self-immolation, to grow by giving is the universal law. That which refuses to give itself is still the food of the comic Powers. " The eater eating is eaten " is the formula, pregnant and terrible, in which the Upanishad sums up this aspect of the universe, and in another passage men are described as the cattle of the gods. It is only when the law is recognised and voluntarily accepted that this kingdom of death can be overpassed and by the works of sacrifice Immortality made possible and attained. All the powers and potentialities of the human life are offered up, in the symbol of a sacrifice, to the divine Life in the Cosmos.

The giving by man of what he possesses in his being to the higher or divine nature and its fruit is the farther enrichment of his manhood by the lavish bounty of the gods. The wealth thus gained constitutes a state of spiritual riches, prosperity, felicity which is itself a power for the journey and a force of battle.

The work of the Aryan is a sacrifice which is at once a battle and an ascent and a journey, a battle against the powers of darkness, an ascent to the highest peaks of the mountain beyond earth and heaven into Svar, a journey to the other shore of the rivers and the ocean into the farthest Infinity of things.

The principal *features* of the sacrifice are the kindling of the

divine flame, the offering of the *ghṛta* and the Soma-wine and the chanting of the sacred word. By the hymn and the offering the gods are increased ; they are said to be born, created or manifested in man and by their increase and greatness here they increase the earth and heaven, that is to say, the physical and mental existence to their utmost capacity and, exceeding these, create in their turn the higher worlds or planes. The higher existence is the divine, the infinite of which the shining Cow, the infinite Mother, Aditi, is the symbol ; the lower is subject to her dark form Diti. The *object* of the sacrifice is to win the higher or divine being and possess with it and make subject to its law and truth the lower or human existence.

The *ghṛta* of the sacrifice is the yield of the shining Cow ; it is the clarity or brightness of the solar light in the human mentality.

The *Soma* is the immortal delight of existence secret in the waters and the plant and pressed out for drinking by gods and men.

The *word* is the inspired speech expressing the thought-illumination of the Truth which rises out of the soul, formed in the heart, shaped by the mind.

SADMA. Seats or homes of the soul, which progresses from plane to plane and makes of each a habitation. They are sometimes called the cities. There are seven such planes each with its seven provinces and one additional above. Usually we hear of a hundred cities, the double number perhaps representing the downward gaze in each of the Soul upon Nature and the upward aspiration of Nature to the Soul.

SĀMAN. The word of calm and harmonious attainment. Hymn of God-attainment and self-expression.

SĀMRĀJYA. Vide svārājya.

SARAMĀ. A power of the Truth that seeks and discovers, that finds a divine faculty of insight the hidden Light and the denied Immortality.

Intuition, hound of heaven who descends into the cavern of the subconscient and finds there the concealed illuminations.

Forerunner of the dawn of Truth in the human mind.

Action of Saramā : It is precisely that of the Intuition which goes straight to the Truth by the straight path of the Truth and not through the crooked paths of doubt and error and which delivers the Truth out of the veil of darkness and false appearances ; it is through the illuminations discovered by her that the Seer-mind can attain to the complete revelation of the Truth.

Saramā and *Sarasvati* : Sarasvati gives the full flood of the knowledge ; she is or awakens the great stream, *maho arṇaḥ*, and illumines with plenitude all the thoughts. Sarasvati possesses and is the flood of the Truth ; Sarama is the traveller and seeker on its path who does not herself possess but rather find that which is lost.

Saramā and *Ilā* : Neither is she the plenary word of the revelation, the Teacher of man like the goddess Ila ; for even when what she seeks is found, she does not take possession but only gives the message to the seers and their divine helpers who have still to fight for the possession of the light that has been discovered.

SARASVATI. The river of inspiration flowing from the Truth-consciousness.

Streaming current of the Truth-consciousness and the word of its inspiration.

The divine Word, who represents the stream of inspiration that descends from the Truth-consciousness ; goddess of the inspiration, of *śruti*.

SATAKRATU. Of hundredfold activities of will and of thought (Indra).

SATYA MANTRA. The true thought expressed in the rhythm of the truth.

*SATYASRAVAS.** Name of a Rishi, a covert figure for the characteristics of the Sun-birth in man.

SAVITRI. Creator, especially in the sense of producing, emitting from the unmanifest and bringing out into the manifest.

* whose is the inspired hearing of the Truth.

The luminous Creator ; the desirable flame and splendour of the divine Creator on which the seer has to meditate and towards which this god impels our thoughts, the bliss of the creative godhead on the forms of which our soul must meditate as it journeys towards it.

Vide Surya.

SEVEN. The number seven plays an exceedingly important part in the Vedic system, as in most very ancient schools of thought. We find it recurring constantly, — the seven delights, the seven flames, tongues or rays of Agni ; the seven forms of the Thought-principle ; the seven Rays of Cows, forms of the Cow unslayable etc. All these sets of seven depend, it seems to me, upon the Vedic classification of the fundamental principles, the *tattvas,* of existence. The enquiry into the number of these *tattvas* greatly interested the speculative mind of the ancients and in Indian Philosophy we find various answers ranging from the One upward and running into the twenties. In Vedic thought the basis chosen was the number of the psychological principles, because all existence was conceived by the Rishis as a movement of conscious being. These classifications were closely connected with a living psychological practice of which they were to a great extent the thought-basis.

In the Veda, then, we find the number of the principles variously stated. The *One* was recognised as the basis and continent ; in this One there were the *two* principles divine and human, mortal and immortal. The dual number is also otherwise applied in the two principles, Heaven and Earth, Mind and Body, Soul and Nature. It is significant, however, that Heaven and Earth, when they symbolise two forms of natural energy, the mental and physical consciousness, are no longer the father and mother, but the two mothers. The *triple* principle was doubly recognised, first in the threefold divine principle answering to the later Sachchidananda, the divine existence, consciousness and bliss, and secondly in the threefold mundane principle, Mind, Life, Body, upon which is built the triple world of the Veda and Puranas. But the full number ordinarily recognised is seven. The figure was arrived at by adding the three divine principles to the three mundane and interpolating a seventh or link-principle which is precisely that of the Truth-

consciousness, *ṛtam bṛhat*, afterwards known as Vijnana or Mahas.

All these principles, be it noted, are supposed to be really inseparable and omnipresent and therefore apply themselves to each separate formation of Nature.

The *seven thoughts*, for instance, are Mind applying itself to each of the seven planes as we would now call them and formulating Matter-mind, if we may so call it, nervous mind, pure mind, truth-mind and so on to the highest summit, *parama parāvat*.

The *seven rays* or *cows* are Aditi the infinite Mother, the Cow unslayable, supreme Nature or infinite Consciousness, pristine source of the later idea of Prakriti or Shakti, the Mother of things taking form on the seven planes of her world-action as energy of conscious being.

So also, the *seven rivers* are conscious currents corresponding to the sevenfold substance of the ocean of being which appears to us formulated in the seven worlds enumerated by the Puranas. It is their full flow in the human consciousness which constitutes the entire activity of the being, his full measure of substance, his full play of energy. In the Vedic image, his cows drink of the water of the seven rivers.

sapta gāvaḥ : the seven Cows or the seven Lights.

saptagu : that which has seven rays. (*gu* and *gau* bear throughout the Vedic hymns the double sense of cows and radiances.)

In the ancient system of thought being and consciousness were aspects of each other and Aditi, infinite existence from whom the gods are born, described as the Mother with her seven names and seven seats, is also conceived as the infinite consciousness, the Cow, the primal Light manifest in seven Radiances, *sapta gāvaḥ*.

Seven Energies : There are seven sacrificial energies (*hotra*) in the human being, one corresponding to each of the seven constituents of his psychological existence, — body, life, mind, supermind, bliss, will and essential being.

Seven Rishis : The seven divine Rishis, *ṛṣayo divyāḥ*, who fulfilling consciousness in each of its seven principles and harmonising them together superintend the evolution of the world.

Seven Waters : The word *āpaḥ* has, covertly, a double signi-

finance ; for the root *ap* meant originally not only to move, from which in all probability is derived the sense of waters, but to be or bring into being. The seven Waters are the waters of being ; they are the Mothers from whom all forms of existence are born.

SEVENFOLD MANIFESTATION. Seven rays have cast out this apparent world from the Eternal Luminousness which dwells like a Sun of ultimate being beyond its final annihilation, *ādityavat tamasaḥ parastāt*, and by these seven rays in their subjectivity the subjective world and by these seven rays in their objectivity the phenomenal world is manifested. *sat, cit, ānanda, vijnāna, manas, prāṇa, anna* are the sevenfold subjectivity of the *jyotirmaya* Brahman, *prakāśa,* essential light, *agni,* fiery light, *vidyut,* electrical illumination, *jyoti,* solar light, *tejas,* clarity and effulgence, *doṣa,* twilight, *chāyā,* negative luminosity are His sevenfold objectivity.

SEVEN-HEADED THOUGHT. The knowledge of the divine existence with its seven heads or powers, the seven-rayed knowledge of Brihaspati.

SHUNAHSHEPA. The Legend of Shunahshepa is a symbol of the human soul bound by the triple cord of sin and released from it by the divine power of Agni, Surya, Varuna.

Ignorance, the matrix of sin, has in its substantial effect the appearance of a triple cord of limited mind, inefficient life, obscure physical animality, the three ropes with which the Rishi Shunahshepa in the parable was bound as a victim to the sacrificial post. The whole result is a struggling or inert poverty of being ; it is the meagreness of a mortal undelight and the inefficiency of a being that collapses at every moment towards death. When Varuna the Mighty comes and sunders this threefold restraint, we are freed towards riches and immortality. Uplifted, the real man arises to his true kingship in the undivided being. The upper cord flies upward releasing the wings of the Soul into superconscient heights ; the middle cord parts both ways and all ways, the constrained life breaking out into happy breadth of existence ; the lower cord collapses downward taking with it the alloy of our physical being to disappear and be dissolved in the stuff of the Inconscient.

This liberation is the purport of the parable of Shunahshepa and his two great hymns to Varuna.

SHUSHNA. Enemy who afflicts with his impure and ineffective force.

SIN. That which excites and hurries the faculties into deviation from the good path. There is a straight road or road of naturally increasing light and truth leading over infinite levels and towards infinite vistas by which the law of our nature should normally take us towards our fulfilment. Sin compels instead to travel with stumblings and uneven and limited tracts and along crooked windings.

The crude conception of sin as a result of natural wickedness found no place in the thought of these deep thinkers and subtle psychologists. What they perceived, was a great insistent force of ignorance ; either a non-perception of right and truth in the mind or a non-seizing of it in the will, or an inability of the life-instincts and desires to follow after it, or the sheer inefficiency of the physical being to rise to the greatness of the divine law.

SOLAR QUATERNARY. Varuna, Mitra, Aryaman, Bhaga. The function of the Four is to build up the whole divine state into its perfection by the natural interaction of its four essential elements. The Divine is existence all-embracing, infinite and pure ; Varuna brings to us the infinite oceanic space of the divine soul and its etheral, elemental purity. The Divine is boundless consciousness, perfect in knowledge, pure and therefore luminously right in its discernment of things, perfectly harmonious and happy in its concordance of their law and nature ; Mitra brings us this light and harmony, this right distinction and relation and friendly concord, the happy laws of the liberated soul concordant with itself and the Truth in all its rich thought, shining actions and thousandfold enjoyment. The Divine is in its own being pure and perfect power and in us the eternal upward tendency in things to their source and truth ; Aryaman brings to us this mighty strength and perfectly guided happy inner upsurging. The Divine is the pure, the faultless, the all-embracing, the untroubled ecstasy that enjoys its own infinite

being and enjoys equally all that it creates within itself; Bhaga gives us sovereignty that ecstasy of the liberated soul, its free and unfallen possession of itself and the world.

This quaternary is practically the later essential trinity of Sachchidananda, — Existence, Consciousness, Bliss with self-awareness and self-force, Chit and Tapas, for double terms of Consciousness; but it is here translated into its cosmic terms and equivalents. Varuna the King has his foundation in the all-pervading purity of Sat; Mitra the Happy and the Mighty, most beloved of the Gods, in the all-uniting light of Chit; many-charioted Aryaman in the movement and all-discerning force of Tapas; Bhaga in the all-embracing joy of Ananda.

Yet as all these things form one in the realised godhead, as each element of the trinity contains the others in itself, and none of them can exist separately from the rest, therefore each of the Four also possesses by force of his own essential quality every general attribute of his brothers.

Varuna makes directly for strength; we discover a force and a will vast in purity; Aryaman the Aspirer is secured in the amplitude of his might by Varuna's infinity; he does his large works and effects his great movement by the power of Varuna's universality. Mitra makes directly for bliss, — Bhaga the Enjoyer is established in a blameless possession and divine enjoyment by the all-reconciling harmony of Mitra, by his purifying light of right discernment, his firmly-basing law.

SOMA. Soma is a figure for the divine Ananda, the principle of Bliss, from which, in the Vedic conception, the existence of Man, this mental being, is drawn. A secret Delight is the base of existence, its sustaining atmosphere and almost its substance. This Ananda is spoken of in the Taittiriya Upanishad as the ethereal atmosphere of bliss without which nothing could remain in being. In the Aitareya Upanishad Soma, as the lunar deity, is born from the sense-mind in the universal Purusha and, when man is produced, expresses himself again as sense-mentality in the human being. For delight is the *raison d'etre* of sensation, or, we may say, sensation is an attempt to translate the secret delight of existence into the terms of physical consciousness. But in that consciousness, — often figured as *adri*, the hill, stone, or dense substance — divine light and divine delight are both

of them concealed and confined, and have to be released or extracted. Ananda is retained as *rasa*, the sap, the essence, in sense-objects and sense-experiences, in the plants and growths of the earth-nature, and among these growths the mystic Soma-plant symbolises that element behind all sense-activities and their enjoyments which yields the divine essence. It has to be distilled and, once distilled, purified and intensified until it has grown luminous, full of radiance, full of swiftness, full of energy. It becomes the chief food of the gods who, called to the Soma-oblation, take their share of the enjoyment and in the strength of that ecstasy increase in man, exalt him to his highest possibilities, make him capable of the supreme experience.

The Soma wine symbolises the replacing of our ordinary sense-enjoyment by the divine Ananda. That substitution is brought about by divinising our thought-action, and as it progresses it helps in its turn the consummation of the movement which has brought it about.

Soma is the representative deity of the highest Beatitude. The wine of his ecstasy is concealed in the growths of earth, in the waters of existence ; even here in our physical being are his immortalising juices and they have to be pressed out and offered to all the gods ; for in that strength these shall increase and conquer.

The Soma was mixed with water, milk and other ingredients ; Soma is said to clothe himself with the Waters and with ' cows ', that is the illuminations or yield of Dawn the shining Cow.

Soma as the delight extracted from existence is typified by the honey-wine of the Soma.

It is mixed with the milk (*go*), the milk being that of the luminous cows ; with the curds (*dadhi*), the curds the fixation of their yield in the intellectual mind ; with the grain (*yava*), the grain the formulation of the light in the force of the physical mind.

The strainer, *pavitra*, in which the Soma is purified is made of the fleece of the Ewe. Indra is the Ram ; the Ewe must therefore be energy of Indra, probably the divinised sense-mind, *indriyam*.

Soma is the Lord of the wine of delight, the wine of immortality. Like Agni he is found in the plants, the growths of earth, and in the waters. The Soma-wine used in the external sacrifice is the symbol of this wine of delight. It is pressed out by the

pressing-stone (*adri, grāvan*) which has a close symbolic connection with the thunderbolt, the formed electric force of Indra also called *adri*. The Vedic hymns speak of the luminous thunders of this stone as they speak of the light and sound of Indra's weapon. Once pressed out as the delight of existence Soma has to be purified through a strainer (*pavitra*) and through the strainer he steams in his purity into the wine bowl (*camu*) in which he is brought to the sacrifice, or he is kept in jars (*kalaśa*) for Indra's drinking. Or, sometimes, the symbol of the bowl or the jar is neglected and Soma is simply described as flowing in a river of delight to the seat of the Gods, to the home of Immortality.

Sifted, strained, the Soma-wine of the life turned into Ananda comes pouring into all the members of the human system as into a wine-jar and flows through all of them completely in their every part. As the body of a man becomes full of the touch and exultation of strong wine, so all the physical system becomes full of the touch and exultation of this divine Ananda.

Purification of the system for Soma : It is not every human system that can hold, sustain and enjoy the potent and often violent ecstasy of that divine delight. *Ataptatanur na tad āmo aśnute*, he who is raw and his body not heated does not taste or enjoy that ; only those who have been baked in the fire bear and entirely enjoy that. The wine of the divine Life poured into the system is a strong, overflooding and violent ecstasy ; it cannot be held in the system unprepared for it by strong endurance of the utmost fires of life and suffering and experience. The raw earthen vessel not baked to consistency in the fire of the kiln cannot hold the Soma-wine ; it breaks and spills the precious liquid. So the physical system of the man who drinks this strong wine of Ananda must by suffering and conquering all the torturing heats of life have been prepared for the secret and fiery heats of the Soma ; otherwise his conscious being will not be able to hold it ; it will spill and lose it as soon as or even before it is tasted or it will break down mentally and physically under the touch.

Purifying strainer for Soma : The strong and fiery wine has to be purified and the strainer for its purifying has been spread out wide to receive it in the seat of heaven, *tapas pavitram vitatam divas pade* ; its threads or fibres are all of pure light

and stand out like rays. Through these fibres the wine has to come streaming. The image evidently refers to the purified mental and emotional consciousness, the conscious heart, *cetas,* whose thoughts and emotions are the threads or fibres. Dyau or Heaven is the pure mental principle not subjected to the reactions of the nerves and the body. In the seat of Heaven,— the pure mental being as distinguished from the vital and physical consciousness,— the thoughts and emotions become pure rays of true perception and happy psychical vibration instead of the troubled and obscured mental, emotional and sensational reactions that we now possess. Instead of being contracted and quivering things defending themselves from pain and excess of the shocks of experience they stand out free, strong and bright, happily extended to receive and turn into divine ecstasy all possible contacts of universal existence. Therefore it is *divas pade*, in the seat of Heaven, that the Soma-strainer is spread out to receive the Soma.

SON. The godhead created within the humanity.
The sons or children are the new soul-formations which constitute the divine Personality, the new births within us.

ŚRAVAS. Literally hearing and from this primary significance is derived its secondary sense, ' fame '. But psychologically, the idea of hearing leads up in Sanskrit to another sense which we find in *śravaṇa, śruti, śruta,* — revealed knowledge, the knowledge which comes by inspiration. *dṛṣṭi* and *śruti*, sight and hearing, revelation and inspiration are the two chief powers of that supramental faculty which belongs to the old Vedic idea of the Truth, the *ṛtam.*
The Thing heard or its result knowledge that comes to us through hearing ; inspiration or inspired knowledge.

ŚRUTI. Seerhood brings with it not only the far vision but the far hearing. As the eyes of the sage are opened to the light, so is his ear unsealed to receive the vibrations of the Infinite ; from all the regions of the Truth there comes thrilling into him its Word which becomes the form of his thoughts.

STOMA. Hymn of praise and God-affirmation.

STREAMS OF TRUTH. The descent of the superconscient into our life, imaged as the rain of heaven ; it forms the seven celestial rivers that flow down upon the earth-consciousness.

STUBH. Word as a power which affirms and confirms in the settled rhythm of things.

The all-supporting rhythm of the hymn.

SUBSTANCE OF THE VEDA. The Vedic hymns, whatever else they may be, are throughout an invocation to certain *āryan* gods, friends and helpers of man, for ends which are held by the singers, — or seers, as they call themselves (*kavi, ṛṣi, vipra*), — to be supremely desirable. These desirable ends, these boons of the gods are summed up in the words *rayi, rādhas,* which may mean physically wealth or prosperity, and psychologically a felicity or enjoyment which consists in the abundance of certain forms of spiritual wealth. Man contributes as his share of the joint effort the work of the sacrifice, the Word, the Soma-wine and the *ghrta* or clarified butter. The Gods are born in the sacrifice, they increase by the Word, the Wine and the *ghrta* and in that strength and in the ecstasy and intoxication of the Wine they accomplish the aims of the sacrificer. The chief elements of the wealth thus acquired are the Cow and the Horse ; but there are also others, *hiraṇya*, gold, *vīra*, men or heroes, *ratha*, chariots, *prajā* or *apatya*, offspring. The very means of the sacrifice, the fire, the Soma, the *ghrta*, are supplied by the God and they attend the sacrifice as its priests, purifiers, upholders, heroes of its warfare, — for there are those who hate the sacrifice and the Word, attack the sacrificer and tear or withhold from him the coveted wealth. The chief conditions of the prosperity so ardently desired are the rising of the Dawn and the Sun and the downpour of the rain of heaven and of the seven rivers, — physical or mystic, — called in the Veda the Mighty Ones of heaven. But even this prosperity, this fullness of cows, horses, gold, men, chariots, offspring, is not a final end in itself ; all this is a means towards the opening up of the other worlds, the winning of Svar, the ascent to the solar heavens, the attainment by the path of the Truth to the Light and to the heavenly Bliss where the mortal arrives at Immortality.

SUDHANVAN. *Dhanvan* in this name does not mean a ' bow ' but the solid or desert field of Matter otherwise typified as the hill or rock out of which the waters and the rays are delivered.

SUMATI. Right thoughts, right sensibilities. Vedic *mati* includes not only the thinking, but also the emotional parts of mentality. *sumati* is a light in the thoughts ; it is also a bright gladness and kindness in the soul.

SUN. *Vide* Surya.

SUPERMIND. A vastness beyond the ordinary firmaments of our consciousness in which truth of being is luminously one with all that expresses it and assures inevitably truth of vision, formulation, arrangement, word, act and movement and therefore truth also of result of movement, result of action and expression, infallible ordinance of law. Vast all-comprehensiveness ; luminous truth and harmony of being in that vastness and not a vague chaos or self-lost obscurity ; truth of law and act and knowledge expressive of that harmonious truth of being.

In the language of the Vedic Rishis, as infinite Existence, Consciousness and Bliss are the three highest and hidden Names of the Nameless, so this Supermind is the fourth Name — (*turīyam svid*, ' a certain Fourth ', also called *turīyam dhāma*, the fourth placing or poise of existence) fourth to That in its descent, fourth to us in our ascension.

The Vedic seers seem to speak of two primary faculties of the " truth-conscious " soul ; they are Sight and Hearing, by which is intended direct operations of an inherent Knowledge describable as *truth-vision* and *truth-audition* and reflected from far-off in our human mentality by the faculties of revelation and inspiration. Besides, a distinction seems to be made in the operations of the Supermind between knowledge by a comprehending and pervading consciousness which is very near to subjective knowledge by identity and knowledge by a projecting, confronting, apprehending consciousness which is the beginning of objective cognition.

SŪRI. Illumined thinker.

6

SURYA. The Godhead of the supreme Truth and Knowledge and his rays are the light emanating from that supreme Truth and Knowledge.

The Illuminer in the sense of the Lord of Knowledge.

He is the light of the Truth rising on the human consciousness in the wake of the divine Dawn whom he pursues as a lover follows after his beloved and he treads the paths she has traced for him.

Luminous vision and luminous creation are the two functions of Surya.

The Sun is the master of the supreme Truth — truth of being, truth of knowledge, truth of process and act and movement and functioning. He is therefore the creator or rather the manifester of all things — for creation is outbringing, expression by the Truth and Will — and the father, fosterer, enlightener of our souls. The illuminations we seek are the herds of this Sun who comes to us in the track of the divine Dawn and releases and reveals in us night-hidden world after world up to the highest Beatitude.

Surya and the Gods : All the other Gods follow in the march of Surya and they attain to this vastness by the force of his illumination. That is to say, all the other divine faculties or potentialities in man expand with the expansion of the Truth and Light in him ; in the strength of the ideal super-mind they attain to the same infinite amplitude of right becoming, right action, and right knowledge.

Four Powers of Surya : *Varuṇa*, a vast purity and clear wideness destructive of all sin and crooked falsehood ; *Mitra*, a luminous power of love and comprehension leading and forming into harmony all our thoughts, acts and impulses ; *Aryaman*, an immortal puissance of clear-discerning aspiration and endeavour ; *Bhaga*, a happy spontaneity of the right enjoyment of all things dispelling the evil dream of sin and error and suffering.

Names of Surya : The name Surya is seldom used when there is question of this creation ; it is reserved for his passive aspects as the body of the infinite Light and the revelation. In his active power he is addressed by other names ; then he is Savitri, from the same root as Surya, the Creator ; or he is Twashtri, the Fashioner of things ; or he is Pushan, the Increaser, — appellations that are sometimes used as if identical with Surya, sometimes as if expressing other forms and even other personalities

of this universal Godhead. Savitri, again, manifests himself, especially in the formation of the Truth in man, through four great and active deities, Mitra, Varuna, Bhaga and Aryaman, the Lords of pure Wideness, luminous Harmony, divine Enjoyment, exalted Power.

Sūrya Savitri : The divine being in his creative and illuminative solar form.

SUVITAM AND *DURITAM*. They mean literally right going and wrong going. *suvitam* is truth of thought and action, *duritam* error or stumbling, sin and perversion. *suvitam* is happy going, felicity, the path of Ananda ; *duritam* is calamity, suffering, all ill result of error and ill doing.

Vide Duritam.

SUVṚKTI. Corresponds to the Katharsis of the Greek mystics — the clearance, riddance or rejection of all perilous and impure stuff from the consciousness. It is Agni Pavaka, the purifying Fire who brings to us this riddance or purification.

SVADHĀ. Self-ordering power of Nature.

SVADHITI. An equivoque on the double sense of *svadhiti*, an axe or another cleaving instrument and the self-ordering power of Nature, *svadhā.*

(The image is of the progress of the divine Force through the forests of the material existence as with an axe. But the axe is the natural self-arranging progression of Nature, the World-Energy, the Mother.)

SVAR. Name of a world or supreme Heaven above the ordinary heaven and earth. Sometimes it is used for the solar light proper both to Surya and to the world which is formed by his illumination.

This wide world, *bṛhat dyau* or *svar*, which we have no attain by passing beyond heaven and earth, this supra-celestial wideness, this illimitable light is a supra-mental heaven, the heaven of the supramental Truth, of the immortal Beatitude ; the light which is its substance and constituent reality is the light of Truth.

The world of divine solar light to which we have to ascend

and which is revealed by the release of the luminous herds from the nether cave and the consequent uprising of the divine Sun.

The divine mind pure to the luminous Truth.

SVĀRĀJYA. *svārājya* and *sāmrājya*, perfect empire within and without, rule of our inner being and mastery of our environment and circumstances, was the ideal of the Vedic sages, attainable only by ascending beyond our mortal mentality to the luminous Truth of our being, the supramental infinities on the spiritual plane of our existence.

SVARNARA. Often spoken of as if it were a country ; it is not Svar itself, the utter superconscient plane, but the power of itself which the light of that world forms in pure mentality.

SYMBOLIC SPIRIT OF THE VEDIC AGE. In the Vedic age everything is symbolic. The religious institution of sacrifice governs the whole society and all its hours and moments, and the ritual of the sacrifice is at every turn and in every detail mystically symbolic. Not only the actual religious worship but also the social institutions of the time were penetrated through and through with the symbolic spirit. Take the hymn of the Rig Veda which is supposed to be a marriage hymn for the union of a human couple and was certainly used as such in the later Vedic ages. Yet the whole sense of the hymn turns about the successive marriages of Surya, daughter of the Sun, with different gods and the human marriage is quite a subordinate matter overshadowed and governed entirely by the divine and mystic figure and is spoken in the terms of that figure. Mark, however, that the divine marriage here is not a decorative image or poetical ornamentation used to set off and embellish the human union ; on the contrary, the human is an inferior figure and the image of the divine.

This symbolism influenced for a long time Indian ideas of marriage and is even now conventionally remembered though no longer understood or effective.

SYMBOLISM OF THE VEDA. The symbolism of the Veda depends upon the image of the life of man as a sacrifice, a journey and a battle. The ancient Mystics took for their theme

the spiritual life of man, but, in order both to make it concrete to themselves and to veil its secrets from the unfit, they expressed it in poetical images drawn from the outward life of their age. That life was largely an existence of herdsmen and tillers of the soil for the mass of the people varied by the wars and migrations of the clans under their kings, and in all this activity the worship of the gods by sacrifice had become the most solemn and magnificent element, the knot of all the rest. For by the sacrifice were won the rain which fertilised the soil, the herds of cattle and horses necessary for their existence in peace and war, the wealth of gold, land, (*kṣetra*), retainers, fighting-men which constituted greatness and lordship, the victory in the battle, safety in the journey by land and water which was so difficult and dangerous in those times of poor means of communication and loosely organised inter-tribal existence. All the principal features of that outward life which they saw around them the mystic poets took and turned into significant images of the inner life. The life of man is represented as a sacrifice to the gods, a journey sometimes figured as a crossing of dangerous waters, sometimes as an ascent from level to level of the hill of being, and, thirdly, as a battle against hostile nations. But these three images are not kept separate. The sacrifice is also a journey ; indeed the sacrifice itself is described as travelling, as journeying to a divine goal ; and the journey and the sacrifice are both continually spoken of as a battle against the dark powers.

SYNTHESIS IN THE VEDA. A synthesis of the psychological being of man in its highest flights and widest rangings of divine knowledge, power, joy, life and glory with the cosmic existence of the gods, pursued behind the symbols of the material universe into those superior planes which are hidden from the physical sense and the material mentality. The crown of this synthesis was in the experience of the Vedic Rishis something divine, transcendent and blissful in whose unity the increasing soul of man and the eternal divine fulness of the cosmic godheads meet perfectly and fulfil themselves.

TAD EKAM, TAT SATYAM. The self-luminous One is the goal of the Aryan-minded ; therefore the seers worshipped him

in the image of the Sun. One existent, him have the seers called
by various names, Indra, Agni, Yama, Matarishvan. The
phrases " That One ", " That Truth ",* occur constantly in the
Veda in connection with the Highest and with the image of His
workings here, the Sun.

TEJAS. Tejas is of seven kinds, *chāyā* or negative luminosity
which is the principle of *annakoṣa* ; twilight or *doṣa*, the basis
of *prāṇakoṣa* being *tejas* modified by *chāyā* ; *tejas* proper or
simple clarity and effulgence, dry light, which is the basis of the
manaḥkoṣa ; *jyoti*, or solar light, brillance which is the basis of
the *vijñānakoṣa* ; *agni* or fiery light, which is the basis of the
citkoṣa ; *vidyut* or electrical illumination which is the basis of
the *ānandakoṣa* ; and *prakāśa* which is the basis of the *satkoṣa*.
Each of the seven has its own approprite energy ; for the energy
is the essential reality and the light only a characteristic accom-
paniment of the energy. Of all these Agni is the greatest in the
world, greater than the *vidyut* — although the God of the
Vaidyuta energy is Vishnu himself who is the Lord of the
Ananda ; the *vaidyuto mānavaḥ*, Electrical Man, of the Upani-
shads. In the *vijñāna*, Surya as well as Vishnu, is greater than
Agni, but here he and Vishnu both work under the dominant
energy of Agni and for the satisfaction of Indra, — Vishnu in
the Upanishads being younger than Indra, — Upendra. Trans-
lated into the language of physics, this means that Agni,
commanding as he does heat and cold, is the fundamental active
energy behind all phenomenon of light and heat ; the Sun is
merely a reservoir of light and heat ; the peculiar luminous blaze
of the sun being only one form of *tejas* and what we call sunlight
is composed of the static energy of *prakāśa* or essential light
which is the basis of the *satkoṣa*, the electrical energy or *vaidyu-
tam*, and the *tejas* of Agni modified by the nature of Surya and
determining all other forms of light. The *prakāśā* and *vaidyutam*
can only become active when they enter into Agni and work
under the conditions of his being and Agni himself is the supplier
of Surya ; he creates *jyoti*, he creates *tejas*, he creates, negatively,
chāyā. Right or wrong, this is the physics of the Veda.
Translated into the language of psychology, it means that in the

* *tad ekam, tat satyam* — phrases always carefully misinterpreted by
the commentators.

intelligent mind, which now predominates, neither *jñāna* nor *ānanda* can be fully developed, though essentially superior to mind ; not even Soma, the rational *buddhi,* can really govern ; but it is Indra full of Soma, the understanding based on the senses and strengthened by the *buddhi*, who is supreme and for whose satisfaction Soma, Surya, Agni and even the supreme Vishnu work. The reason on which man prides himself, is merely a link in evolution from the *manas* to the *vijñānam* and must serve either the senses or the ideal cognition ; if it has to work for itself it only leads to universal agnosticism, philosophic doubt and arrest of all knowledge. It must not be thought that the Veda uses these names merely as personifications of psychological and physical forces ; it regards these gods as realities standing behind the psychological and physical operations, since no energy can conduct itself, but all need some conscious centre or centres from or through which they proceed.

THUNDER. It is the outcrashing of the word of the Truth, the *śabda,* as the lightning is the outflashing of its sense.

TRIDHĀTU. The three divine principles of, being, its infinite existence, its infinite consciousness-force, its infinite bliss.

The triple principle or triple material of existence, is the Sachchidananda of the Vedanta ; in the ordinary language of the Veda it is *vasu,* substance, *ūrj,* abounding force of our being, *priyam* or *mayas,* delight and love in the very essence of our existence. Of these three things all that exists is constituted and we attain to their fullness when we arrive at the goal of our journey.

TRĪNI ROCANĀNI. There are three successive worlds of mentality one superimposed on the other, — the sensational, aesthetic and emotional mind, the pure intellect and the divine intelligence. The fullness and perfection of these triple worlds of mind exists only in the pure mental plane of being, where they shine above the three heavens, *tisro divaḥ,* as their three luminosities, *trīni rocanāni.*

Their light descends upon the physical consciousness and effects the corresponding formations in its realms, the Vedic

pārthivani rajānsi, earthly realms of light. They are also triple *tisro pṛthivīḥ*, the three earths.

TRIPLE CORDS. When the seer of the house of Atri cries high to Agni, " O Agni, O Priest of the offering, loose from us the cords," he is using not only a natural, but a richly laden image. He is thinking of the triple cord of mind, nerves and body by which the soul is bound as a victim in the great world-sacrifice, the sacrifice of the Purusha ; he is thinking of the force of the divine Will already awakened and at work within him, a fiery and irresistible godhead that shall uplift his oppressed divinity and cleave asunder the cords of its bondage ; he is thinking of the might of that growing Strength and inner Flame which receiving all that he has to offer carries it to its own distant and difficult home, to the high-seated Truth, to the Far, to the Secret, to the Supreme.

TRITA ĀPTYA. The god or Rishi of the third plane, full of luminous mental kingdoms unknown to the physical mind.

The Third or Triple, apparently the Purusha of the mental plane. In the tradition he is a Rishi and has two companions significantly named *Eka*, one or single, and *Dvita*, second or double, who must be the Purushas of the material and the vital or dynamic consciousness. In the Veda he seems rather to be a god.

TRUTH IN THE VEDA. The psychological conception is that of a truth which is truth of divine essence, not truth of mortal sensation and appearance. It is *satyam*, truth of being ; it is in its action, *ṛtam*, right, — truth of divine being, regulating right activity both of mind and body ; it is *bṛhat*, the universal truth proceeding direct and undeformed out of the Infinite. The consciousness that corresponds to it is also infinite, *bṛhat*, large as opposed to the consciousness of the sense-mind which is founded upon limitation. Another name for this supramental or truth consciousness is Mahas which also means the great, the vast.

Faculties of the truth-consciousness : *dṛṣṭi*, direct vision of the truth, *śruti*, direct hearing of its word, *viveka*, direct discrimination of the right.

Whoever is in possession of this truth-consciousness or open to the action of these faculties, is the *ṛṣi* or *kavi*, sage or seer.

Five Powers of Truth-Consciousness : Mahi or Bharati, the vast Word that brings us all things out of the divine source ; Ila, the strong primal word of the Truth who gives us its active vision ; Sarasvati, its streaming current and the word of its inspiration ; Sarama, the Intuition, hound of heaven who descends into the cavern of the subconscient and finds there the concealed illuminations ; Dakshina, whose function is to discern rightly, dispose the action and the offering and distribute in the sacrifice to each godhead its portion.

Truth comes to us as a light, a voice, compelling a change of thought, imposing a new discernment of ourselves and all around us. Truth in thought creates truth of vision and truth of vision forms in us truth of being, and out of truth of being (*satyam*) flows naturally truth of emotion, will and action.

Truth and Bliss : For the Vedic Rishi Truth is the passage and the antechamber, the Bliss of the divine existence is the goal, or else Truth is the foundation, Bliss the supreme result.

It is by the dawning of the true or infinite consciousness in man that he arrives out of this evil dream of pain and suffering, this divided creation into the Bliss.

Truth veiled by Truth : The active cosmic Truth of things diffused and arranged in their mutability and divisibility of Time and Space veils the eternal and unchanging Truth of which it is a manifestation.

TRUTH-WORLD. The Vedic seers were conscious of a divine self-manifestation and looked on it as the greater world beyond this lesser, a freer and wider plane of consciousness and being the truth-creation of the Creator which they described as the seat or own home of the Truth, as the vast Truth, or the Truth, the Right, the Vast, *sadanam ṛtasya, sve dame ṛtasya, ṛtasya bṛhate, ṛtam satyam*, or again as a Truth hidden by Truth where the Sun of Knowledge finishes his journey and unyokes his horses, where the thousand rays of consciousness stand together so that there is That One, the supreme form of the Divine Being. But this world in which we live seemed to them to be a mingled weft in which truth is disfigured by an abundant falsehood, *anṛtasya bhureḥ,* here the one light has to

be born by its own vast force out of an initial darkness or sea
of Inconscience (*apraketam salilam*) ; immortality and godhead
have to be built up out of an existence which is under the yoke
of death, ignorance, weakness, suffering and limitation. This
self-building they figured as the creation by man in himself of
that other world or high ordered harmony of infinite being which
already exists perfect and eternal in the Divine Infinite. The
lower is for us the first condition of the higher ; the darkness is
the dense body of the light, the Inconscient guards in itself all
the concealed Superconscient, the powers of the division and
falsehood hold from us but also for us and to be conquered from
them the riches and substance of the unity and truth in their
cave of subconscience. This was in their view, expressed in the
highly figured enigmatic language of the early mystics, the sense
and justification of man's actual existence and his conscious or
unconscious Godward effort, his conception so paradoxical at
first sight in a world which seems its very opposite, his aspiration
so impossible to a superficial view in a creature so ephemeral,
weak, ignorant, limited, towards a plenitude of immortality,
knowledge, power, bliss, a divine and imperishable existence.

TRYARUNA TRASADASYU. The half-gold, man turned
into the Indra type. In all things he reproduces the characteris-
tics of Indra.

TUGRA. The Forceful-Hastening.

TWASHTRI. The Divine as the Fashioner of things pervades
all that He fashions both with His immutable self-existence and
with that mutable becoming of Himself in things by which the
soul seems to grow and increase and take on new forms. By
the former He is the indwelling Lord and Maker, by the latter
He is the material of his own works.

UNIVERSE. The Godhead has built this universe in a
complex system of worlds which we find both within us and
without, subjectively cognised and objectively sensed. It is a
rising tier of earths and heavens ; it is a stream of diverse waters ;
it is a Light of seven rays, or of eight or nine or ten ; it is a

Hill of many plateaus. The seers often image it in a series of trios ; there are three earths and three heavens. More, there is a triple world below, — Heaven, Earth and the intervening mid-region ; a triple world between, the shining heavens of the Sun ; a triple world above, the supreme and rapturous abodes of the Godhead.

URU. The wideness of the infinite Truth-plane with the manifold wealth of its spiritual contents. Its condition is the perfection of the thought-mind and psychic mentality proper to a divine nature, which comes to man as the grace of the gods, *sumati.*

USHA. The divine Dawn — not merely the physical ; her cows or rays of the Dawn are the illuminations of the dawning divine consciousness.

Usha, daughter of Heaven, is the medium of the awakening, the activity and the growth of the other gods ; she is the first condition of the Vedic realisation. By her increasing illumination the whole nature of man is clarified ; through her he arrives at the Truth, through her he enjoys the Beatitude. The divine Dawn is the advent of the divine Light throwing off veil after veil and revealing in man's activities the luminous godhead. In that light the Work is done, the sacrifice offered and its desirable fruits gathered by humanity.

Dawn divine is the coming of the Godhead. She is the light of the Truth and the Felicity pouring on us from the Lord of Wisdom and Bliss.

Usha is the divine Dawn, for the Sun that arises by her coming is the Sun of the superconscient Truth ; the day he brings is the day of the true life in the true knowledge, the night he dispels is the night of the ignorance which yet conceals the dawn in its bosom. Usha herself is the Truth, *sūnṛtā*, and the mother of Truths. These truths of the divine Dawn are called *her cows, her shining herds* ; while the forces of the Truth that accompany them and occupy the Life are called her horses.

Around this symbol of the cows and horses much of the Vedic symbolism turns ; for these are the chief elements of riches sought by man from the gods. The cows of the Dawn have been stolen and concealed by the demons, the lords of darkness in

their nether cave of the secret subconscient. They are the
illuminations of knowledge, the thoughts of the Truth, *gāvo
matayaḥ*, which have to be delivered out of their imprisonment.
Their release is the upsurging of the powers of the divine
Dawn.

It is also the recovery of the Sun that was lying in the dark-
ness ; for it is said that the Sun, " that Truth ", was the thing
found by Indra and the Angirasas in the cave of the Panis. By
the rending of that cave the herds of the divine Dawn which are
the rays of the Sun of Truth ascend the hill of being and the
Sun itself ascends to the luminous upper ocean of the divine
existence, led over it by the thinkers like a ship over the waters,
till it reaches its farther shore.

USHANAS KĀVYA. The Rishi of the heavenward desire
that is born from the seer-knowledge.

Ushanas drives the herded illuminations of our thought up
the path of the Truth to the Biiss which Surya possesses.

VĀJA. *Vide* Ribhus.

VALA. Chief of the Panis, a demon whose name signifies
probably the circumscriber or " encloser ". Vala dwells in a
lair, a hole (*bila*) in the mountains ; Indra and the Angirasa
Rishis have to pursue him there and force him to give up his
wealth ; for he is Vala of the cows, *valasya gomataḥ*.

Vala is the enemy, the Dasyu, who holds back in his hole,
his cave, *bilam, guhā,* the herds of the Light ; he is the personifi-
cation of the subconscient. Vala is not himself dark or incons-
cient, but a cause of darkness. Rather his substance is of the
light but he holds the light in himself and denies its conscious
manifestation. He has to be broken into fragments in order that
the hidden lustres may be liberated.

VAMADEVA. A Rishi, at once one of the most profound
seers and one of the sweetest singers of the Vedic age.

VANAM. The forests or delightful growths of earth (*vana*
means also pleasure). They are the basis of the mid-world, the

vital world in us which is the realm of Vayu, the Life-God. That is the world of the satisfaction of desires.

Vanāni : The receptive sensations seeking in all objectivities the Ananda whose quest is their reason for existence.

Vanaspati : Lords of the forest and lords of enjoyment.

VARNA. The brightness of the light of the truth is the *ārya varṇa*, the hue of these Aryans who are *jyotiragrāḥ* ; the darkness of the night of the ignorance is the hue of the Panis, the *dāsa varṇa*. In this way *varṇa* would come to mean almost the nature or else all those of that particular nature, the colour being the symbol of the nature ; and that this idea was a current notion among the ancient Aryans seems to me to be shown by the later use of different colours to distinguish the four castes, white, red, yellow and black.

VARUNA. The etherial, oceanic, infinite King of wide being, wide knowledge and wide might, a manifestation of the one God's active omniscience and omnipotence, a mighty guardian of the Truth, punisher and healer, Lord of the noose and Releaser from the cords, who leads thought and action towards the vast light and power of a remote and high-uplifted Truth. Varuna is the King of all kingdoms and of all divine and mortal beings, earth and heaven and every world are only his provinces.

Represents the ethereal purity and oceanic wideness of the infinite Truth.

His godhead is the form or spiritual image of an embracing and illuminating Infinity.

Varuna the King has his foundation in the all-pervading purity of Sat.

Varuna represents in creation, the principle of pure and wide being, Sat in Saccidananda.

Represents, in man, largeness, right and purity ; everything that deviates from the right, from the purity recoils from his being and strikes the offender as the punishment of sin. So long as man does not attain to the largeness of Varuna's Truth, he is bound to the posts of the world-sacrifice by the triple bonds of mind, life and body as a victim and is not free as a possessor and enjoyer.

Varuna is the oceanic surge of the hidden Divine as he rises, progressively manifested, to his own infinite wideness and ecstasy in the soul of the god-liberated seer.

The illusions which he shatters with his tread are the false formations of the Lords of Evil. Varuna, because he is this ether of divine Truth and ocean of divine being, is what no personified physical sea or sky could ever become, the pure and majestic King who strikes down evil and delivers from sin. Sin is a violation of the purity of the divine Right and Truth ; its reaction is the wrath of the Pure and Puissant. Against those who like the Sons of Darkness serve self-will and ignorance, the king of the divine Law hurls his weapons ; the cord descends upon them ; they fall into the snare of Varuna. But those who seek after the Truth with sacrifice are delivered from bondage to sin like a calf released from the rope or a victim set free from the slaying-post.

VASISHTHA. A Rishi of even harmonies.

VAST LIGHT. A wide, free and luminous consciousness beyond mind.

VĀYU. Master of Life, inspirer of that Breath or Dynamic energy called Prana, which is represented in man by the vital and nervous activities.

Vayu is always associated with the Prana, or Life-Energy, which contributes to the system the ensemble of nervous activities that in man are the support of the mental energies governed by Indra.

VEDA THE SOURCE. The Veda possesses the high spiritual substance of the Upanishads, but lacks their phraseology ; it is an inspired knowledge as yet insufficiently equipped with intellectual and philosophical terms. We find a language of poets and illuminates to whom all experience is real, vivid, sensible, even concrete, not yet of thinkers and systematisers to whom the realities of the mind and soul have become abstractions. Yet a system, a doctrine there is ; but its structure is supple, its terms are concrete, the cast of its thought is practical and experimental, but in the accomplished type of an old and

sure experience not of one that is crude and uncertain because yet in the making. Here we have the ancient psychological science and the art of spiritual living of which the Upanishads are the philosophical outcome and modification and Vedanta, Sankhya and Yoga the late intellectual result and logical dogma. But like all life, like all science that is still vital, it is free from the armoured rigidities of the reasoning intellect ; in spite of its established symbols and sacred formulae it is still large, free, flexible, fluid, supple and subtle. It has the movement of life and the large breath of the soul. And while the later philosophies are books of Knowledge and make liberation the one supreme good, the Veda is a Book of Works and the hope for which it spurns our present bonds and littleness is perfection, self-achievement, immortality.

VEDIC KNOWLEDGE—METHOD. To enter passively into the thoughts of the old Rishis, allow their words to sink into our souls, mould them and create their own reverberations in a sympathetic and responsive material — submissiveness, in short, to the *śruti* — was the theory the ancients themselves had of the method of Vedic knowledge — *girām upaśrutim cara, stomam abhi svara, abhi gṛṇīhi ā ruva.*

VENA. Soma, the master of mental delight of existence, creator of the sense-mind.

VIBHU. Becoming or coming into existence pervasively.

VIBHVA. *Vide* Ribhus.

VIMADA. A Rishi. The rapturous one.

VICARṢANI. All-seeing, wide-seeing.

VIPAŚCIT. The clear in perception. Illumined seer.

VIPRA. Illuminate.

VISHNU. Vishnu of the vast pervading motion holds in his triple stride all these worlds ; it is he that makes a wide room

for the action of Indra in our limited mortality ; it is by him
and with him that we rise into his highest seats where we find
waiting for us the Friend, the Beloved, the Beatific Godhead.

Vishnu paces out the vast frame-work of the inner worlds in
which our soul-action takes place.

Three strides of Vishnu : They are earth, heaven and the
triple principle, *tridhātu*.

Earth, heaven and " that " world of bliss are the three strides.
Between earth and heaven is the Antariksha, the vital worlds,
literally " the intervening habitation ". Between the heaven and
the world of bliss is another vast Antariksha or intervening
habitation, Maharloka, the world of the superconscient Truth of
things.

Thus in three wide movements of Vishnu all the five worlds
and their creatures have their habitation.

Viṣṇoḥ padam : The highest, the Supreme stride of Vishnu.
Vishnu has three strides or movements, earth, heaven and the
supreme world of which Light, Truth and the Sun are the
foundation.

The supreme step of Vishnu, his highest seat, is the triple
world of bliss and light, *paramam padam*, which the wise ones
see extended in heaven like a shining eye of vision ; it is
this highest seat of Vishnu that is the goal of the Vedic
journey.

It is the *tridhātu*, the triple principle beyond Heaven or super-
imposed upon it as its highest level which is the supreme stride
or supreme seat of the all-pervading deity.

Vishnu and Rudra : Vishnu the all-pervading has, in the
Rigveda, a close but covert connection and almost an identity
with the other deity exalted in the later religion, Rudra. Rudra
is a fierce and violent godhead with a beneficent aspect which
approaches the supreme blissful reality of Vishnu ; Vishnu's
constant friendliness to man and his helping gods is shadowed
by an aspect of formidable violence. Rudra is the father of the
vehemently-battling Maruts ; Vishnu is hymned under the name
of Evaya Marut as the source from which they sprang, that
which they become, and himself identical with the unity and
totality of their embattling forces. Rudra is the Deva or Deity
ascending in the cosmos, Vishnu the same Deva or Deity helping
and evoking the powers of the ascent.

VISHVAMITRA. A Rishi of puissant and energetic hymns.

VIŚVEDEVĀH. The universal collectivity of the divine powers ; all-gods ; they have like any god common character they are fosterers or increasers of man and upholders of his labour and effort in the work, the sacrifice.
Vaiśvadevyam : Union of all the godheads in our consenting universality.

VRATĀNI. The Aryan or divine workings, those of the divine law of the Truth to be revealed in man.

VRITRA. The Serpent, the grand Adversary ; he obstructs with his coils of darkness all possibiiity of divine existence and divine action.
A demon who covers and holds back the Light and the waters and the Vritras are his forces fulfilling that function.

VRJINA. Crooked ; crookedness of the falsehood as opposed to the open straightness of the Truth.

VYĀHRTI. The three worlds, *bhūr* (Earth), *bhuvah* (Middle region), *svah* (Heaven).

WATERS. The Waters, otherwise called the seven streams or the seven fostering Cows, are the Vedic symbol for the seven cosmic principles and their activities, three inferior, the physical, vital and mental, four superior, the divine Truth, the divine Bliss, the divine Will and Consciousness, and the divine Being. On this conception also is founded the ancient idea of the seven worlds in each of which the seven principles are separately active by their various harmonies.
Outpouring of the luminous movement and impulse of the divine or supramental existence.

WIDE LEVELS. Wide free infinite planes of existence founded on the Truth, the open levels opposed to the uneven crookedness which shut in men limiting their vision and obstructing their journey.

7

WILL. Will, in the Vedic idea, is essentially knowledge taking the form of force.

WORD. The inspired speech expressing the thought-illumination of the Truth which rises out of the soul, formed in the heart, shaped by the mind.

WORLD IN VEDIC IMAGERY. This world is a series of heights that are depths and a mutual involution and evolution of vastnesses that have no ending : ether below rises to ever more luminous ether above, every stratum of consciousness rests upon many inferior and aspires to many higher strata.

WORLDS-SYSTEM. The Rishis speak of three cosmic divisions, Earth, Middle region (*antariksa*) and Heaven (*dyau*); but there is also a greater Heaven (*brhad dyau*) called also the Wide World, the Vast (*brhat*), and typified sometimes as the Great Water, (*maho arnah*). This *brhat* is again described as *rtam brhat* or in a triple term *satyam rtam brhat*. And as the three worlds correspond to the *vyāhrtis* (*bhūr bhūvah svah*), so this fourth world of the Vastness and the Truth seems to correspond to the fourth *vyāhrti* mentioned in the Upanishads, Mahas.

In the Puranic formula the four are completed by three others, Jana, Tapas and Satya, the three supreme worlds of the Hindu cosmology. In the Veda also we have three supreme worlds whose names are not given. But in the Vedantic and Puranic system the seven worlds correspond to seven psychological principles or forms of existence, Sat, Chit, Ananda, Vijnana, Prana, Manas and Anna. Now Vijnana, the central principle, the principle of Mahas, the great world, is the Truth of things, identified with the Vedic *rtam* which is the principle of *brhat*, the Vast, while in the Puranic system Mahas is followed in the ascending order by Jana, the world of Ananda, of the divine Bliss, in the Veda also *rtam*, the Truth leads upward to Mayas, Bliss. We may, therefore, be fairly sure that the two systems are identical and that both depend on the same idea of seven principles of subjective consciousness formulating themselves in seven objective worlds.

YAJNA. Yajna, the Master of the Universe, is the universal living Intelligence who possesses and controls His world ; Yajna is god.

Not only is He called Yajna, but all action is called Yajna, and Yoga, by which alone the process of any action is possible, is also called Yajna. The material sacrifice of action is only one form of Yajna which, when man began to grow again material, took first a primary and then a unique importance and for the man of men stood for all action and all Yajna. But the Lord is the master of all our actions ; for Him they are, to Him they are devoted, with or without knowledge we are always offering our works to their Creator. Every action is therefore, an offering to Him and the world is the altar of our life-long session of sacrifice. In this world-wide *karmakāṇḍa* the mantras of the Veda are the teachers of right action (*ṛtam*) and it is therefore that the Veda speaks of Him as Yajna and not by another name.

YAJUR. The word which guides the sacrificial action in accordance with the *ṛk*.

YAMA. In the later ideas Yama is the god of Death and has his own special world ; but in the Rig Veda he seems to have been originally a form of the Sun, even as late as the Isha Upanishad we find the name used as an appellation of the Sun, — and then one of the twin children of the wide-shining Lord of Truth. He is the guardian of the Dharma, the law of the Truth, *satyadharma*, which is a condition of immortality, and therefore himself the guardian of immortality. His world is Svar, the world of immortality.

Epilogue

The Veda is a book of esoteric symbols, almost of spiritual formulae, which makes itself as a collection of ritual poems. The inner sense is psychological, universal, impersonal ; the ostensible significance and the figures which were meant to reveal to the initiates what they concealed from the ignorant, are to all appearance crudely concrete, intimately personal, loosely occasional and allusive. To this lax outer garb the Vedic poets are sometimes careful to give a clear and coherent form quite other than the strenuous inner soul of their meaning ; their language then becomes a cunningly woven mask for hidden truths.

To enter into the very heart of the mystic doctrine, we must ourselves have trod the ancient paths and renewed the lost discipline, the forgotten experience. And which of us can hope to do that with any depth or living power ? Who in this Age of Iron shall have the strength to recover the light of the Forefathers or soar above the two enclosing firmaments of mind and body into their luminous empyrean of the infinite Truth ? The Rishis sought to conceal their knowledge from the unfit, believing perhaps that the corruption of the best might lead to the worst and fearing to give the potent wine of the Soma to the child and the weakling. But whether their spirits still move among us looking for the rare Aryan soul in a mortality that is content to leave the radiant herds of the Sun for ever imprisoned in the darkling cave of the Lords of the sense-life or whether they await in their luminous world the hour when the Maruts shall again drive abroad and the Hound of Heaven shall once again speed down to us from beyond the rivers of Paradise and the seals of the heavenly waters shall be broken and the caverns shall be rent and the immortalising wine shall be pressed out in the body of man by the electric thunder-stones, their secret remains safe to them. Small is the chance that in an age which blinds our eyes with the victorious trumpets of a material and

mechanical knowledge many shall cast more than the eye of an intellectual and imaginative curiosity on the pass-words of their ancient disciplines or seek to penetrate into the heart of their radiant mysteries. The secret of the Veda, even when it has been unveiled, remains still a secret.

Appendix

Some Hymns

ADITI

In the dawn I call to the divine Mother infinite, in the mid-day and at the rising of the Sun. (RV. V. 69.3)

May we abide in the law of thy workings and be blameless before the Mother Infinite. (RV. I. 24.15)

AGE

As a mist dims a form, age diminishes us ; before that hurt falls upon us arrive. (RV. I. 71.10)

AGNI, THE VEDIC FIRE

This is the omniscient who knows the law of our being and is sufficient to his works ; let us build the song of his truth by our thought and make it as if a chariot on which he shall mount. When he dwells with us, then a happy wisdom becomes ours. With him our friend we cannot come to harm.

Whosoever makes him his priest of the sacrifice, reaches the perfection that is the fruit of his striving, a home on a height of being where there is no warring and no enemies ; he confirms in himself an ample energy ; he is safe in his strength, evil cannot lay its hand upon him.

This is the fire of our sacrifice ! May we have strength to kindle it to its height, may it perfect our thoughts. In this all that we give must be thrown that it may become a food for the gods ; this shall bring to us the godheads of the infinite conscious-ness who are our desire.

Let us gather fuel for it, let us prepare for it offerings, let us make ourselves conscious of the jointings of its times and its seasons. It shall so perfect our thoughts that they shall extend our being and create for us a larger life.

This is the guardian of the world and its peoples, the shepherd of all these herds ; all that is born moves by his rays and is compelled by his flame, both the two-footed and the four-footed creatures. This is the rich and great thought-awakening of the Dawn within.

This is the priest who guides the march of the sacrifice, the first and ancient who calls to the gods and gives the offerings ; his is the command and his the purification ; from his birth he stands in front, the vicar of our sacrifice. He knows all the works of this divine priesthood, for he is the Thinker who increases in us.

The faces of this God are everywhere and he fronts all things perfectly ; he has the eye and the vision ; when we see him from afar, yet he seems near to us, so brilliantly he shines across the gulfs. He sees beyond the darkness of our night, for his vision is divine.

O you godheads, let our chariot be always in front, let our clear and strong word overcome all that thinks the falsehood. O you godheads, know for us, know in us that Truth, increase the speech that finds and utters it.

With blows that slay cast from our path, O thou Flame, the powers that stammer in the speech and stumble in the thought, the devourers of our power and our knowledge who leap at us from near and shoot at us from afar. Make the path of the sacrifice a clear and happy journeying.

Thou hast bright red horses for thy chariot, O Will divine, who are driven by the stormwind of thy passion ; thou roarest like a bull, thou rushest upon the forests of life, on its pleasant trees that encumber thy path, with the smoke of thy passion in which there is the thought and the sight.

At the noise of thy coming even they that wing in the skies are afraid, when thy eaters of the pasture go abroad in their haste. So thou makest clear thy path to thy kingdom that thy chariots may run towards it easily.

This dread and tumult of thee, is it not the wonderful and exceeding wrath of the gods of the Life rushing down on us to found here the purity of the Infinite, the harmony of the Lover ? Be gracious, O thou fierce Fire, let their minds be again sweet to us and pleasant.

God art thou of the gods, for thou art the lover and friend ; richest art thou of the masters of the Treasure, the founders of the home, for thou art very bright and pleasant in the pilgrimage and the sacrifice. Very wide and far-extending is the peace of thy beatitude ; may that be the home of our abiding !

That is the bliss of him and the happiness ; for then is this

Will very gracious and joy-giving when in its own divine house, lit into its high and perfect flame, it is adored by our thoughts and satisfied with the wine of our delight. Then it lavishes its deliciousness, then it returns in treasure and substance all that we have given into its hands.

O thou infinite and indivisible Being, it is thou ever that formest the sinless universalities of the spirit by our sacrifice ; thou compellest and inspirest thy favourites by thy happy and luminous forcefulness, by the fruitful riches of thy joy. Among them may we be numbered. Thou art the knower of felicity and the increaser here of our life and advancer of our being ! Thou art the godhead ! (RV. I. 94)

ALTAR

O Flame, sit with the gods on the seat of the soul's fullness. (RV. V. 26.5)

ANCIENT FRIENDSHIP

Let there be that ancient friendship between you gods and us as when with the Angirasas who spoke aright the word, thou didst make to fall that which was fixed and slewest Vala as he rushed against thee, O achiever of works, and thou didst make to swing open all the doors of his city. (RV. VI. 18.5)

ANGIRASAS

Our fathers by their words broke the strong and stubborn places, the Angiras seers shattered the mountain rock with their cry ; they made in us a path to the Great Heaven, they discovered the Day and the sun-world and the intuitive ray and the shining herds. (RV. I. 71.2)

ASCENT

I have arisen from earth to the mid-world, I have arisen from the mid-world to heaven, from the level of the firmament of heaven I have gone to the Sun-world, the Light. (Yajur Veda. 17.67)

THE ASHVINS, LORDS OF BLISS

Lo, that Light is rising up and the all-pervading car is being yoked on the high level of this Heaven ; there are placed satisfying delights in their triple pairs and the fourth skin of honey overflows. Full of honey upward rise the delight, upward horses and cars in the wide-shinings of the Dawn and they roll aside the veil of darkness that encompassed on every side and they extend the lower world into a shining form like that of the luminous heaven. Drink of the honey with your honey-drinking mouths, for the honey yoke your car beloved. With the honey you gladden the movements and its paths ; full of honey, O Ashvins, is the skin that you bear. Full of the honey are the swans that bear you, golden-winged, waking with the Dawn, and they come not to hurt, they rain forth the waters, they are full of rapture and touch that which holds the Rapture. Like bees to pourings of honey you come to the Soma-offerings. (RV. IV. 45)

ASPIRATION

Touch either heaven's superior peak or swing wide open with all the extent of the earth, O doors of aspiration ! (RV. X. 70.5)

BLACK MAGIC

May these men, heroes in the slayings of the Coverers, who work out the thought I have voiced, overcome all undivine magic-knowledge. (RV. VII. 1.10)

Not even by magic can the mortal foe master the man who offers worship to the Fire. (RV. VIII. 23.15)

COMPELLING WORD

Vatsa compels thy mind even from the supreme world of thy session, O Fire, by his word that longs for thee. (RV. VIII. 11.7)

CONCORD

Join together, speak one word, let your minds arrive at one knowledge even as the ancient gods arriving at one knowledge

partake each of his own portion. Common Mantra have all these, a common gathering to union, one mind common to all, they are together in one knowledge ; I pronounce for you a common Mantra, I do sacrifice for you with a common offering. One and common be your aspiration, united your hearts, common to you be your mind, — so that close companionship may be yours. (RV. X. 191.2-4)

CONSECRATED SERVICE

When in his service men cast down their sweat on the paths, they ascend to a self-born ground as if to wide levels. (RV. V. 7.5)

CREATION

Then existence was not nor non-existence, the mid-world was not nor the Ether nor what is beyond. What covered all ? Where was it ? In whose refuge ? What was that ocean dense and deep ? Death was not nor immortality nor the knowledge of day and night. That One lived without breath by his self-law, there was nothing else nor aught beyond it. In the beginning Darkness was hidden by darkness, all this was an ocean of inconscience. When universal being was concealed by fragmentation, then by the greatness of its energy That One was born. That moved at first as desire within, which was the primal seed of mind. The seers of Truth discovered the building of being in non-being by will in the heart and by the thought ; their ray was extended horizontally ; but what was there below, what was there above ? There were Casters of the seed, there were Greatnesses ; there was self-law below, there was Will above. (RV. X. 129.1-5)

DAWN

Dawn of the luminous journey, Dawn queen of truth, large with the Truth, how wide is the gleam from her rosy limbs,— Dawn divine who brings with her the heaven of light ! Her the seers adore with their thoughts. This is she who has the vision and she awakens man and makes his paths easy to travel and

walks in his front. How large is her chariot, how vast and all-pervading the goddess, how she brings Light in the front of the days ! This is she who yokes her cows of rosy light ; her journey does not fail and such is the treasure she makes that it passes not away. She hews out our paths to happiness ; divine is she, far-shining her glory, many the hymns that rise to her, she brings with her every boon. Behold her in her biune energy of earth and heaven, how she comes into being in her whiteness and discloses her body in our front. She follows perfectly the paths of Truth, as one who is wise and knows, and she hedges not in our regions. Lo, how brilliant is her body when she is found and known ! How she stands on high as if bathing in light that we may have vision ! Driving away all enemies and all dark-nesses Dawn, the daughter of Heaven, has come with the Light. Lo, the daughter of Heaven like a woman full of happiness moves to meet the gods and her form travels ever nearer to them. Unveiling all blessings for the giver of sacrifice the goddess young for ever has created the Light once more even as in the beginning. (RV. V. 80)

DAY AND DAY

A day that is black and a day that is argent bright, two worlds revolve in their different paths by forces that we must know. (RV. VI. 9.1)

DELIVER INTO PEACE

Those within whose gated house the goddess of Revelation with her hands of light sits filled with her fullnesses, them deliver from the doer of harm and the Censurer, O forceful Fire ; give to us the peace that hears the Truth from afar. (RV. VII. 16.8)

DOORS

May the divine Doors swing open, wide to our call, easy of approach with our prostrations of surrender ; may they stretch wide opening into vastnesses, the imperishable Doors purifying the glorious and heroic kind. (RV. II. 3.5)

Swing wide, O divine doors ; be easy of approach that you may be our guard : lead further further and fill full our sacrifice. (RV. V. 5.5)

Widely expanding may they spring apart making themselves beautiful for us as wives for their lords ; O divine doors, vast and all-pervading, be easy of approach to the gods. (RV. X. 110.5)

DUALITY

I cannot travel to the Truth of the luminous Lord by force or by duality. (RV. V. 12.2)

EARTH THE FOUNDATION

As in earth are founded all the worlds, they founded all happinesses in the purifying Fire. (RV. VI. 5.2)

EQUAL

Thou art the lord who looks with equal eyes on all the peoples in many lands. (RV. VIII. 43.21)

ETERNAL WEALTH

To be rejected is the abundance of the riches that bring no delight, let us be the masters of a wealth that is eternal ; that which is born from another is not the Son. (RV. VII. 4.7)

EVIL IN DUSK AND DAWN

Do thou guard us from evil in dusk and in dawn from the bringer of calamity — thou art by day and night inviolable. (RV. VII. 15.15)

EVIL MIND

Let not the evil mind of mortal besiege us. (RV. III. 15.6)

EVIL THOUGHTS

Let not calamity from every evil-thoughted hostile around smite us like a billow smiting a ship. (RV. VIII. 75.9)

EXPECTANT

My ears range wide to hear and wide my eyes to see, wide this Light that is set in the heart ; wide walks my mind and I set my thought afar ; something there is that I shall speak ; something that now I shall now think. (RV. VI. 9.6)

FIVE PEOPLES

May the Peoples of the five Births accept my sacrifice, those who are born of the Light and worthy of worship ; may Earth protect us from earthly evil and the Mid-region from calamity from the gods. Follow the shining thread spun out across the mid-world, protect the luminous paths built by the thought ; weave an inviolate work, become the human being, create the divine race. . . . Seers of truth are you, sharpen the shining spears with which you cut the way to that which is Immortal ; knowers of the secret planes, form them, the steps by which the gods attained Immortality. (RV. X. 53. 5, 6, 10)

GOD AND I

The god who is the guardian of the order and laws of the Truth knows me but I know him not. (RV. V. 12.3)

GODS

Many powers born in the finding of knowledge and wearing the forms of gods move abroad to this sacrifice. (RV. III. 4.5)

GUARD BENIGNANT

Far from us all unconsciousness, sin and evil mind when thou art on guard, a benignant Power in the night, O Fire, O son of force, over him to whom thou cleavest for his weal. (RV. IV. 11.6)

GUEST

In his visioned glory he lodges as the guest in every house, as a bird in forest and forest; he disdains not the peoples, universal he dwells in being and being, common to all he dwells in man and man. (RV. X. 91.2)

HEALER

I voice the Shining One with its richly varied lights, the fair and happy, the great in whom is nothing hostile ; Fire, the priest of the call, the master of the house gives the healing forces that sustain the world, he gives us the hero-energy. (RV. X. 122.1)

HEART AND LIGHT

Following the thought with the heart he has reached knowledge of the light. (RV. III. 26.8)

HOLY COMPANY

May the peoples of the gods abandon us not even as the unslayable luminous herds full of milk leave not a calf that is lean. (RV. VIII. 75.8)

HOSTILE FORCES

These worlds of beings born are full of harm : burn to ashes the hostile forces that come against us. (RV. III. 18.1)

The hostile powers have hidden within in mortals the king of those who dwell in creatures in whom all creatures dwell ; let the wisdom-words of Atri release him, let the binders themselves become the bound. (RV. V. 2.6)

HUNDRED YEARS

May we revel in the rapture strong with the strength of the Heroes, living a hundred winters. (RV. VI. 12.6)

8

IGNORANT

O thou who art conscious and free from ignorance, ignorant are we and we know not thy greatness, thou only knowest. (RV. X. 4.4.)

IMMORTAL IN MORTALS

O Immortal, thou art born in mortals in the law of the Truth, of Immortality, of Beauty. (RV. IX. 110.4)

IMPEDIMENTS

Let us pass beyond the foe and the sin and the stumbling ; let us pass beyond these things, pass in thy keeping through them safe. (RV. VI. 2.11)

INDRA

Come, O Indra, with thy rich lustres, these Soma-juices desire thee ; they are purified by the subtle powers and by extension in body.

Come, O Indra, impelled by the mind, driven forward by the illumined thinker, to my soul-thoughts, I who have poured out the Soma-juice and seek to express them in speech.

Come, O Indra, with forceful speed to my soul-thoughts, O lord of the bright horses ; hold firm the delight in the Soma-juice. (RV. I. 3.4-6)

INFINITE AND FINITE

O Godhead, guard for us the Infinite and lavish the finite. (RV. IV. 2.11)

INNER FOES

Wholly consume our inner foes, consume the self-expression of the enemy who would war against us, O lord of the riches, consume, conscious in knowledge, the powers of ignorance. (RV. III. 18.2)

O Fire, destroy with a new word the expression of these within in the bodies, destroy within us the beings hostile to those who give thee, let all the enemy forces, the hostile spirits depart from here who would do hurt to us, — let all that are hostile be rent asunder. (RV. VIII. 39.2)

INTUITION

An intuition in the heart sees that truth. (RV. I. 24.12)

Yea, he creates the light of intuition even for one who is far off in the night. (RV. V. 7.4)

KNOWLEDGE AND IGNORANCE

Let the knower discriminate the Knowledge and the Ignorance, the straight open levels and the crooked that shut in mortals. (RV. IV. 2.11)

LAUD

O thou of the many births, I the sage, the thinker, the man of perfect works have fashioned for thee this laud like a chariot. If, indeed, O god, thou shouldst take an answering joy in it, by this we could conquer the waters that carry the light of the sun-world. (RV. V. 2.11)

LAW

The gods move according to the law of the workings of the gods. (RV. III. 7.7)

All follow the working of the Law when they make the Sun to rise up in heaven. (RV. IV. 13.2)

Because the immortal Fire sets the gods to their work none can corrupt the eternal Laws. (RV. III. 3.1)

LIGHT

Our fathers found out the hidden light, by the truth in their thoughts they brought to birth the Dawn. (R.V. VII. 76.4)

Beholding the higher Light beyond the darkness we came to the divine Sun in the Godhead, to the highest Light of all. (RV. I. 50.10)

LOTUS OF THE HEAD

O Fire, Atharvan churned thee out from the lotus of the head of every chanting sage. (RV. VI. 16.13)

MAHI

Thus Mahi for Indra full of the rays, overflowing in her abundance, in her nature a happy truth, becomes as if a ripe branch for the giver of the sacrifice. (RV. I. 8.8)

MANIFESTATION

State upon state is born, covering upon covering has become conscious and aware, in the lap of the mother he sees. (RV. V. 19.1)

MANTRA

As the unborn he has held the wide earth, he has up-pillared heaven with his Mantra of truth. (RV. I. 67.3)

Here men who hold in themselves the Thought come to know him when they have uttered the Mantras formed by the heart. (RV. I. 67.2)

We bring to thee, O Fire, by the illumining word an offering that is shaped by the heart. (RV. VI. 16.47)

MARUTS, THE THOUGHT-GODS

The shining host has arisen in my soul, the host of the Thought-gods and they sing a hymn as they march upward, a hymn of the heart's illumination. March thou on, O my soul, impetuously to their violent and mighty music. For they are drunken with the joy of an inspiration that betrays not to falsehood, because the truth of eternal Nature is its guide. They are the comrades of a firm and blazing Light and in the force of

the Light they work out their lofty aggressions ; conquerors, violently they march on their path, self-protecting they guard of themselves the soul against falsehood ; for they are many and march without a gap in their brilliant ranks. Violent are they as a herd of rushing bulls ; the nights come against them, but they overleap the nights ; they possess the earth in our thoughts and they rise with them to the heavens. No half-lights, no impotent things are they, but mighty in aggression and puissant to attain. Spears of light they hold and they loose them from their hands at the children of Darkness ; the flashing lightnings of the Thought-gods search the night and the light of heaven rises of itself on our souls at their battle-call. Truth is their shining strength ; the host of the Thought-gods are the artificers of the soul and they fashion its immortality ; themselves they yoke their coursers to the chariot of our life and they drive galloping to the joy that is its goal.

They have bathed their limbs in the waters of Purushni, in the stream that has a multitude of currents, they have put on their divine raiment and now with the wheels of their chariots they break open all Nature's secret caves. Sometimes they march on a thousand branching paths, sometimes they rush direct at their goal ; sometimes their paths are within, sometimes they follow outward Nature's thousand ways ; the world-sacrifice fulfils itself by the many names of their godhead and by their ever-widening march. Now they make themselves as galloping forces of our life, now they are gods and powers of the soul ; at last they put on forms of a supreme world, forms of vision, forms of light. They have attained to the goal, they support the rhythms of the world, chanting they weave their glorious dance round the very fountain of things ; they are creators of supreme forms, they expand the soul in vision and make it a divine blaze of light. For these are rushing seekers of the Truth ; for the Truth their lightnings stab and search ; they are seers, they are creators and ordainers ; their aggressions are inspired by the might and force of heaven, therefore affirmed in our thoughts they speed carrying us confidently on their way. When the mind is full of them, it is borne on towards godhead, for they have the radiant inspiration of the path.

Who has known the place of their birth or who has sat in their high beatitudes ? Who desires and seeks his Friend

beyond ? A Mother bore them many-hued in her soul and of her they tell him ; a Violent One was their father whose impulse drives all beings that are born, and him they reveal. Seven and seven the Thought-gods came to me and seven times they gave a hundredfold ; in Yamuna I will bathe the shining herds of my thoughts which they have given, I will purify my swiftnesses in the river of my soul.

Lo, they march on in their cohorts and their companies ; let us follow in their steps with the pace of our thinkings. For they bear with them an imperishable seed of creation and the grain of immortal forms and this if they plant in the fields of the soul, there shall grow as its harvest life universal and bliss transcendent. They will put by all that derides our aspiration and pass beyond all that limits us ; they will destroy all faults and dumb-ness and the soul's poverties. For theirs is the rain of abundance of heaven and theirs the storms that set flowing the rivers of life ; their thunders are the chant of the hymn of the gods and the proclamations of the Truth. They are the eye that leads us on a happy path and he who follows them shall not stumble, nor have pain nor hurt, nor decay nor die ; their plenitudes are not destroyed nor their felicities diminished ; they make of man a seer and a king. Their vastness is the blazing of a divine Sun ; they shall place us in the seats of Immortality.

Of all that was of old and of all that is new, of all that rises from the soul and all that seeks expression they are the impellers. They stand in the upper, and the lower and the middle heaven ; they have descended from the highest supreme. They are born of the Truth ; they are luminous leaders of the mind ; they shall drink the sweet wine of delight and give us the supreme inspiration. The Woman, the Divine is with them who shall put away from us hurt and thirst and desire and refashion man's mind in the form of the godhead. Lo, these are knowers of the Truth, seers whom the Truth inspires, vast in expression, vast in diffusion, young for ever and immortal. (Based on RV. V. 52 and V. 58)

MAYA

The Masters of Maya shaped all by His Maya ; the Fathers who have divine vision set Him within as a child that is to be born. (RV. IX. 83.3)

MEN WITHOUT THE WORD

To him I am giving immortality in my several parts and what shall they do to me who possess not Indra and have not the word ? (RV. V. 2.3)

Those who live undelighted with the word that is languid and scanty, narrow and dependent on their belief, what now and here can they say to thee, O Fire ? Uninstrumented let them remain united with the unreal. (RV. IV. 5.14)

MY MITE

Mine is not the cow unslayable, I have no axe at hand, so I bring to thee this little that I have.
What is eaten by the ant, what the white ant overruns, let all that be to thee as if thy food of life. (RV. VIII. 102. 19, 21)

MYSTERY

I know not the woof, I know not the warp, nor what is this web that they weave moving to and fro in the field of their motion and labour. There are secrets that must be told. (RV. VI. 9.2)

NAME

Hard to seize by the mind in this world is the name of the immortal because he puts on features and becomes divergent forms. (RV. X. 12.6)

The seers guard the seat of the Truth, they hold in the secrecy the supreme Names. (RV. X. 5.2)

OCCULT

The thought in which the gods meet together, when it is occult we konw not of it. (RV. X. 12.8)

The truths occult exist not for the mind of the ignorant. (RV. VII. 61.5)

ONE

All the Gods with a single mind, a common intuition, move aright in their divergent paths towards the one Will. (RV. VI. 9.5)

PANIS

The traffickers who have not the will for the work, the binders in knots, who have the speech that destroys, who have neither faith nor growth in the being, nor sacrifice, these the Destroyers Fire has scattered before him ; supreme he has made nether in their realm those who will not to do sacrifice. (RV. VII. 6.3)

PASSWORD

May the Restrainers say to us, " Nay, forth and strive on even in other fields, reposing on Indra your activity." (RV. I, 4.5)

PATH

We have come to the path of the gods, may we have power to tread it, to drive forward along that road. (RV. X. 2.3)

PURIFICATION

Let the giver be the best by work of the will ; today winning thee let him become one overflowing with affluence : a mortal, he shall taste the perfect purification. (RV. VI. 16.26)

QUERY

Who keep the foundation of the Falsehood, O Fire ? Who are the guardians of the untrue Word ? (RV. V. 12.4)

RAIN

The purifying rains are extended before us in the shape of the waters : take us over to the state of bliss that is the other shore of them. (RV. III. 31.20)

RAKSHASA

This Fire overpowers the workings of knowledge that are undivine and evil in their impulse, he sharpens his horns to gore the Rakshasa. (RV. V. 2.9)

RIBHUS, ARTISANS OF IMMORTALITY

Lo, the affirmation made for the divine Birth with the breath of the mouth by illumined minds, that gives perfectly the bliss ; Even they who fashioned by the mind for Indra his two bright steeds that are yoked by Speech, and they enjoy the sacrifice by their accomplishings of the work. They fashioned for the twin lords of the voyage their happy car of the all-pervading movement, they fashioned the fostering cow that yields the sweet milk. O Ribhus, in your pervasion you made young again the Parents, you who seek the straight path and have the Truth in your mentalisings. The raptures of the wine come to you entirely, to you with Indra companioned by the Maruts and with the Kings, the sons of Aditi. And this bowl of Twashtri new and perfected you made again into four. So establish for us the thrice seven ecstasies, each separately by perfect expressings of them. They sustained and held in them, they divided by perfection in their works the sacrificial share of the enjoyment among the Gods. (RV. I. 20)

RULER OF THOUGHT

O Fire, thou art the ruler over every Thought and thou carriest forward the mind of thy worshipper. (R.V. IV. 6.1)

SACRIFICE

Today let thy sacrifice march forward unceasingly, thy sacrifice that shall bring the whole epiphany of the godheads. Strew the seat of thy soul that there they may sit. (RV. V. 26.8)

SARAMA

Sarama discovered the mass of the Ray-Cow, the strong place.

the wideness, and now by that the human creature enjoys bliss. (RV. I. 72.8)

SARASVATI

May purifying Sarasvati with all the plenitude of her forms of plenty, rich in substance by the thought, desire our sacrifice.

She, the impeller to happy truths, the awakener in conscious-ness to right mentalisings, Sarasvati, upholds the sacrifice.

Sarasvati by the perception awakens in consciousness the great flood (the vast movement of the *Ṛtam*) and illlumines entirely all the thoughts. (RV. I. 3. 10-12)

SAT AND ASAT

He is the being and non-being in the supreme ether, in the birth of the Understanding in the lap of the indivisible Mother. (RV. X. 5.7)

SECRET WORDS

All these are secret words that I have uttered to thee who knowest, O Agni, O Disposer, words of leading, words of seer-knowledge that express their meaning to the seer, — I have spoken them illumined in my words and my thinkings. (RV. IV. 3.16)

SHIP

Thou givest us O Agni, for chariot and for home a ship travelling with eternal progress of motion that shall carry our strong spirits and our spirits of fullness across the births and across the peace. (RV. I. 40.12)

As in a ship over the ocean, bear us over into thy felicity. (RV. I. 97.8)

SIN

The sin we have done as cunning gamesters offend in their play, our sin against the truth and our sin by ignorance, all these cleave away like loosened things ; then may be dear to thee, O Varuna. (RV. V. 85.8)

SINLESS

If at all in our humanity by our movements of ignorance we have done any evil against thee, O Fire, make us wholly sinless before the Mother indivisible ; O Fire, mayest thou loosen from us the bonds of our sins to every side. (RV. IV. 12-4)

SOMA, THE GOD OF THE MYSTIC WINE

Giving birth to the luminous worlds of heaven, giving birth to the Sun in the waters, the Brilliant One clothes himself with the waters and the rays. He by the ancient thought flows pressed out in a stream, a god around the gods. For one increasing and swiftly advancing there flow for his winning of the plenty the Soma-juices with their thousand strengths. Milked out, the ancient food, he is poured into the strainer that purifies and shouting he brings to birth the gods. Soma, purifying himself, travels to all desirable boons, to the gods who increase the Truth. Stream on us, O Soma, when thou art pressed out, that in which are the Cows, the Heroes, the Steeds, the Plenty ; stream impulsions vast. (RV. IX. 42)

SPEECH

Our words are thoughts seeking for godhead. (RV. VII. 10.3)

STOMA

Lo, the hymn of your affirmation, O Maruts ; it is fraught with my obeisance, it was framed by the heart, it was established by the mind, O ye gods. (RV. I. 171.2)

SUPREME GOAL

That supreme plane in the secrecy which is the highest goal of our path, which is over and above all, that we have reached, free from bondage. (RV. IV. 5.12)

SURRENDER

Travellers with surrender to the plane of the godhead, seekers of inspired knowledge, they won an inviolate inspiration, they

held the sacrificial Names and had delight in thy happy vision. (RV. VI. 1.4).

SURYA

O Sun, O Light, because today blameless in thy rising thou hast declared the Truth to the Lord of Love and the Lord of Purity, so may we abide in the godhead, dear to thee, O Mother infinite, dear to thee, O Lord of strength, in all our speaking. O Mitra, O Varuna, this is he that seeth for the soul, the Sun that rises over earth and heaven in the prevading wideness, and he guards all that is in motion and all that is stable ; for he beholds the straight things and the crooked in mortals. Seven shining energies has this Bright One yoked today in the world of our achievement and they bear him on in their clarity, and he beholds the homes of the soul and the places of its birth like a herdsman who watches over his herds.

Upward rise your honied satisfactions ; for our sun has climbed into the ocean of pure Light and for him the Children of the Infinite hew out his paths, even the Lord of Love and the Lord of Strength and the Lord of Purity in one harmony. These are they that discern and separate all the much falsehood in us ; they, the Lords of Love and Strength and Purity. These grow in the house of Truth, puissant and unvanquished Sons of the Infinite. These are the Love and the Purity hard to repress who by their discernings give knowledge to him who has no knowledge ; they bring to him their impulses of a will that has right vision and they lead him by the good path beyond the evil. These with sleepless eyes see and know in his earth for man that is ignorant and lead him : in his forward faring he comes to the fathomless pit in the river, yet shall they bear him across to the other shore of this wideness. The peace and the protection and the happiness which the infinite Mother and the Lords of Love and Purity give to the servant of the sacrifice, in that let us found all our creation and building, let us do no violence to the godhead, O ye swift Wayfarers.

He whom the Lord of Purity upholds, puts away from his altar by the powers of sacrifice whatsoever hurts : cut away, O Lord of Strength, from the servant of the sacrifice the hurt and the division, form in him that vast other world, O givers

of the abundance. A blazing strength and a world of illumination is the coming together of these Godheads and they overcome by their near and approaching force. Lo, we quiver with the fear of you ; set us at ease by the greatness of your discerning. For when a man by sacrifice wins right-mindedness in the getting of the plenitude, in the conquest of the supreme Felicity, the strong Warriors, the Lords of the Treasure cleave to his heart of emotion and they form there the Vast for his dwelling-place making it of a perfect temper. For you we have made in front this work of the divine representative in our sacrifices ; lead us safe through all difficult places. Keep us always with constant felicities. (RV. VII. 60)

SURYA SAVITRI, CREATOR AND INCREASER

Men illumined yoke their mind and they yoke their thoughts to him who is illumination and largeness and clear perceiving. Knowing all phenomena he orders, sole, the Energies of the sacrifice. Vast is the affirmation in all things of Savitri, the divine Creator. All forms he takes unto himself, the Seer, and he creates from them good for the twofold existence and the fourfold. The Creator, the supreme Good, manifests Heaven wholly and his light pervades all as he follows the march of the Dawn. In the wake of his march the other gods also reach by his force to the greatness of the Divinity. He has mapped out the realms of earthly light by his mightiness, — the brilliant one, the divine Creator. And thou reachest, O Savitri, to the three luminous heavens ; and thou art utterly expressed by the rays of the Sun ; and thou encompassest the Night upon either side ; and thou becomest by the law of thy actions the lord of Love, O God. And thou art powerful for every creation ; and thou becomest the Increaser, O God, by thy movings ; and thou illuminest utterly all this world of becomings. Shyavaswa has attained to the affirmation of thee, O Savitri. (RV. V. 81)

TAPAS

From the kindled fire of Energy of Consciousness Truth was born and the Law of Truth ; from that the Night, from the Night the flowing ocean of being. (RV. X. 190.1)

THOU AND I

O friendly light, if thou wert the mortal and I the immortal,
— I would not give thee over to Assailant or to sinfulness ; he
who lauded me would not be won without understanding or
miserable nor one plagued by gilt, O Fire. (RV. VIII. 19.25-26)

O Fire, if I wert thou and thou art I, then would thy longings
here become true. (RV. VIII. 44.23)

TIME

Night was born and from Night the flowing ocean of being
and on the ocean Time was born to whom is subjected every
seeing creature. (RV. X. 190. 1,2)

TRIPLE PEACE

May we be doers of good deeds before the godheads, protect
us with a triple armour of peace. (RV. V. 4.8)

TRUTH

There is a Permanent, a Truth hidden by a Truth where the
Sun unyokes his horses. The ten hundreds (of his rays) came
together — That One. I saw the most glorious of the Forms
of the Gods. (RV. V. 62.1)

By the Truth they hold the Truth that holds all, in the power
of the Sacrifice, in the supreme ether. (RV. V. 15.2)

TWO BIRDS

Two birds beautiful of wing, friends and comrades, cling to
a common tree, and one eats the sweet fruit, the other regards
him and eats not. (V. I. 164.20,21)

UNIVERSAL

Even in the stone he is there for man, he is there in the
middle of his house, — he is as one universal in creatures.
(RV. I. 70.2)

UNKNOWABLE

It is not now, nor is It tomorrow ; who knoweth that which is Supreme and wonderful ? It has notion and action in the consciousness of another, but when it is approached by the thought, It vanishes. (RV. I. 170.1)

VARUNA

Varuna has put the will in our hearts, the divine fire in the waters, the Sun of Light in our heavens, the plant of Delight on the mountain of our being. (RV. V. 85.2)

One in many births, a single ocean holder of all streams of movement, sees our hearts. (RV. X. 5.1)

VASTNESS

Illumine our impulsions, animate in us the expanding powers of the Vast, O wakeful flame. (RV. III. 3.7)

VISTAS

As one mounts peak after peak, there becomes clear the much that has still to be done. (RV. I. 10.2)

VISHNU

Thrice Vishnu paced and set his step uplifted out of the primal dust ; three steps he has paced, the Guardian, the Invincible, and from beyond he upholds their laws. Scan the workings of Vishnu and see from whence he has manifested their laws. That is his highest pace which is seen ever by the seers like an eye extended in heaven, that the illumined, the awakened kindle into a blaze, even Vishnu's step supreme. (RV. I. 22. 17-21)

VISHVADEVAS

O fosterers who uphold the doer in his work, O all-gods, come and divide the Soma wine that I distribute. O all-gods who

bring over to us the Waters, come passing through to my Soma-offerings as illumined powers to your places of bliss. O all-gods, you who are not assailed nor come to hurt, free-moving in your forms of knowledge, cleave to my sacrifice as its upbearers. (RV. I. 3.7-9)

WATERS

May those divine waters foster me, the eldest (or greatest) of the ocean from the midst of the moving flood that go purifying, not settling down, which Indra of the thunderbolt, the Bull, clove out. The divine waters that flow whether in channels dug or self-born, whose movement is towards the Ocean, — may those divine waters foster me. In the midst of whom King Varuna moves looking down on the truth and falsehood of creatures, they that stream honey and are pure and purifying, — may those divine waters foster me. In whom Varuna the king, in whom Soma, in whom all the Gods have the intoxication of the energy, into whom Agni Vaishvanara has entered, may those divine waters foster me. (RV. VII. 49. 1-4)

WORD

Found for those who from age to age speak the word that is new, the word that is a discovery of knowledge, O Fire, their glorious treasure; but cut him in twain who is a voice of evil. (RV. VI. 8.5)

YĀTUDHĀNA

Turning on them by our sacrifices thy arrows O Fire, by our speech thy javelins, plastering them with thy thunderbolts pierce these in their heart the demon-sorcerers who confront us break their arms. (RV. X. 87.4)

O youthful god, subject him to eye of thy divine vision. (RV. X. 87.8)

Burn with the divine Light this being without knowledge who does hurt to the Truth. (RV. X. 87.12)

Other Titles by M.P. Pandit

OTHER TITLES BY SRI AUROBINDO